Album

ELIZABETH SIEGEL

GALLERIES OF FRIENDSHIP AND FAME

A History of

Nineteenth-Century

American

Photograph Albums

YALE UNIVERSITY PRESS, NEW HAVEN AND LONDON

Designed and set in Monotype Bell and Sackers Gothic by Laura Lindgren
Printed in China by Asia Pacific Offset

Library of Congress Cataloging-in-Publication Data
Siegel, Elizabeth, 1969–
 Galleries of friendship and fame : a history of nineteenth-century American
photograph albums / Elizabeth Siegel.
 p. cm.
 Includes bibliographical references and index.
 ISBN 978-0-300-15406-1 (cloth : alk. paper)
 1. Photograph albums—United States—History—19th century. 2. United
States—Social life and customs—19th century. 3. Popular culture—United
States—19th century. I. Title.
 TR501.S537 2010
 779—dc22 2009024048

A catalogue record for this book is available from the British Library.

This paper meets the requirements of ANSI/NISO z39.48-1992 (Permanence of Paper).

10 9 8 7 6 5 4 3 2 1

Illustrations on cover and pages i, xiii, 14, 68, 112, 156, 168: From albums
in the collection of the author, photographed by Greg Harris.

For Greg

CONTENTS

Acknowledgments ix

1 INTRODUCTION

15 CHAPTER ONE

THE CURRENCY OF
THE CARTE DE VISITE

69 CHAPTER TWO

ALBUMS ON THE MARKET

113 CHAPTER THREE

ALBUMS IN THE PARLOR

157 CHAPTER FOUR

THE DEMISE OF THE CARD ALBUM,
THE RISE OF THE SNAPSHOT ALBUM

Appendix: Photograph Album Poems and Songs 169
Notes 175
Index 197
Illustration Credits 203

ACKNOWLEDGMENTS

When I first began researching nineteenth-century photograph albums, photographs were made from film and printed on paper; camera phones and social networking sites were years away. It has been a long process, and I would like to express my gratitude to the many people who have helped me along the way.

For their intelligent guidance at the University of Chicago I thank Marty Ward, Tom Gunning, and especially Joel Snyder, who never wavered in his enthusiasm about the history of albums or in his faith in my ability to write it. A major influence on my research was the student photography reading group, whose scholarship on the fascinating untold histories of nineteenth-century photography inspired me, and without whose example I surely would have embarked on an entirely different project.

The wonderful staffs of the many institutions where I conducted research helped immensely and with constant good cheer, and I extend my whole-hearted appreciation to the archivists, librarians, and curators at the George Eastman House, Smithsonian Institution National Museum of American History, Winterthur Museum and Library, Society for the Preservation of New England Antiquities, Strong National Museum of Play, New-York Historical Society, American Bible Society, and Chicago History Museum. I have been privileged to have the Art Institute of Chicago as my own intellectual home and training ground for the past ten years, and I am grateful for the museum's support.

Earlier iterations of the ideas presented in this book were published in *Phototextualities: Intersections of Photography and Narrative* (University of New Mexico Press, 2003) and *The Scrapbook in American Life* (Temple University Press, 2006).

Among the many colleagues and friends who have helped encourage or improve this book, I would like to thank Kate Bussard, Erin Hogan, Corey Keller, Doug Nickel, Greg Nosan, Britt Salvesen, Shawn Smith, David Travis, Colin Westerbeck, and Matt Witkovsky. For their help with the photographs, I am indebted to Joseph Mohan and Greg Harris. It has been a pleasure to work with Patricia Fidler, Heidi Downey, and the staff of Yale University Press, and I am grateful for their hard work; I couldn't be

happier that this book is being published at the press of my undergraduate alma mater.

Finally, I am pleased to have this chance to publicly thank my family for years of encouragement, faith, and generosity. My parents, Ben and Jane Siegel, have fostered academic exploration and excellence since I was a child. I also drew support from the kindness and encouragement of my sister Rebecca, and that of the Jacobs family: Fran and Jerry, Ian and Val, and Julie. My beautiful daughters, Audrey and Nina, keep reminding me what is important; my own photograph albums are now filled with their smiles. Most of all, Greg Jacobs has sustained, motivated, challenged, and believed in me, and it is to him that this book is dedicated.

GALLERIES OF FRIENDSHIP AND FAME

INTRODUCTION

In the coldest places in the house, on consoles or gueridons in the draw-
ing room, they were most likely to be found: leather covered with metal
latches and gilt-edged pages as thick as a finger on which the foolishly
draped or embellished figures were distributed.

<div align="right">

—WALTER BENJAMIN,
"A SHORT HISTORY OF PHOTOGRAPHY"

</div>

Walter Benjamin knew exactly what a photograph album was: cold, false, embellished, filled with silly and often pretentious photographs. From the vantage point of 1931, when he wrote the essay "A Short History of Photography," the Victorian family album seemed stuffy, stopped in time, with poses so formulaic and forced as to reveal little about the sitter. He lamented the retouching and overuse of props that photographers employed in an attempt to imitate painting, and argued that with the advent of commercial studio photography a "sudden decline in taste" had set in. Benjamin's view of the Victorian photograph album seems to have been shared by later critics and scholars. Mass-produced, unauthored, and exceedingly common, early photograph albums have been overlooked or dismissed by most historians of photography.

Yet in this same essay Benjamin began to point to a way to approach photographic history, urging a move away from aesthetics and toward an understanding of "social functions."[1] Indeed, the many reasons that albums have not been pursued as a serious field of inquiry are precisely those which make them an invaluable window onto nineteenth-century society and visual culture. The codified poses of cartes de visite—the small, inexpensive, and widely reproduced portrait photographs that filled albums in the 1860s—and the repetitive formats of albums themselves reveal a trend, in even these most personal of images, toward standardization and assimilation. The fact that neither the albums nor the photographs in them were created by artists in the conventional sense forces attention away from artistic intent and

toward an exploration of reception and viewing practices. Produced not by a single maker but by a shifting collective of commercial photographers and consumer keepers of albums, photograph albums can be best understood as systems of representation. And although traditional art history has privileged uniqueness and rarity, the album's ubiquity indicates its importance to an immense number of people in nineteenth-century America.

This book is a social and cultural history of nineteenth-century American photograph albums, in which I examine their development, functions, and meanings. More than anything else, it is a study of practices. Rather than trace the visual representation of a specific family or the work of a single photographer, I explore the broader significance of early family albums. The central questions include how albums originated; what kinds of photographic self-representations were contained within them; how they were marketed to families; how they were displayed in the parlor; and what kinds of stories people told about and through them. I argue here that family albums acquired meaning in the context of a reciprocal relationship between the public, commercial sphere and the private, domestic one. The domestic parlor was commonly portrayed as an oasis in Victorian America, insulated from the world of business. In looking closely at family albums and period literature, however, it becomes apparent that the spheres were anything but separate. On the contrary, domestic practices were profoundly shaped by commercial concerns, and the personal habits of consumers could in turn have a tremendous effect on commerce. The many functions of photograph albums—family record, parlor entertainment, social register, national portrait gallery, or advertisement for photography itself—cannot be understood without taking into account this striking reciprocity.

This investigation of early albums builds on a generation of scholars dedicated to a more inclusive and methodologically diverse history of photography. In its quest to legitimate itself as an art, photographic history has focused primarily on important figures, key movements, and iconic works—in short, it has been treated as a history of art—and commercial and popular photography have often been neglected.[2] This approach began to be challenged as new kinds of images were integrated into academic study, and in recent years, research on nineteenth-century commercial photography has been conducted not only in the discipline of art history but outside of it, in fields such as material culture, visual studies, and American studies. A renewed interest in the vernacular on the part of both the academy and the museum has become apparent, and survey histories of photography have also begun including such practices as album-keeping, if only in a cursory way.[3]

Scholars interested in the shaping of personal histories have turned their attention to snapshot albums, paving the way for a more thorough prehistory of those album conventions and practices.[4] Additionally, a few case studies of nineteenth-century albums have added to the field an understanding of particular albums' contents and makers' strategies.[5] Some key scholars of nineteenth-century commercial photography—Elizabeth Anne McCauley on practices in France, Steve Edwards in England, and Shirley Teresa Wajda and Andrea Volpe in the United States—have filled in historical and conceptual gaps in the technique and aesthetics of studio portraiture, the business practices of photographers, and the circulation of photographic images.[6] In my study of albums I aim to incorporate into the discourse primary materials long overlooked as marginal or inconsequential, and to address practices of consumption, reception, and viewing, as well as networks of production.

This history of early photograph albums begins in 1861, the year that carte de visite albums were patented in America and first mentioned in the commercial press, and ends shortly after 1888, with the advent of the Kodak camera and the snapshot. The albums treated in this book are the mass-produced variety with standard-sized slots to hold cartes or, later, cabinet cards. At times I refer to them as family albums, even though they often contained celebrity portraits, views (landscapes), or genre scenes; the terms *family*, *photograph*, *card*, and *portrait album* are all used interchangeably here. Although there were other kinds of photographic albums produced during this period—travel albums were quite popular, as were wartime portfolios, such as Alexander Gardner's *Photographic Sketch Book of the Civil War*—they were distinct from family albums in several respects. The large format of the pictures within made the viewing experience more akin to examining a portfolio of engravings than miniatures of loved ones; sold by subscription in limited numbers, they were usually more expensive and did not have the card album's popular appeal; and they often came pre-assembled, and thus did not represent the individual taste and selections of the owner in the same way.

Although photography was, by the 1860s, an international industry, I have limited this study to the United States for several reasons. Cartes de visite and albums emerged as the country was transitioning from an agrarian to an industrial economy: the national population doubled between 1850 and 1880 from under 25 million to over 50 million; cities grew enormously; American entrepreneurs contributed to the development of the photographic industry; and a large and extensive domestic market sprang up, sparked by the growth of railroads and by western expansion.[7] It is also no coincidence that the popularity of the photograph album mirrored the escalation of the Civil War, when

thousands of young men fell in battle and photographic portraits provided a new and powerful way of preserving their memory. Compared to Europe, the United States was still a young country, a nation of immigrants and self-made men whose ancestries did not stretch back as far as their old-world counterparts. The desire for everyday Americans to possess a visual genealogy and to use photographs to assimilate into middle-class society, then, may be both indicative of American national character and a product of it. The accessibility of the card format held a particularly democratic appeal to Americans, and numerous commentators noted that cartes de visite and albums were affordable to nearly all. Inexpensive pictures of national notables circulated widely, but instead of the cartes of royalty and titled peers that populated European collections, the celebrities that filled American albums were generally political, military, and cultural figures, which entailed a different kind of reception and viewing. Finally, the broad and shifting American middle class—the vast middle, neither very rich nor very poor, which was targeted as the prime consumers of albums—was characterized by both geographic and social mobility. The physical shifts of westward migration and movement from country to city paralleled the potential for changes in social status. As Karen Halttunen has explained it, the middle class was really about transition more than a particular level or state: "Whether rising or falling, however, middle-class Americans were defined as men in social motion, men of no fixed status."[8] While my conclusions are limited to the United States, this study could have implications for understanding the rise of inexpensive portraiture and albums in Europe as well; indeed, the popularity of the carte de visite album rose among the European middle classes at the same time as it did in the United States (even preceding it slightly), and photographic developments and news quickly crisscrossed the Atlantic. Still, in America photographs and albums came to serve distinct purposes and have particular meanings for a nation that was young, democratically inclined, physically and socially mobile, and riven by war. Albums helped fix Americans in time and place and provided them with both a personal genealogy and a national history.

The materials examined here—many for the first time—include the popular and professional press, broadsides and advertisements, patents, posing guides, sales catalogues, manuals for agents selling albums, household account books, and of course albums themselves. Surprisingly little exists in diaries, letters, or novels about maintaining and displaying family pictures in albums, suggesting that these practices were so commonplace as to be unremarkable to everyday commentators. Instead, I found a wealth of

information in the literature and records of commercial photography, and so it is perhaps to be expected that the personal album's intersection with the marketplace emerges as a central concern in this book. Through my reading of the varied professional photographic literature it became apparent that photographers cared a great deal about how albums were used, and that albums were a significant part of the technical and aesthetic discourse of photography in the 1860s and 1870s.

The collodion era witnessed a professionalization of the field, and along with new photographic societies, new publications sprang up to become the voice of the photographic community. Professional photography journals provided a great deal more than technical and business advice for their readership. They also commented on social interactions between photographers and their customers, reported on popular responses to innovations in the field, and passed aesthetic judgments on photographic displays. In the United States, some journals were founded by photographers or were the organs of amateur photographic societies, but many were started up by photographic supply houses. For example, *Anthony's Photographic Bulletin* was introduced by the E. & H. T. Anthony Company, a leading photographic manufacturer and publisher; the Scovill Manufacturing Company published the *Photographic Times;* and the *American Journal of Photography* was headed by Charles Seely and H. Garbanati, partners in a photochemical business.[9] As Steve Edwards has articulated for England in the same years, "photographic literature set about defending a professional interest."[10] The journals of the day were filled with self-promotional plugs and advertisements for their own products, and commentary by photographers attempted to elevate and advance the art. I have tried to bear these positions in mind when encountering press excerpts that sing the praises of such technological developments as photograph albums or make claims for their universality.

The popular press proved to be an illuminating source as well. The social changes being wrought by this new technology widened the scope of voices contributing to the discourse on photography. For example, Oliver Wendell Holmes—the eminent Boston physician, poet, and essayist who published and lectured widely about medicine and the Union in Civil War, as well as about more lighthearted topics—contributed a series of important articles on photography to the *Atlantic Monthly*, a journal of the east coast literary elite. Rather than promote a commercial interest (although Holmes had invented an American version of the stereoscope), his essays delineated a new social landscape in which photography was a transforming force. In popular and women's journals, news items and editorials promoted photographic trends,

fashion plates showed women in the latest finery holding albums, cartoons poked fun at photographic sitters and consumers, and romantic short stories and poems employed photographs and albums as key plot points. Such items entertained and advised an audience of the growing middle class—and were often geared specifically to women, who were potential consumers of (among other things) photograph albums—thus fanning the flames of the initial album craze and encouraging the album's permanent place in households across the country.

Finally, the hundreds of albums I examined hammered home the incredible consistency of presentation from family to family. (The exceptions to this rule—the most revealing and surprising finds—are given lengthier treatment in the following chapters.) The physical materials of albums themselves—their covering and gilding, the order of differently sized slots, binding methods, techniques of picture insertion—proved to be of great interest to me, as albums' intended use seemed intimately bound up in their design. Filled with portraits made by numerous different photographers and often arriving to the modern scholar severed from any history of their organizer, albums also pose fascinating authorial problems: Who, for example, might we think of as the creator, the photographers or the album-keeper? How can we interpret an album without knowing anything about its maker? Such questions steered me away from a biographical or case-study approach. In fact, I have not undertaken many in-depth analyses of individual albums here, only partly because of the frustrating limitations of case studies but more importantly to emphasize the discourse and cultural significance of albums in general.

Accordingly, I have also chosen to analyze the aggregate of studio portraiture, which displayed a visual sameness that was commented upon even at the time, over individual photographs. This pictorial repetitiveness reflects the realities of modern mass production as well as middle-class aspirations and assimilation. Although contemporary editorials and artistic photographers lamented such homogeneity as a debasing of the art, that sentiment does not seem to have been widely expressed by consumers. American sitters may well have embraced the standardization seen across photograph albums and images, understanding that the act of being photographed—and then circulating their images—allowed them to become part of society by becoming part of a social archive.[11] Indeed, participating in album rituals may have allowed Americans to envision themselves as members of what Benedict Anderson has called an "imagined community," in which most people will never meet but are nonetheless aware of the existence of others.[12] In Anderson's model, this national consciousness emerges with the rise of

print-capitalism, as the reader of the newspaper or a popular novel recognizes a community of other readers simultaneously engaging in the same activity. A parallel can be seen most clearly in the case of celebrity cartes de visite, which were reproduced and circulated in such large numbers that they entered the home on a national scale; the shared experience of viewing the same photographs in the same way linked album owners as members of a national community.

Although early albums may now be viewed as relics of the Victorian age, when they first came on the market they were considered products of new technology. Cartes de visite and photograph albums bear many of the hallmarks of modernity—mass production, standardization, circulation, and technological innovation—and represent a distinctly modern way of picturing families and communities. The transition from a textual to a pictorial record—from telling to showing—created new ways of understanding the family. As chronicles of names and dates in household Bibles gave way to photographs assembled together in an album, physical changes over time became apparent and hereditary links among family members became visible. The photograph album represents the unprecedented access of the middle class to this kind of genealogical record. Moreover, the "family" album was not limited strictly to family; it also encompassed images of local personages and commercially produced photographs of national notables. These "galleries of friendship and fame," as an 1861 source called them, mapped out a more national idea of family.[13]

As collections of photographs, albums performed many more functions and possessed wider meanings than any single picture could alone. This study reveals connections among collecting, identity, and everyday objects, on both a personal and a national scale. By examining the visual standardization that is part of even these most intimate of pictures, the history of nineteenth-century photograph albums also contributes to a deeper understanding of modernity and mass production. This book ultimately addresses the ways family and nation were defined, the history of technology and innovation, the interconnectedness of the public and private spheres, and how visual images and collections came to help people understand who they were. Photograph albums shaped how American families imagined their memories and histories, and the ways they continue to do so today.

Chapter 1, "The Currency of the Carte de Visite," forms the basis for a commercial understanding of albums by analyzing their contents in detail. In this chapter I examine the carte craze that swept America in the 1860s, take

a close look at how the conventions of the carte affected self-presentation in albums, and ask how these pictures obtained social currency in their circulation. Cheap, portable, and reproducible in previously unheard-of quantities, these small pictures became the most popular form of portraiture in the period. All but the poorest could afford likenesses of themselves and their children—often in repeated sittings over the course of a childhood or lifetime—and could trade them for pictures of extended family. Distributing one's own photograph and accumulating other people's for display in the parlor marked the sitter's or collector's place within a social network. Exchanged in astonishing numbers, cartes de visite were the means by which sitters could present themselves to family members as well as to outside visitors to the parlor.

This presentation was governed by the commercial apparatus of mass-produced studio photography, and the process of being photographed for a carte de visite resulted in pictures that looked nearly identical. Posing manuals taught photographers how best to arrange their subjects, and educated potential patrons on how to comport themselves in front of the camera. Mass-produced props and backgrounds were reused in portrait after portrait, with little regard for the sitter's character or social standing. The formulaic nature of such images served to undermine the very notion of unique identity or individuality that these small pictures seemed to celebrate. The images and identities of the sitter would be differentiated only in the eyes of family and friends who would view the picture in an album. What the carte de visite did manage to convey was more than just certain physical details of features, bearing, and clothing: it revealed that the sitter could afford to have a picture taken and chose to circulate it.

Individual cartes de visite, sold by the dozen and traded among intimates, are contrasted with celebrity cartes de visite, which circulated in the thousands and were available for purchase on the mass market. If the personal carte resisted commodity status, the celebrity carte embraced it. Such portraits could now be found not only in public galleries but also in albums on the parlor's center table. These household collections of local and national notables conferred status on the collector (the selection signaling gentility or cosmopolitanism) just as the judicious circulation of one's own portrait did. The two kinds of pictures might mingle intimately in the pages of a family album, inviting an easy familiarity with the famous personages of the day and conflating two different kinds of looking—one connected to recalling family stories, the other associated with emulating heroes and producing national histories.

In Chapter 2, "Albums on the Market," I argue that the photographic industry shaped the ways that family records were kept, and that, in turn, the intimate practices of assembling and displaying albums affected the business of photography. Far from being strictly a private and personal family document, the photograph album was a product of industrial capitalism, guided by the commerce of photography. Like many similar mass-produced goods of the nineteenth century, albums muddied the distinctions between the public, commercial arena and the private, domestic one as they made their way from the market to the parlor. They belonged to a class of products that fell somewhere between standardization and personalization, commodity and keepsake. Even filled with photographs of loved ones, albums were extraordinarily consistent, repetitive, and conventionalized. The standardization evident in the photograph album's design, card size, poses, backgrounds, and props reflected the influence of the machine and the market, and challenged the notion that each family was unique. The conventions that took hold in purchasing, arranging, and displaying albums—the standards, that is, of picturing the family—can fully be understood only by addressing this peculiar intersection of personal and commercial concerns.

Albums were critically important to the growth of the photographic industry in the 1860s. Publishers and album manufacturers engaged in patent battles, produced increasingly elaborate designs, and priced their albums competitively. They advertised extensively and hired agents to hawk albums door to door. These efforts to make the album a domestic necessity would both reflect and shape the ways families ultimately employed albums. The photographic press marketed the album in general by appealing to some very basic—and emotional—themes: sentiment and loss, the importance of family, fashion and assimilation, and even nationhood and patriotism. At stake was not only the expansion of the photographic industry but also the definition and visual representation of family and home at a moment in the nation's history when those institutions were changing dramatically.

Even after albums entered the supposed haven of the parlor, they were not immune from the interventions of commerce. Album manufacturers and various critics cared a great deal about what happened after people purchased albums, filled them, and displayed them in the home. A surprising amount of advice about how to keep albums—from photographers and the photographic press, as well as from social critics—circulated in articles and in the albums themselves. One such album, a genealogical album with elaborate instructions on how to record the physical and personal characteristics of one's family members, is examined here at length. The instructions in this

album and other advice on album-keeping reveal that the domestic practices of recording one's family had significant perceived ripple effects on the photographic industry, as well as implications for the preservation of genealogies on a national scale.

In Chapter 3, "Albums in the Parlor," I examine how people actually used albums and individualized an otherwise uniform, mass-produced object. I argue that through personal arrangements and display, narratives told and implied across pictures, and other means of inserting individuality into an album, families attempted to differentiate their stories. I explore the photograph album's origins in Bibles and genealogies, the transition from textual records to visual ones, the conventions of collection and domestic display, the narratives that albums occasioned, and the function of albums in creating both personal memories and national histories.

Photograph albums were cherished keepsakes and intimate collections of family, but they also functioned as advertisements of their owners' character, social networks, and status. On view in the parlor, the most public space of the house, the photograph album enabled a new kind of self-presentation to others and a new excuse for that display. Thus their contents could have great significance for both owners and viewers of family or celebrity photographs. The wide variety of arrangements that took hold within an album— from strict chronological organization to haphazard arrangement, from a collection composed entirely of Union generals to one in which cousins and colonels intermingled—indicates that its organization was an intensely personal activity. Additionally, there were various ways in which an album owner could individualize the collection. Through craft skills learned in the home, women sometimes went beyond editing and juxtaposition to drawing around, cutting and pasting, or otherwise manipulating the images. This domestic production stood in contrast to industrial mass production; it might be best understood as a production of meaning, a kind of creation that encompassed the arranging, displaying, and interpreting of machine-made albums and their contents.

Photograph albums became the occasion and the means to tell family stories, and it was also through the act of identifying and describing the people in a family album to others that these rather standardized collections could take on personal meaning. The practices of viewing and narrating photograph albums altered the way our family histories were told in two fundamental ways: by making a familial past visible in the first place, and by linking our private narratives with public ones. In their early years, albums looked forward, with empty pages to be filled by living members of the current gen-

eration or saved for future additions. As a pictorial present ceded to a pictorial past, however, the album's memorializing function shifted, and Chapter 3 explores how photographs both replaced and required memory. The album's narratives also became enmeshed with national biographies and histories. In one popular song of the time called "Uncle Sam's Big Album," analyzed here, the famous and the familiar mingle in an album understood as a national family. Made viewable in photographs and assembled together for the first time, all of these people were part of the same history; both personal memories and national histories were beginning to take shape visually together.

Finally, Chapter 4, "The Demise of the Card Album, the Rise of the Snapshot Album," serves as an epilogue to the story of the first photograph albums. It traces the transition from studio-based portraits to Kodak snapshots, from the parlor to the living room, from a Victorian sensibility to a modern one. By the late 1880s the carte de visite and cabinet card were fading from fashion. Their stiff poses, dated clothing, and albumenized surfaces looked worn—in short, they had become objects of the past rather than the latest craze. New methods for displaying photographs in the home abounded, and advice guides began to suggest more casual arrangements of family pictures. Moreover, the parlor itself was changing toward a more informal space for family gathering and the entertainment of guests. The family album was often a completed, rather than an ongoing, collection. Now that there was a pictorial past to view there was more distance between the viewers of an album and those pictured within, and that divide often occasioned storytelling. A generation after the first family albums had entered the parlor there emerged a distinct difference between recording the people and events of the day and memorializing ancestors.

The most significant change in family albums, however, was technological: snapshots, and the new albums that arose to contain them, affected the practice of photography in profound ways. When the Kodak camera appeared in 1888—with its "You Push the Button, We Do the Rest" philosophy—people could take their own pictures of loved ones instead of visiting the photographer's studio. These casual snapshots were more intimate and spontaneous than card portraits; taken more frequently than studio portraits, they also showed the subject in a variety of situations or events, becoming much more rooted in time and place. Streamlined, black-paged snapshot albums replaced Victorian-era designs reminiscent of Bibles. Their contents varied much more than those of the carte de visite album, and owners had the freedom to collage, juxtapose, annotate, and manipulate—in other words, to create a narrative, and often a separate identity. Specialized albums for weddings,

vacations, or individual family members became more common. Whereas a single album had once contained an entire family's past as a cohesive whole, now a series of different but related pasts began to seem a more appropriate record of the times. Nevertheless, the snapshot album retained—and retains even today—some of the basic properties of commemoration, entertainment, self-presentation, and self-expression that characterized the album at its inception.

The word *album* derives from *albus*, the Latin word for white.[14] With its connotations of purity and potential—a blank slate—an album was its owner's to fill with appropriate contents. Even before the emergence of photography, albums were understood as more than collections of poems or drawings: they were metaphors for life itself. Each time something was added to the album it grew richer, and each time it was opened and shared with others they were enriched as well. Verses commonly inscribed in such volumes throughout the nineteenth century compared the album to the great book of life, in which the pages mark time and God is the ultimate viewer. One such poem, inscribed in a commonplace book in 1832, employed the white page as a symbol of virtue:

> May thy Album prove the emblem of thy life,
> And no dark shade on its page appear,
> Each page a day, each day devoid of strife,
> And spotless virtue thy polar star,
> So where you've filled the measure of thy book,
> And shall be called to pass the stern review,
> That the great Critic may approving look,
> And haply see, thy errors, are but few.[15]

In an album could be seen the toils and triumphs of a life, each page signifying another day passing. With written contributions from members of an intimate circle, an album began to form a portrait of its owner over the course of years.

 With the addition of photographs into this structure, the metaphor of the album as a book of life was transformed. Contained in these pages were records of loved ones at all stages of existence, the "shadows" of the past (in the parlance of the day). In a carte de visite album belonging to a Samuel T. Cushing, photographs of the owner were arranged chronologically from six-and-a-half to forty-nine years of age; a newspaper clipping was pasted in the

front that described the "seven distinct stages of being photographed," from tiny baby to withered old man. "Silently the old finger-marked album, lying so unostentatiously on the gouty centre table, points out the mile-stones from infancy to age," it read, "and back of the mistakes of a struggling photographer is portrayed the laughter and the tears, the joy and the grief, the dimples and the gray hairs of one man's lifetime."[16] In a single volume, the photograph album could hold a lifetime; to open the pages and view the faces therein was to review one's own existence.

This metaphor can be extended yet another step to encompass communities and nations. Far from being a strictly personal collection of immediate family, the carte de visite album typically featured other relatives, friends, local personages, and national celebrities. Albums mingled the famous and the obscure, the beloved and the inspirational. In "Uncle Sam's Big Album," the widely diverse people who formed the United States were related by virtue of being countrymen—being included in the same album. The photograph album became a symbol of a much larger family, the American nation; it was a place where local, cultural, and national identity were on display. The album reflected not merely individuals but also members of a collective and community.

This book redefines the Victorian family album as encompassing much more than just family. The parlor album functioned as a link to the past and to the future, a display of status and social connections, a family genealogy, and a national history. Its history was written in the factory, the photographer's studio, and the domestic parlor; it was produced by album manufacturers, photographers, and entrepreneurs, as well as by young women participating in a fashionable craze and heads of families recording family images for posterity. This complexity is fitting. By understanding the myriad roles and purposes of the nineteenth-century American photograph album we begin to understand how the advent of photography has affected who we think we are, and how we show ourselves to others.

As I write this, nearly one hundred and fifty years since albums were introduced in America, it is impossible to ignore the parallels between these earliest modes of mass visual self-presentation and today's ubiquitous social-networking sites.[17] In virtual communities we can collect friends, link to the famous, and post "albums" of images that reveal our edited personal lives, forging connections across a variety of social groups. The origins of this phenomenon—the mediated representation of people in a technological culture—can be found in the history of nineteenth-century photographs and albums, the very first face books.

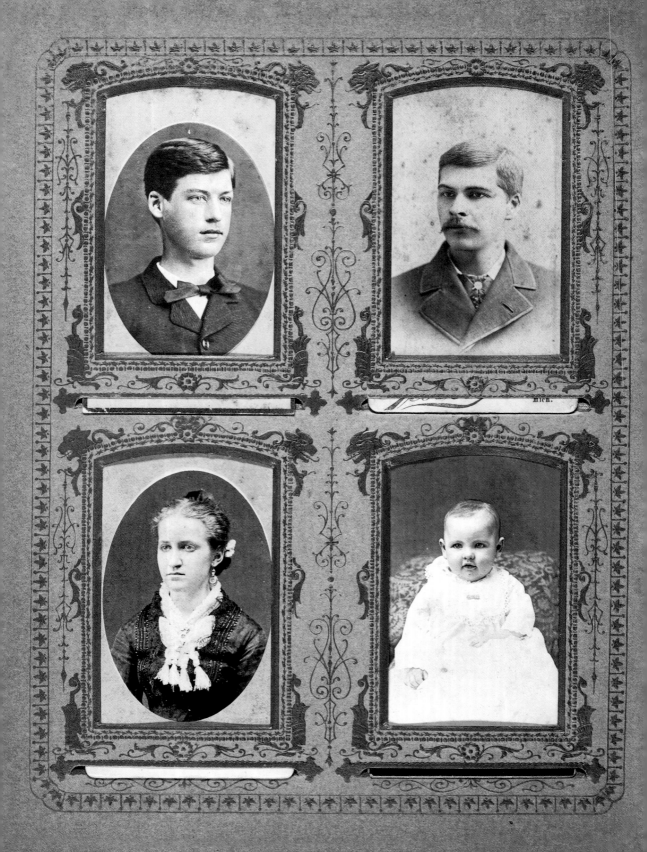

THE CURRENCY OF
THE CARTE DE VISITE

In the last of three articles on photography for the *Atlantic Monthly*, the distinguished Boston physician and essayist Oliver Wendell Holmes, also a photography aficionado, took his readers on a tour of photographic technology as of 1863. With characteristic wit he described the tremendous craze for small photographic portraits—cartes de visite—that had swept the nation, noting the huge "popularity of *card portraits*, which, as everybody knows, have become the social currency, the sentimental 'green-backs' of civilization, within a very recent period."[1] Holmes's comparison of fashionable cartes de visite with newly minted dollar bills was not entirely facetious, nor was it a lengthy metaphorical stretch. By 1863, at the height of "cartomania," card portraits, like money, held symbolic value, with an implied faith in what they represented and in their worth on the social marketplace of carte exchange. Like currency, card photographs became a standard of value for nineteenth-century Americans, part of a social network in which connections among family, friends, and national figures were built.

Holmes offered several reasons for the carte's popularity, especially as compared with its sister photographic entertainment, the stereographic picture: "It is the cheapest, the most portable, requires no machine to look at it with, can be seen by several persons at the same time—in short, has all the popular elements."[2] Stereographic cards, while cheap and plentiful, were properly viewed through the mediation of the stereoscope, and only one set of eyes could peer though it at a time. By contrast, cartes de visite prompted group viewing in parlors, most notably in albums; they became communal entertainment, edification, and pictorial history. In comparison to the earlier portrait medium of the daguerreotype (itself a relatively affordable and democratic art), a carte de visite could be purchased by all but the most

impecunious, allowing unprecedented access to a visual family record. Small and lightweight, card portraits were easily circulated through the mails to distant loved ones, and their reproduction in large numbers led to their rapid exchange among friends and relatives. Mass-produced cartes de visite of celebrities were bought and sold by the thousands at photographers' galleries and in the pages of popular magazines, familiarizing the famous of the day. All of these "popular elements"—for the first time ever, there was a portrait medium that was portable, readily reproducible, and accessible to nearly all classes—contributed to the carte's astonishing near-universality in America's Civil War years, making it the primary means for self-presentation both to intimate family and to a larger community (fig. 1).

It was the carte de visite that gave rise to the first photograph albums; before we can understand photograph albums, we have to understand the pictures that filled them. In this chapter I examine the aristocratic origins yet democratic appeal of the card portrait; the transition from "cartomania" as a fashionable craze to the lasting value of the picture for families; the standards of pose, expression, accessories, and backgrounds that resulted in a typical carte de visite; the public nature of these seemingly private images; and the moral blueprints provided by celebrity cartes de visite. The immense popularity of cartes de visite, of both family and the famous, indicates that these small pictures held great fascination for their owners. Yet the kind of information available from the carte de visite was circumscribed by the standardizing conventions of studio portrait photography, which rendered all sitters equivalent through their formulas. The "social currency" of cartes might be measured not by their intrinsic or aesthetic worth as pictures but by their value on the public and private markets of exchange.

Family Portraiture and the Emergence of the Carte de Visite

The carte de visite differed dramatically from other portrait formats in its low cost, tremendous reproducibility, and wide circulation. Many of the carte's pictorial conventions, however, were already in place by the time it became the portraiture standard in the 1860s, and a brief summary of earlier kinds of family pictures reveals the extent to which the carte de visite relied on or departed from prior models. Before the advent of photography, a portrait meant an oil painting, a miniature, or a silhouette. Of these, the painted oil was the least accessible to anyone outside of a certain privileged class. Even with the rise of more affordable itinerant portraitists, oil paintings connoted prestige, taste, and the wealth necessary to commission the work, and those

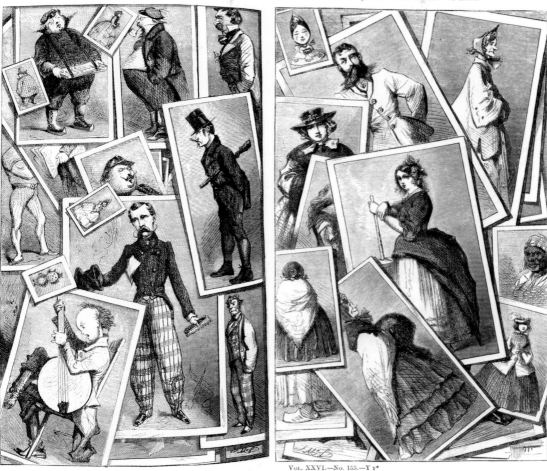

VOL. XXVI.—No. 155.—Y Y*

Fig. 1. "A Few Cartes de Visite,"
Harper's New Monthly Magazine 26, no. 155 (April 1863): 718–19.

in possession of ancestral portraits were generally those few possessed of ancestry itself. In the United States, painted family portraits did not initially depict a family together. Separate paired pictures for husband and wife, or perhaps mother with children, can be found in the earlier eighteenth century, with parents and their children shown together decades later. It is not until the end of that century that a visual celebration of the family as a unit seems to have taken hold.[3]

Somewhat more affordable were miniatures, small painted portraits that could fit in the palm of the hand, which were in great demand around the beginning of the nineteenth century.[4] Portable, private, and intimate, the

miniature portrait often acted as a substitute for a loved one. These wares were frequently commissioned on the occasion of a betrothal or marriage, and were given in exchange; they also served as mourning memorials following a death. Housed in jewelry and often painted on ivory, miniatures generally recorded the upper and upwardly mobile classes; as a result, the form itself acquired a patina of wealth. A much cheaper and quite popular option was the cut profile, or silhouette. Made either by snipping a profile from a piece of paper or pasting a cut profile on a sheet of contrasting paper, the silhouette depended on the skill of the artisan. The invention of the physiognotrace—a mechanical means of tracing and transferring a shadow onto paper—further cut costs and time, and imbued the process with the veracity and impartiality of the machine. The resulting portraits, valued for their fidelity to the sitter's features, were larger in scale and suitable for display on the wall, but also appropriate for inclusion in an album. For a true likeness, however, the American public would have to wait for the daguerreotype.

Introduced in France in 1839, the daguerreotype was the first pictorial medium accessible to most classes, and it remained popular in the United States long after it had been replaced in Europe by positive/negative paper processes.[5] A sharp image on a highly polished plate, the daguerreotype was prized for its faithful detail as well as its democratic appeal, and it became the medium of choice for portraiture. In the 1840s and 1850s, Americans were possessed by a veritable daguerreotype mania, with millions of photographs being made and purchased every year. The profession employed thousands, and the commercial success of the daguerreotype rippled into numerous supporting industries. Its drawbacks, however, were made apparent when the daguerreotype was contrasted with the later carte de visite: daguerreotype images were unique, not reproducible unless a copy daguerreotype was made; covered with glass to protect their fragile surfaces and housed in elaborate cases, and therefore less easily mailed; and relatively expensive—about $1 to $5 each in the earlier years, about 50 cents to $2 each by the 1850s—when compared with the much cheaper carte.

The conventions of photographic portraiture born from the daguerreian era lingered into the card portrait years. The daguerreotype established new ideals of likeness and expression in portraiture, and character was never so apparently visible as in the new medium. Photographers began instructing sitters on how to pose, and sitters, many of them fresh to portraiture entirely, internalized the codes and conventions of photography. Newly conversant in

technical considerations, such as what to wear to best take advantage of the color sensitivity of the new process or how to sit so that the lens flattered rather than distorted, daguerreotype customers also became increasingly aware of the social aspects of photographic portraiture. Articles in the photographic press advised photographers, who then instructed their public, as seen in this guidance from the *Daguerreian Journal* of 1851: "The picture should express feeling, thought, and intelligence. An embarrassed, affected, or constrained expression will always insure dissatisfaction, and should be assiduously avoided; since it is the 'every day,' 'home' expression, which renders the picture an object of admiration in the familiar circle where it is to be, if at all, appreciated."[6] Daguerreotypes, like the card pictures that followed, would be appreciated overwhelmingly in the home, as family portraits. There were even attempts by the industry to group family pictures together for display; in 1858, for example, the Scovill photographic company announced its "family case," which held six pictures accordion-style, presaging family albums. Unlike portraits in albums, however, daguerreotypes were generally best inspected by one person at a time, held close to the body and turned in the hand so that the mirrored surface best reflected the sitter, not the viewer. This shift in viewing experience would be one of the more dramatic changes, along with accessibility and reproducibility, from the daguerreotype to the carte de visite.

Photographers and merchandisers of the card era learned from their daguerreian forebears how to market the new medium by playing on the heartstrings. The lines "Secure the shadow, ere the substance fade/Let Nature imitate what nature made!" were adopted by daguerreotype operators across the country to entice customers to have their likeness taken.[7] Variations of this sentimental yet successful argument would later be employed to sell cartes de visite and albums to families. Celebrity images—largely lithographs based on daguerreotypes, although copy daguerreotypes circulated as well—were also made widely available for the first time. While they were not collected at the magnitude and pace of celebrity cartes, daguerreotypes of national notables set lasting precedents for photography's role in nation-building and emulation. In the grand galleries, common sitters could find themselves elevated by the presence of presidents and generals who had submitted to the same photographic process, and might even join them on the elegant walls. Above all, the daguerreotype was a new way for people to see themselves and begin to construct a visual past that was both personal and communal. These functions would continue—and broaden—with the arrival and mass acceptance of the carte de visite.

Although the carte de visite came to embody democratic accessibility, its origins lay in the visiting rituals of the European gentry.[8] The carte de visite was invented in France, and, like other French fashions, was eagerly adopted by the nineteenth-century American bourgeoisie. Patented by André Adolphe-Eugène Disdéri in 1854, the carte de visite (literally, visiting card) was a photographic portrait on paper just smaller than its $4 \times 2^1/_2$ inch vertical cardboard mount. (The size of the mounting card would prove more important than that of the picture pasted on it once mounts were mass-produced and albums with standardized slots entered the market; regardless of the type of camera used, photographs would be trimmed to fit the card size.) Disdéri configured a special camera with four lenses and a plate holder that could be moved from one side to the other, allowing one exposure on each half of the plate. This could result in eight nearly identical negatives or, if the photographer uncapped the lenses separately, in several different poses from which the patron could choose. With so many negatives (a single print of the entire plate would yield eight different pictures that could be cut up and mounted), the reproducibility of the carte de visite was greater than that of any other portrait medium.

The standard carte de visite was a full-length portrait. This was in part due to technical considerations: in order to gain sufficient sharpness with the available optics, the photographer had to stand about fifteen feet from his subject. The lens would be opened to its widest aperture to let in more light and allow as brief an exposure as possible; at this setting it also provided the least depth of field, and focusing from a distance rather than close up kept the planes relatively sharp. But, as Elizabeth Anne McCauley points out, the greater ease of focusing and a shortened exposure time were not enough to make this format the dominant one—if the pose had been unsatisfactory, it would have been corrected by cropping or even enlarging.[9] Rather, the full-length pose fell neatly into a tradition of painted portraiture in which members of the aristocracy and church were depicted from head to toe. Those who saw their own portraits in photographs rather than in oils emulated their betters by adopting this regal stance. Moreover, the pose played into positivistic beliefs by submitting the entire figure for the scrutiny and approval of the viewer. The carte de visite imitated the presentation of the self in society by revealing the whole of the body, not just a fragment. Jabez Hughes, the noted British photographer and commentator on photography, penned an early article on the new format in the United States, in which he stressed the integral importance of the standing pose—

especially the inclusion of the feet—to producing a "complete portrait." "The distinguishing characteristic of these portraits is their including a full length," he reasoned. "The position may be sitting or standing, but the feet must be introduced. This constitutes the charm of the picture, for the photograph is no longer a fragmentary representation of a half or three-quarter length, or the mere head, but comprises a complete portrait of the whole person. Thus a skillful artist may in these pictures produce more truthful likenesses by rendering accurately not only the features but also the proportion and form of the figure, together with many of those peculiarities of dress and deportment that constitute the idiosyncrasy of the individual."[10] Truth value, then, was perceived to be in direct proportion to the amount of the figure on display; the face alone was deemed insufficient to provide a sense of the sitter's personality, character, and status. With its emphasis on the whole body, the carte de visite offered a hint of aristocracy along with its claims of accuracy.

In the mid-1850s in Europe the carte de visite began as a plaything for the wealthy, more directly linked to its namesake, the visiting card. The visiting card, a small card engraved tastefully with the name of its owner, presupposed leisure time for visiting, titles for inclusion on the card, and servants or parlor-maids at the door for its presentation—and possible refusal. Such cards were marks of social standing and crucial to rituals of exclusion and inclusion among the urban elite, and when their photographic equivalent was first invented, it was the Parisian moneyed class that enjoyed it. With the substitution of a small photographic portrait, the carte de visite acquired greater symbolic worth and expressive power, as visitors now demonstrated their gentility through their facial expression, pose, and studio surroundings. The custom of making calls and exchanging visiting cards set the stage for the practice of leaving behind and trading cartes de visite. These took their places in overflowing card baskets (later, of course, in the album), on display for future visitors to admire and as evidence of the owner's social connections. As McCauley has observed, the carte's eventual mass popularity should not obscure its more aristocratic origins; the fad filtered down from above and found its market in the bourgeoisie, becoming a full-blown craze between 1859 and 1861.

By contrast, in the United States the carte de visite never really gained acceptance as a visiting card. In his 1862 treatise on the carte de visite, Charles Waldack noted, "As the name indicates, these little photographs were intended as visiting cards, but as such they are very little or not at all used."[11] The etiquette manuals of the day are surprisingly silent on

the topic of photographs, addressing them only in the context of calls and calling cards. As in Europe, the American calling-card ritual was governed by an elaborate etiquette, including the timing of visits, the number of cards given to the hosts by the visitors, the wording of the names on the card, the folding of certain corners, and so on. Advice guides disdained the use of a photographic portrait as a visiting card, however, as it seemed vulgar, even presumptuous, to scatter portraits of oneself throughout one's daily calls. One etiquette manual explained the potential pitfalls of leaving one's picture as cavalierly one would an engraved card, cautioning that it could end up in the wrong hands—those of the working class: "A card with a photograph portrait upon it, though to a certain extent fashionable, is a vulgarism that can never obtain general favor. If you are a gentleman, your visage may be reserved by the chambermaid, to exhibit as 'one of her beaux,' and no lady, surely, would ever display her face on a visiting card."[12] (She meant a card used to announce a caller, not a photographic carte de visite.) Gentlemen and ladies did, of course, exhibit their faces on the carte de visite photograph, in droves. But the ability to control the destination and afterlife of one's portrait was much hampered by the broadly circulating card photograph, and the laws that governed society's visits and visiting cards could not strictly apply to it.

By the time the carte de visite arrived in America at the end of the 1850s, its use had already been established in Europe not as a visiting card but as a collectible and exchangeable portrait. The term *carte de visite* was clearly defined among both professional photographers and their eager patrons: "They are neither regarded nor used as visiting cards, nor does anyone think of applying to them a plain English designation to that effect; and yet everybody understands a *Carte de Visite* to be a small photographic portrait, generally a full length, mounted on a card; and everybody is equally anxious both to obtain his or her miniature, executed in this style, and to form a collection of these *Cartes de Visite*—the portraits of everybody else."[13] Taking a different trajectory than in France, the card picture arrived in the United States fully formed, with little confusion about the two different practices and the circles they implied. While its appeal as an item of European commerce no doubt was tied up in certain ideas of class and fashionable society, the carte de visite immediately attracted purchasers at all but the lowest levels.

From Fashion to Family: The Carte Craze in America

CARTE DE VISITES
I'm loved and admired
Adored and desired,
And by many I might be obtained,
If they seek the right place
They'll find beauty and grace,
But if not, it will all be in vain.

'Tis the countenance sweet,
On the Carte de Visite,
And it must be just as we take them;
'Tis the lustre of charms,
That the cold heart disarms,
But 'tis Heaven alone that can make them.

Ladies, pass not by us;
Gents, step in and try us;
Where we hope by our attention and skill,
Your graces to unfold,
Your patronage to hold,
And our duty to the public fulfill.
—ADVERTISEMENT FOR A PHOTOGRAPHER, 1864

The carte de visite was "loved and admired, adored and desired" by both the photographic industry and the American family.[14] Introduced in the United States in late summer 1859 by two competing New York photographers, C. D. Fredericks and George C. Rockwood, the carte de visite became the primary format for portraiture—as well as a major fashion—by the end of 1860.[15] American photographers and professionals in associated industries found the mania for the carte de visite a boon to business and stoked it accordingly. Reflecting on the previous year, an 1862 editorial in the *American Journal of Photography* presciently outlined the course of commercial photography in the future: "Eighteen hundred and sixty-one is, however, memorable for a revolution in the fashions of pictures. The Card Photograph has swept everything before it; and it is the style to endure. The manufacturers of cases, mats, and preservers—their occupation is gone. A long farewell to our favorites of the olden time, Daguerreotype, Ambrotype,

and the big Photograph! Let us buckle on our harness for the great works of the future!"[16] Instead of manufacturing cases, mats, and preservers for pictures on metal and glass, photographic supply houses now equipped photographers with card mounts, passepartouts (presentation mats), and albums, as well as new camera and darkroom kits and reams of albumen paper to accommodate the tremendous number of prints being made. Modern technology had produced a picture for the times and revolutionized the business of photography.

Popular response paralleled that of the industry. Accolades spilled out of the pages of the photographic and popular press as sitters streamed into studios and print shops. An 1861 article in the *American Journal of Photography*, capturing the brand of unrestrained praise typical of the moment, supplied several reasons for the carte craze—not least, perhaps, being a certain vanity on the part of anyone who had ever sat for his portrait: "They are such true portraits, and they are so readily obtainable, and so easily reproduced, that they may well aspire to become absolutely universal. Few, indeed, are the individuals whose personal lineaments are not regarded with especial sympathy by at least a small group of loving friends; and, on the other hand, no less limited is the number of those persons who do not cherish the associations that are best conveyed by means of the portraits of the loved, and esteemed, and honored. And then we all have a peculiar liking for our own portraits, and we always like them to be liked."[17] If the desire to see oneself propelled sales, the desire for images of others—friends and family as well as celebrities—sustained them. The distribution of one's own carte went hand in hand with the accumulation of other people's for display in the parlor, and each action marked the sitter's or collector's place within a social circle.

School chums exchanged pictures with each other even as they collected photographs of the famous. Young ladies amassed quantities of pictures of their beaux, and young men returned the favor, making the gift of a carte de visite a key component of the courtship ritual. Selected entries from the 1868–69 diary of a young Philadelphia clerk named William Kirkbride, for example, provide a snapshot of how photographs circulated among young men and women. March 20, 1868: "I received a letter from Herb Potts informing me that Miss Reeves was in town. So I went down to see her immediately after tea. She is well and as sweet as ever. She gave me her picture." May 7, 1868: "I received a letter from my Cincinatti [*sic*] friend and not only so but she sent me her picture which I *think very* good." October 9, 1868: "I spent the evening with Mame. I gave her back my watch picture and had quite a

little spat."[18] One can only imagine what young Kirkbride's personal album looked like. At times, card collectors aimed for quantity rather than intimacy, accumulating vast collections of others while circulating numerous copies of themselves. The British cultural observer Andrew Wynter, in an article in the *American Journal of Photography*, wryly noted that the carte de visite "enables every one to possess a picture gallery of those he cares about, as well as those he does not, for we are convinced some people collect them for the mere vanity of showing, or pretending, they have a large acquaintance."[19] That sentiment was echoed by this observation in *Humphrey's:* "It is a source of pride and emulation among some people to see how many cartes de visite they can accumulate from their friends and acquaintances. Young gentlemen who travel on their appearance, have their cartes printed off by the dozen, and distribute them under the impression that they are affording a gratification to their numerous friends and acquaintances."[20] More likely than not, this impression was not entirely mistaken; the presentation of one's carte de visite was, in spite of the amounts deluging the market, nevertheless something of an honor, and the gift was appreciated if not always treasured.

In early 1861, the *American Journal of Photography* reported that the demand for card photographs, "now the height of fashion," was so great that a prominent New York gallery was at least a week behind in orders, and patrons had to make their appointments a week in advance.[21] If sitting for and distributing one's carte was a preoccupation, obtaining them from others sometimes shifted into a full-fledged craze. (Using terms of insanity is not overstating the case; an 1861 article on the topic in *Harper's Weekly* was appropriately titled "Photomania.") Two cartoons in *Vanity Fair*, both titled "The Carte de Visite Fever," caricature the ridiculous extremes to which carte collectors, most often women, would go to obtain pictures in large quantities. The first one shows an errand boy approaching a seated gentleman in his room on behalf of Mrs. Pumpkins, the new lodger, who sends her compliments and a request for his "card de vizard" (fig. 2). Although she is plainly not on familiar terms with the gentleman, his picture will soon (if he obliges her) be included among those of her friends and family. The second cartoon portrays a rather unattractive Miss Jones, having just been introduced to Mr. Dreary at a gathering, asking him: "Oh! I want about thirty cartes de visite to complete my set. May I reckon upon you for an assorted dozen of your own, Sir—one in an attitude of prayer?" (fig. 3). The craze clearly teetered at times on the verge of inappropriateness, fostering a false sense of intimacy among people. Such extreme instances of

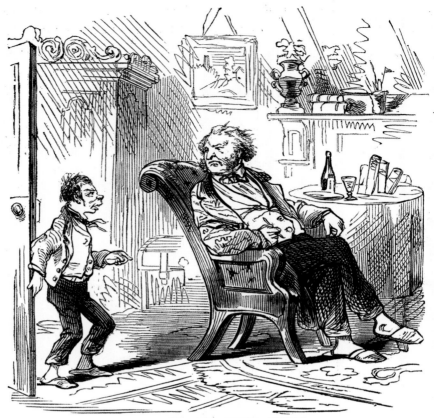

THE CARTE DE VISITE FEVER.

Boy.—"Mrs. Pumpkins, the new lodger, sends her compliments, Sir, and wants to know if you can't obleege her with yer Card de Vizard."

Fig. 2. "The Carte de Visite Fever," *Vanity Fair* 50 (March 8, 1862): 116.

acquisitiveness may have even replaced intimacy, doing away with pretense entirely. *Littel's Living Age*, in an article on current fashions, reported that the chains of connection from sitter to claimant were growing ever weaker: "The demand for photographs is not limited to relations or friends. It is scarcely limited to acquaintances. Any one who has ever seen you, or has seen anybody that has seen you, or knows anyone that says he has seen a person who thought he has seen you, considers himself entitled to ask you for your photograph. . . . The claimant does not care about you or your likeness in the least. But he or she has got a photograph book, and, as it must be filled, you are invited to act as padding to that volume."[22] The absurd demands lampooned here were simply an extreme form of the fashion, however; nearly everyone acquired and circulated photographs in some manner. This trade in likenesses marked an entirely new kind of social relations, in

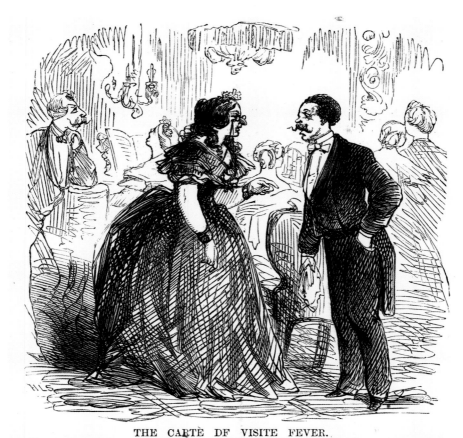

THE CARTE DF VISITE FEVER.

Miss Jones, (who has just been introduced to Mr. Dreary.)—" Oh ! I want about thirty cartes de visite to complete my set. May I reckon upon you for an assorted dozen of your own, Sir—one in an attitude of prayer ?"

Fig. 3. "The Carte de Visite Fever," *Vanity Fair* 50 (March 15, 1862): 134.

which people were collected and hoarded and studied like so many botanical specimens.

One reason for the instant popularity of the card picture, and the astonishing number of portraits in circulation, was its affordability. Prices ranged from about $2 or $3 per dozen, or 25 cents each, to as low as $1.50 for a set of twelve; individual pictures, and cartes made in less reputable settings, could be had for less.[23] Consumers remarked on this fact, at times perhaps even exaggerating, as an 1862 article gushed: "The ease with which photographs are taken, and the cheapness at which they are sold, has reached its highest development in the carte de visite. A man can now have his likeness taken for a dime, and for three cents more, he can send it across plains, mountains, and rivers, over thousands of miles to his distant friends."[24] A glance into some household account books might put these prices and

practices into perspective. John Dickinson Logan, the head of a well-off Philadelphia family, paid for photographs four times in the spring of 1863, at the highly regarded studio of Gutekunst, for a total of $21. A little further down the economic ladder, a Miss H. R. Weldin purchased a dozen photographs in February 1865 for $1.50, and the next month another dozen for $2.50. In April of that year she bought six vignettes for $1.25 and in June made copies of "Mother & Henry's 'types'" (daguerreotypes) for a dollar; after Lincoln's assassination she purchased the president's portrait for 15 cents, later buying two more for a total of 20 cents. William Kirkbride, the young clerk (living in Philadelphia with his parents), recorded spending $1 on four pictures in April 1867, and $1 more for his own portrait in September; in 1868, he bought another $2 worth of photographs, and his entries for the following year are peppered with photograph purchases of 75 cents to $1.75.[25] These repeated expenditures on photographs lend some credence to the rapt 1864 report from a western correspondent, in the pages of *Harper's Monthly*, that "everybody . . . has his picture taken; and since the photograph is cheap and universal, everybody will always continue to have it taken."[26]

The low cost of the card picture allowed unprecedented access to what had once been the sole purview of the wealthy, and that fact was not lost on commentators of the day. Wrote one observer, toward the end of the craze: "It has placed within the reach of the most humble the great pleasure formerly reserved for the privileged classes—the pleasure of possessing the likenesses of those we love."[27] Possessing and circulating such likenesses now signaled entry into—or at least aspirations toward—middle-class society. With the currency of a portrait in hand, new sitters could join society's marketplace. The entire system of portraiture, not just its patrons, had also changed; with the advent of the daguerreotype, and increasingly in the carte period, portrait production was no longer confined to those who had been laboriously trained in the art of painting. As one writer put it, "The making of fine portraits is not now peculiar to genius, nor their possession to the purses of the rich. The humblest chambermaid can to-day send to her lover as true a likeness as a duchess can have at her bidding."[28] True, there existed more skilled and polished (and more expensive) photographers along with the cheap operators in shabby rooms, and the range of quality (of technique, of setting) signaled a similar range of status. Nevertheless, both the reputable studio and the no-frills tyro provided their sitters with a characteristic likeness to take with them. Now pictures looked more like the sitter than like the painter, and a certain quality of appearance or family resemblance would

be due not to the painter's hand but to the physiognomy of the subjects. If the sun printed photographs, as many claimed it did, it did so seemingly without regard to class. Indeed, it was this very fidelity to nature that seemed to make the portrait photograph cut across class lines, as an 1862 article in *Scientific American* observed: "Heretofore, a few individuals in the community have been able to have their portraits painted by artists who, after devoting years to study and training, have been able to produce a picture bearing some resemblance to the person for whom it was designed; but the pictures of the photographer, though possessing a fidelity unapproachable by any painter that ever lived, are produced with a rapidity and ease that places them literally within reach of all classes of the community."[29] The combination of convenience, affordability, and accuracy put a kind of visual genealogy into the hands of almost all; for the first time, those without family heralds and crests could afford to obtain a visual past, and to pass on present portraits to future generations.

The carte de visite also allowed something previously unheard of: repeated sittings over time. Couples on their wedding day and on into middle age, sweethearts facing a long absence, and children of all stages—and above all, babies—could now sit for their portraits more than once. Lucy Lawrence of Maine, for example, recorded picture sessions for her newborn in January, February, *and* March of 1877, and then again in July of 1878.[30] Children, who grew and changed most rapidly, suffered through the most return visits to the photographer, as Jabez Hughes reported in the photographic press: "When the 'welcome little stranger' appears on the scene, one of its earliest troubles is with the photographer. At every successive growth, 'baby' has the fact chronicled by the lens. Boyhood and girlhood, in all their stages of advancement, are as faithfully depicted, and during adolescence many are the occasions when youth and maiden visit the studio, for reasons of their own, and make interesting exchanges of their *fac similes*."[31] Eligible young men and women, depending on means, might also visit the photographer repeatedly, to show off the latest fashion in their portrait or to bestow a new carte de visite upon a new beau. Selecting the most flattering or most characteristic likeness from among several sittings, they could update the image they distributed to their friends and suitors. Now editing had become an option: with more images to choose from, sitters and album-keepers could more carefully fashion their own self-presentation or the representation of others.

Even at the outset of the carte craze, photography journals were already encouraging their readership to visit a local studio on a regular basis to

record the incremental moments of growth on the path through life. The possibility of recording these transitions seemed wondrous:

> What would a man value more highly late in life than this accurate record of the gradual change in his features from childhood to old age? What a splendid illustration would such a series of photographs make in every household. First, the new-born babe in his mother's arms; then the infant creeping on the floor; next the child tottering by the mother's apron; then the various phases of boyhood, till the sprouting beard tells of the time when the plans and hopes of life began to take form and purpose; another portrait with softer locks and eyes is now coupled with the series, and the stern warfare with the world begins; the features henceforward grow harder and more severe; lines slowly come into the forehead, and grey hairs mingle with the locks; the lines grow deeper and the head whiter, till the babe is changed into the wrinkled old man, so different but still the same![32]

Never before had there been such an opportunity to trace one's own past and progress through pictures. Portraits of friends and family were cherished, but a record of oneself over the years would be an entirely new kind of self-knowledge, or at least a new sort of self-documentation. The physiognomic changes over time, made so apparent in repeated photographs, revealed transitions not only in features but also in character and maturity. Each wrinkle was seen to attest to an achievement or loss; in the sitter's eyes, over the years, could be traced determination or defeat. Through the physical links to the past, the photographic portrait became time-specific, recalling a stage in the sitter's life as well as his or her personality as a whole. In contrast to paintings or even daguerreotypes, for which a person might pose only once in a lifetime, the carte de visite did not summarize a life so much as characterize a moment of it; a complete portrait would, from this time on, be cumulative, composed of many smaller ones. Perusing these pictures would reveal a continuity of identity, as each maturing face—"so different but still the same!"—added up to a whole.

The card picture became a fad among circles of friends and acquaintances, but it also had a lasting significance for families. Photographers advertised their wares in terms of preserving records of the family, and customers seemed to take this to heart. The celebrated photographer Marcus Aurelius Root urged patrons to obtain pictures of parents and siblings as a devotional

act to God as well as one's relatives, as an 1862 advertisement for his New York studio advised: "To obtain a faithful Portrait by the Heliographic Art, while in health, of father, mother, sister, brother or valued friend, is almost everyone's religious duty."[33] The carte de visite seemed indeed to be a gift from above, so cherished were these representations of family. In the sentimental paeans that dot the magazine pages of the era, photograph collections seem almost literally to replace the departed. "Scarcely any lodging is now so poor but in it may be found the picture of some cherished one," John Cussans wrote in *Humphrey's Journal.* "With these faithful remembrances before us—shadows less fleeting than the realities—the absent ones seem to return once more to our embrace, and remain with us just as they appeared in life."[34] If memory failed to reproduce the dead or distant, photographs succeeded in bringing them back to life or hearth. Root, who later authored a treatise on photography and commentary on the state of the craft in America (and whose comments should be understood as stemming from a desire to advance the art), provided these reflections: "To what extent domestic and social affections and sentiments are conserved and perpetuated by these 'shadows' of the loved and valued originals, every one may judge."[35]

Photographers marketed the carte de visite, as they had the daguerreotype, as an antidote to loss. In America in the 1860s, the facts of distance and death were especially poignant. While westward migration continued to separate extended families, the Civil War ripped sons from mothers and husbands from wives. The photograph—and especially the photograph album—could be carried across the country, paradoxically allowing families to divide, migrate, and settle elsewhere while bringing them closer together. Root summarized the photograph's impact on the continued existence of the American family: "The exigencies of life, in most cases, necessitate the dispersion of relatives, born and reared under the same roof, towards various points of the compass, and often to remote distances, and by this means the primal household affection almost inevitably becomes impaired, and is frequently transformed into comparative indifference, if not absolute coldness. . . . And the photographs of parents, brothers, and sisters, now within the universal reach, constitute the most effectual means of keeping freshly alive the memories of dear absentees."[36] The loving ties of family that were seen to bind the nation together were coming undone; photography would hold families fast. During the war, millions of cartes de visite made their way across the nation in personal visits and through the mail; even afterward, the flow remained huge. An article on the national "dead-letter office" discussed the fate of unclaimed, misaddressed, or otherwise dead letters—only

a fraction of those letters actually sent—showing the massive circulation of cartes through the mails. It reported that in 1872 alone "there were returned to the senders 38,009 letters containing photographs, of which 32,978 were duly delivered, while 2,181 were again returned to the Dead-Letter Office, and there 'filed for reclamation.' Since photographs have become so cheap, the number which daily passes though the mails is enormous. Especially during the war, photographic cards were sent by millions, and the receipts at this office were correspondingly increased, necessitating the employment of an extra force to return such of them as could not be delivered."[37] Distance might translate into indifference, but the card portrait, easily mailed to several friends and relatives at once, erased distances, preserving the household affections.

It is probably no coincidence that the rise of the card picture in the United States paralleled so closely the years of the Civil War. The carte de visite had to do battle not only with distance, but also with the permanence of death, and a thriving industry arose for this very purpose. Young men were photographed in uniform before heading off to war, and camp-follower photographers also made a tidy profit on pictures to send home to soldiers' mothers and sweethearts. As boys marched off to possible death, obtaining their photographs as guards against their complete erasure from home and memory (if not from this world) was almost obligatory; the war, along with lower prices, catapulted the photograph's status from luxury to necessity. Root described a situation in which a mother of meager means might deplete her entire savings to buy a picture of her only son, who was going off to war: "The poor widow, as she pays her twenty-five cents (which, probably, are her whole savings, through many weeks, from her scanty pittance), for a likeness of her cherished one (perhaps her only son bound for the field of war), who is about leaving her, it may be to return no more, will feel a glow of gratitude to the art that has enabled her to have always within view a 'counterfeit presentment' of one so fondly loved."[38] Even given the photographer's promotion of his art it is not difficult to imagine this scenario playing out in households across the North and the South. In the Civil War, the portrait photograph served to take the place—ideally, temporarily, until the "original" returned—of the soldier sent to battle. Likewise, young men carried mementos of home and loved ones with them in the camps. By the end of the war there seemed to be as many copies of soldiers as originals circulating, as versions of this unhappy tale were repeated throughout the country. Like photographic ghosts, the card pictures of dead young men on display on mantels and in albums would give proof to the living of their former presence on earth.

The card picture might also inadvertently serve as an identification card of sorts, as one sentimental tribute to the carte de visite attests. In this poem, a young girl and her mother are paid a visit by a traveling soldier, who recounts a battle in which a handsome ensign bravely fell. As he describes the youth, the mother and daughter pale; they ask for his regiment, and when he tells them they become even more distraught. The sad truth, however, comes when the soldier says he never knew the youth, or even his name—but carries his carte de visite, which he offers as proof:

> But when we buried our dead that night
> I took from his breast this picture—see!
> It is as like him as like can be;
> Hold it this way, toward the light.[39]

At this, the daughter breaks down, realizing it is her betrothed: the photograph identifies the soldier as surely as his name would have.

The carte de visite, in its ubiquity and affordability, came almost to stand for the person himself. In an age of physiognomy, in which character was thought to make itself visible in the lines of the face and the grace of one's bearing, the card photograph could say volumes about the sitter. An editorial in *Godey's Lady's Book* suggested that photographs be sent as an introduction for a governess or maid; the prospective employer could thus "see" and inspect a young lady if distance prevented a personal interview. Indeed, such an exchange of pictures could work both ways: "In meeting the respective parties seem to be already acquainted, for ladies of kind and amiable dispositions will often send their own *carte de visite* in return, and thus the two are enabled to meet, not with the uncomfortable awkwardness of strangers, but with feelings familiarized by the mutual knowledge and study of each other's personal appearance."[40]

Romantic tales in the pages of popular and women's magazines are littered with hapless fellows who fall in love with pictures; they often then meet and become enamored of the "originals" of these charming copies. In one such love story from *Peterson's Magazine*, a young man named Charlie Smith, checking into a hotel in Saratoga, mistakenly receives a letter addressed to him in which is enclosed a carte de visite. It is a picture of a beautiful girl named Bessie, who clearly belongs to a different Charlie Smith. Naturally he falls in love with the photograph—"there was a magnetism in the pictured face turned so confidingly to mine," he confesses—drawing it out every evening to gaze upon it. Two years later, Charlie finds the flesh-and-blood

version, introduced to him as Lizzie, and eventually manages to win her over. When she says yes, he calls out the name from the picture, "Bessie," which makes her turn pale. She explains to him that that was what her half-brother, the other Charlie Smith, used to call her; he had died on the way to meet her at Saratoga. Mystery solved, Charlie confidently states, "So I won a *first* place in one heart, and wedded the fair original of the 'Carte de visite.'"[41] In stories such as this and in the editorial about prospective employees, viewing a photograph is but one step away from actually having met the person; men become infatuated with women, mothers hire girls to look after their dear children, all without any personal or physical contact.

The carte de visite seems to have supplied some personal meaning to millions of happy recipients, and it was the format of choice for portraiture and self-presentation for a decade and beyond. In his prescient 1863 essay, Oliver Wendell Holmes expressed confidence that a new "photographic intimacy" could be the foundation for new friendships. Two people who had never seen each other's faces could nevertheless become closely acquainted through photography. It is striking, however, that Holmes hoped that this would occur not by the common and standardized form of the carte de visite but rather through a more personal expression. "After an introduction by means of a few views of scenery or other impersonal objects," he wrote, "the artist sends his own presentment, not on the stiff shape of a purchased *carte de visite*, but as seen in his own study or parlor, surrounded by the domestic accidents which so add to the individuality of the student or the artist."[42] Only a few years into the carte craze, Holmes observed that the controlled studio portrait could not adequately capture the singularity of the sitter. He was not alone in noticing that the carte de visite embraced uniformity rather than uniqueness, featuring props instead of personality. The apparatus of photography imposed a conventional sameness on portraits, but the quest for individual expression attempted to counter that standardization.

The Conventions of the Carte

In 1871, Edward L. Wilson, the prolific author of photography manuals and editor and publisher of the monthly *Philadelphia Photographer,* issued an eight-page booklet on sitting for one's portrait, which he intended for photographers to hand out to their customers. The pocket-sized pamphlet became an instant best-seller, with 25,000 copies sold by July of that year, and 100,000 by October; by 1880, over 1 million copies had been printed in several languages. Wilson, who entitled the guide "To My Patrons," instructed the

public on when to come, how to come, how to dress, and how to behave, and informed them about the details of frames, copying, and coloring.[43] In his pamphlet, Wilson urged potential sitters to submit to the photographer and his specialized knowledge and taste as they would to a doctor; by informing the patron beforehand of the issues he or she would confront, it was hoped that both time and tempers would be saved—and that customer satisfaction would prevail.

Posing guides were only one factor among many that influenced the outcome of a photographic portrait. But the combination of standard poses, mass-produced backgrounds, and overused accessories had a pronounced leveling effect, resulting in pictures that looked repetitive and formulaic. In the carte de visite, individual character appeared to be on display; yet the very means by which photographers attempted to differentiate their sitters and elicit personal expression often ended up suppressing that individuality. What resulted instead was evidence of group membership, as each sitter's portrait resembled others across the nation.

People had been posing for photographs for two decades by the time the carte de visite came to dominate the portrait market. But the popularity and accessibility of the format initiated a new class of sitters, those who were less familiar with both the mysteries of photography and the decorum of the public parlor that was the photographer's gallery. Cartoons and humorous tales of misinformation and naive expectations abounded in the photographic and popular press. In one such caricature (fig. 4), a middle-aged woman accosts a baffled photographer with the criticism, "They talk of improvements in photography. I don't see it. This picture of me isn't half as pretty as one I had taken twenty-five years ago." She has had previous experience with photography but possesses overly optimistic hopes for its powers to stop the clock. The cartoon lampoons not her class so much as her combined vanity and naiveté. In contrast, however, another cartoon shows a German immigrant, with his horse and cart, approaching a photographer (fig. 5). "Ich must haben mein Cart and mein Horse," he explains, "or else peoples will not know zat it be mein Cart of Visit; ven zey sees ze Cart, they know it's me." The joke, of course, is on the misunderstanding of the terminology ("cart" de visite) but also on how the working-class grocer undermines the standard studio props to prove to his friends (his presence alone is not sufficient) that he indeed sat for a photograph. Shirley Wajda has argued that this kind of satire, combined with the increasingly elaborate and cultured spaces of photography after the war, served to demarcate, for the bourgeoisie, those worthy of being photographed from those who were not.[44] By contrast to such caricatures, guides

NO IMPROVEMENT.

MISS ARABELLA.—" They talk of improvements in photography. I don't see it. This picture of me isn't half as pretty as one I had taken twenty-five years ago."

Fig. 4. "No Improvement,"
Harper's New Monthly Magazine 25, no. 147 (August 1862): 428.

such as Wilson's attempted to bridge the gaps between photographer and patron, aiming to make the intercourse between the two pleasant, as this was thought to result in the most successful pictures.

In advising the public, Wilson and other intermediaries needed to do two things: make useful customers out of them, and provide them with acceptable pictures. How might such pictures look? Above all, they had to look "natural," a term that crops up again and again in photographic editorials and fictional stories alike. With the inevitable distortion of a short,

TAKING A CART DE VISITE.

TEUTONIC GROCER.—"Ich must haben mein Cart und mein Horse, or else peoples will not know zat it be mein Cart of Visit; ven zey sees ze Cart, they know it's me."

Fig. 5. "Taking a Cart de Visite,"
Harper's New Monthly Magazine 25, no. 149 (October 1862): 715.

or wide-angle, lens, natural often meant positioning the body so that the legs, hands, nose, or other prominent features in the foreground did not appear exaggerated (fig. 6); thus photographers learned to place sitters in a set of poses that felt decidedly unnatural in order to obtain success-ful results. A good photographer aimed to provide the patron with, in the terminology of the day, a *characteristic likeness* combined with the *personal expression* of the sitter, all portrayed with the experienced artistic *taste* of the photographer. The extent to which this was the goal, and not always

"I'M ALL READY! FIRE AWAY!"

Fig. 6. "I'm All Ready! Fire Away!" H. J. Rodgers,
*Twenty-Three Years Under a Sky-Light, or Life and
Experiences of a Photographer* (1872; reprint, New
York: Arno, 1973): 93.

the practice, is revealed by numerous urgent articles in the photographic
press on portrait aesthetics, positions of the sitter, and expression, as well
as entreaties to general good taste. The process had to be a collaboration
between photographer and patron; in order to get the sitter to comply with
the rules necessary to acceptable portrait-making—for example, remaining
still to avoid blur, or wearing colors that "took" well photographically—
photographers needed to educate their consumers. This was important, too,
to their business practice, as an intractable client could eat up several hours of
valuable work time with unreasonable expectations and improper behavior.

Preparatory pamphlets such as Wilson's functioned almost like etiquette
books to the photographically illiterate, allowing the public to participate
in the production of good, or correct, portraits. Unaccompanied by taste,
however, this correctness risked blurring the very personal character that
photographers professed to portray. One writer of an 1862 essay on photo-
graphic likeness complained that the "inartistic photographer, treating every
model on a conventional system, entirely ignores or deforms the individu-

ality of the sitter."[45] Such photographers ushered their patrons indiscriminately through the same props and backgrounds, as if through a factory. Even the "artistic" photographer, however, adhered to conventions of photographic portraiture established to accord with public taste and technical photographic norms. Such conventions could serve to elevate the art of portrait photography itself above the personality and expression of individual sitters, resulting in pictures that looked aesthetically accomplished but still very similar to one another.

The guides translated certain technical peculiarities of photography into terms people could understand and comply with. Manuals counseled visiting the photography studio on overcast days so that the light would be gently diffused yet still adequate. Mornings were best, and not only because of the light; rather, the early hour assured that both the sitter and the photographer would be well rested and in spirits not yet disturbed by the innumerable mishaps of the day: "Go early in the day when you are fresh after the night's repose, and the morning wash, before you have got fatigued by being busy, or by doing nothing during the day; before you have met with some annoyance which any person may meet with before afternoon, and which will, very likely, show on the countenance and change the expression. Go early, when the photographer is fresh after a night's sound repose, and before he has met with some nervous, restless sitter or spoiled child, to try his temper and his patience, for if the artist is in good humor, you will be more likely to have a pleasant expression than if the contrary is the case."[46] Informed about when (and how) to come, customers were also advised on what to wear; by this means photographers explained the limited chromatic range of the photographic plate, which was highly sensitive to the blue rays of the spectrum but not to the red. Posing guides counseled patrons that blue "takes" white, and red "takes" black, and advised them to wear a color that would result in a medium to dark tone, depending on the complexion and hair of the sitter. Striking contrasts of black and white were to be avoided, as they were considered distracting, so sitters were told not to wear, for example, vivid stripes or a lace shawl against a dark background. Writers recommended in great uniformity of opinion that sitters be attired in flowing and ample dress, as it would make the face and extremities appear delicate (gloves were also advised for this purpose).[47] The author of a chatty and humorous guide to sitting asked that one's clothing at the very least accord with one's personal style: "In dress, too often the style of the person is ignored. Everything fashionable is adopted regardless of its appropriateness. It is remarkable, even lamentable, how little individuality there is displayed in what we call 'the

taste' of people."[48] Above all, guides urged sitters (particularly, but not only, women) to dress naturally, shunning the conspicuous trimmings and orna- ment that marked the dresses featured in so many photographs but worn in so few parlors: "The photographer," wrote Wilson, "is very much tried by his patrons sometimes, who place upon their persons, when about to sit for a pic- ture, all sorts of gew-gaws and haberdasheries which they never wear when at home, or when mingling among their friends."[49] By their advice, posing manuals attempted to control some of the variables in advance of the sitting itself, and to anticipate the criticisms of the sitter and her friends and family, who would judge the picture in terms of its faithfulness to the original.

The guides also set standards for behavior in the photograph gallery, most of which fell under the category of leaving the photographer alone to perform his craft. The venerable photographer Alexander Hesler, known for his portraits of Abraham Lincoln, offered this tongue-in-cheek primer for the sitter:

> If a child is to be copied, be sure and bring all the family and relatives; and all insist on keeping it quiet by all talking to it and chirping to it at the same time. And if by chance it assumes a natural pose and expression, all jump in and give it a pull; this will help matters, and leave the artist nothing to do but catch the distressed, scared look so much desired. . . .
>
> If a lady, be sure and dress in some way different from usual, so that your most intimate friend will hardly recognize you, and then insist that the artist must take you as you naturally look every day.
>
> Insist on sitting twice at least in each dress you have, and in each imagine the way you can dress your hair. It won't cost you anything extra, and will make your picture cost your photogra- pher twice what he gets for it; but it makes him feel happy that he is kept employed and fully earns his money.[50]

Training for proper behavior in the photographic studio was to begin in the home, in the preparation of dress and in the ideas passed down about the process to impressionable young sitters. Subjects were urged to defer to the photographer and the exigencies of photography once in the galleries. In his section titled "How to 'Behave,'" Wilson reluctantly but firmly gave advice on pose and expression, asking his sitters to leave their friends outside and reminding them about the function of the headrest in preventing blur. (Guides

to use of the headrest could be humorously contradictory, as in this article on portraiture: "Particular care must be given to the head-rest; and while securing its complete rigidity so as to afford complete immobility to the model, at the same time secure a simple, natural, graceful, and harmonious pose.")[51] Concentration and composure were key qualities on the part of the sitter; physical poise in the posing chair was dependent on a certain calmness of mind. One guidebook, in a tale that was surely apocryphal, described a sitting in which the roof unexpectedly caved in, yet the customer remained unmoving and unconcerned. When asked why he didn't jump, the man simply replied, "That wasn't my business."[52] This very model of composure was held up as an example for patrons to emulate as the photographer attempted to transform an unruly group into profitable, satisfied customers.

Posing guides may be best understood in the context of the hundreds of advice manuals on manners, dress, health, and personal grooming of the era that Karen Halttunen has argued helped construct outward appearance in a socially mobile culture.[53] Even more than how to behave, however, guides to sitting for the photographer showed patrons how to *be*. The author of *How to Sit for Your Photograph* emphasized to sitters that "it is expedient that you should be in a *happy, obliging, believing* state of existence when on photographic pictures bent, for several reasons. . . . If you have not these cardinal, moral excellencies with you, the want will tell in the picture." Wilson counseled, "While sitting for your picture, forget all dolefulness, and also forget where you are. Whistle Yankee-doodle mentally, or think of some pleasant thing that will enliven your spirits, and impress a pleasant look upon your face."[54] To *be* good was to *look* good; conversely, an ill temper or hurried, frantic state would show through in the picture.

That inner character was eminently visible on the face was not a notion particular to photography. A passage on "The Educated Countenance" in an 1873 etiquette book gives a sense of this commonly held belief: "As a rule, we may distinguish intelligence, gentleness, and kindness from ignorance, coarseness, and brutality, by an inspection of the countenance. Habits of mind are stamped upon the face. This is true even of animals. The heart and mind educate the features to express what they suggest."[55] In an age of positivism, what you saw was generally believed to be what you got, and photographers played this both ways—both uncovering truth of character and improving upon nature through photographic technique. On the one hand, photography was seen to reveal the sitter's personality through expression, as the photographer H. J. Rodgers, in a book summarizing his experiences in the studio, proclaimed: "We need scarcely be told that the human face to the

body is what the dial is to a clock; the steam gauge to an engine, or the *contents* to a book. It most vividly and unmistakably reflects the soul; and is the true index of all the different forms which the passions externally assume through the face."[56] Oliver Wendell Holmes asserted that he could detect the social status of sitters behind their finery and airs; their telling physiognomy exposed their true characters and positions: "Attitudes, dresses, features, hands, feet, betray the social grade of the candidates for portraiture. The picture tells no lie about them. There is no use in their putting on airs; the make-believe gentleman and lady cannot look like the genuine article. Mediocrity shows itself for what it is worth, no matter what temporary name it may have acquired. Ill-temper cannot hide itself under the simper of assumed amiability. The querulousness of incompetent complaining natures confesses itself almost as much as in the tones of the voice. The anxiety which strives to smooth its forehead cannot get rid of the telltale furrow. The weakness which belongs to the infirm of purpose and vacuous of thought is hardly to be disguised, even though the moustache is allowed to hide the *centre of expression*."[57] Statements such as this eased anxieties about false or misleading identities in an age in which status was so malleable. Just as a discerning viewer would sense impostors in the flesh, photography would thus reveal the real nature hiding behind any veneer of expression or cloak of fashion.

On the other hand, however, it was the job of the photographer to improve upon nature, to show the sitter in the best possible light. Thoughts might show through the face, but if the photographer could influence those thoughts—as Wilson suggested to his patrons—he could show a more pleasing countenance. By careful cultivation of the inner state of mind during the sitting, the photographer could, in effect, help the sitter project a better person to the camera. (M. A. Root suggested supplying the studio's waiting room with interesting books, beautiful engravings, and even caged songbirds to help set the proper tone.)[58] Thus H. J. Rodgers could also write, without contradicting his comment above likening the face to a clock's dial, that "every person sitting for a picture should for the occasion, arouse their best mood, calling up their loveliest expression, full of *livingness* and meaning."[59] If it was impossible to dissemble in front of the camera, one could nevertheless transform one's attitude during the sitting so that the picture would show a flattering yet still faithful likeness; character could be manufactured, at least in part.

To this end, photographers could assemble their sitters in the right position or set the correct expression on their faces.[60] Many looked to actors and actresses, whose pictures might also grace the walls of the photographer's

Fig. 7. "Suggestions for Posing,"
Anthony's Photographic Bulletin 1, no. 5 (June 1870): 78.

studio, for their innovative poses and general ease in front of the camera. The customer's personality and occupation might dictate certain poses (a member of the clergy, for example, might be pictured sitting with a Bible and a thoughtful air, or a soldier in an upright, more aggressive stance), but how the sitter would be arranged was usually up to the taste and experience of the "artist." For six months in 1870, *Anthony's Photographic Bulletin* provided its photographic and lay readers with a regular illustrated guide called "Suggestions for Posing" (fig. 7). The series showed lithographs of several sitting possibilities on a page, often women depicted singly, but sometimes gentlemen or children, or a few pairs. Vignetted on the page, the examples do not reveal much in the way of accessories or backgrounds, but rather focus on

the arrangement of the hands, the turn of the back, and the tilt of the head in a number of graceful poses. Not one model addresses the camera (or viewer); instead, all gaze into the distance, immerse themselves in a book or letter, or are otherwise absorbed, to avoid a vacant stare or distressed look. Similarly, smiles were not encouraged for fear they would take on the appearance of a smirk during the still rather lengthy exposure. The photographic process itself could undermine the best intentions of the photographer and the patron. "Your very desire to look your best defeats your purpose," reported a sitter on her experiences in front of the camera. "You find that you have practiced attitudes and expression to no effect. 'Not quite so sober,' calls out the operator. As well he might enjoin composure upon a bashful school-girl. How can you look otherwise than solemn at a nail, or a door-knob, or a blank patch of ceiling, with your head in a vise, your muscles twitching, and your eyes blinking from an overdose of sunshine?"[61]

Proper posing was meant to elicit expression—"that something," as Root put it, "which reveals the soul of the sitter, the individuality which differences him from all beings else."[62] However, the same guidelines as to what was fitting and natural, intended to afford room for a portrayal of unique character, served to produce a set of standardized poses and countenances that undermined the sitter's individuality. "The majority of photographers have two or three different positions to which they submit all their models, whether tall, short, long, or small," complained an editorial on photographic aesthetics.[63] A page from a carte de visite album makes this all too clear (fig. 8). In it, two card pictures side by side each show a gentleman leaning against the same carved wooden balustrade, right arm leaning on the finial, left arm straight at his side with fingers tucked under, right foot crossed over the left in a *contrapposto* position. The pictures stand more as testimonies to the photographer's predilection for posing than as meaningful portraits.

Another way to express the personality of sitters, as in painted portraiture, was through objects and settings that would define them. As customers streamed into photographic rooms they began to demand an artistic portrayal that included the signs of taste and class they saw in paintings—and in other photographs. "These little pictures," wrote Jabez Hughes, speaking of the carte de visite and its full-length format, "permit the introduction of many graceful additions, which materially enhance pictorial effect. Drapery, balustrades, columns, pedestals, handsome chairs and tables, footstools, vases, couches, all find their appropriate places when arranged by the hand of taste."[64] In his studio, the photographer assembled a veritable prop-house of elegant accessories and backgrounds that would, for a short time at least,

Fig. 8. Carte de visite album, c. 1860s. Collection of author.

constitute the patron's "home." The mass production of these goods and the marketing of them through trade literature ensured that many photographers employed exactly the same posing chairs and columns, backgrounds and balustrades. Moreover, as evidenced by the repeated laments of "artistic" photographers in the pages of photographic magazines, many used their accessories indiscriminately, placing their sitters assembly-line style in ready-made settings regardless of the patron's manner or position. "There is always too much of the studio in these *carte de visite* portraits," protested one critic.[65] What was supposed to be indicative of individual character instead supplied all sitters with the same signs of gentility.

Accessories progressed from a simple table and chair in the daguerreian era to elaborately theatrical props toward the end of the carte craze. At first, they recalled the spaces of the home, with interior settings and furniture, but they eventually expanded to take on the features of an ideal, even fanciful, landscape. An 1880 report on the state of backgrounds provided this history: "Our accessories, beginning with a fluted column, advanced, after some years, to the rustic gate, then the artificial rock and rustic arbor. At length, emancipated from the house-carpenter, came the balustrade, in imitation of stone, weather-worn and ivy-covered; then the introduction of

set or profiled pieces, after the manner of theatrical scenery, this being an adaptation of an old idea. Soon the country was invaded by a flotilla of small boats; after which, cottages, bridges, classic columns, and trees, until now we have pianos and rustic stiles."[66] Even in the first years of the carte de visite, accessories began poking their way into the new format. Some photographers simply crammed their pictures with whatever they had on hand. The props and scenery could make for an incoherent setting, and the result was practically an advertisement for the photographer's studio offerings, as this 1861 article illustrates:

> It is somewhat amusing to study the paraphernalia with which some photographers are accustomed to ornament their Cartes de Visite. First there is the inevitable column and pedestal. That is well enough. It is very proper sometimes to represent a person thoughtfully contemplating the ruins of Balbeo or Ninevah, and the observing traveller is fitly exhibited leaning on the shaft of some stupendous ruin. But our ambitious photographer is not satisfied with that alone. There is room in the background to introduce a view on the Hudson, and hence it appears. But he is not yet content. A curtain with long cord and tassels can be put in by the side of the column aforesaid and come within the narrow limits of the piece of board on which the picture is to be mounted. Should there by possibility be any space left, our ingenious photo[grapher] is not without resources to fill it. A chair or table and some panel-work can be perhaps introduced spontaneously.[67]

The overuse of such props was seen, even at the time, to indicate both the photographer's lack of taste and the patron's lack of discernment. Many photographers and writers argued against useless accessories and overwhelming backgrounds, hoping that the models of artful restraint they provided would bring about a more judicious use of such additions to the picture.

Backgrounds paralleled accessories in their development from a solid painted backdrop to rolls with several changeable scenes.[68] Originally used to set off the dress or complexion of the sitter through a contrast of tone, the background eventually became the key element in the creation of a fictional reality—whether of an elegant parlor or an exotic, far-off setting. An 1880 summary listed the following: "There have been represented the snowy mountains of Norway, and the parched plains and majestic temples of Egypt; the frozen lake, with skaters, and the garden and orchard with their

flowers and blossoms; the forests of America and the jungles of India; the sea-shore and the mountain-top; the cathedral, the garret, and the kingly palace; the elegant French boudoir and the severe Eastlake drawing-room."[69] The painted background often required a suspension of disbelief; the incongruous profusion of columns and balustrades seemed out of place in the verdant hills, and in portraits made on the battlefield, grass sometimes poked through as the parlor's carpet, breaking the illusion of a more refined setting. The viewer was not supposed to actually believe that the sitter was in Egypt, or even in her own home, but rather would understand that these conventions of portraiture often indicated more about the taste and quality of the photographer than the unique character of the sitter.

The inconsistency of subject and background exhibited by certain photographers plagued those writing in the photographic press. The accessories at times threatened to overwhelm the sitter, and if that wasn't enough, in the eyes of some critics they simply looked absurd: "Never permit yourself to be the lay figure of a photographer's ideal landscapes. The cutting up of a portrait with balustrades, pillars, and gay parterres is fatal to the effects of the figure, which should be the only object to strike the eye. . . . If you have always lived in a modest home, do not be made to stand in marble halls or amid splendid imaginary domains. Young ladies reading in full evening costume, with water and swans behind them, or standing in trailing silks and laces in a mountain pass, are ridiculous enough."[70] The problem was particularly acute in the case of class differences between the sitter and his setting, and articles and cartoons served to remind readers of the proper place of more modest sitters. A cartoon in the *Philadelphia Photographer* shows a man wearing a crumpled hat and patched trousers tucked into country boots; his head tilts awkwardly and his arms hang limply by his sides (fig. 9). He stands posing for his picture next to a genteel writing-desk and a pedestal with an urn atop it, all in front of a pastoral mountain landscape framed by two Corinthian columns. The accompanying article, which suggested the sitter was not only uncouth but also possibly drunk—his "money is as good (hic!) as any man's," says the subject—complained that such a photograph was so inappropriate as to be virtually unrecognizable to the sitter's peers: "Look at him, scan him, and read his character. You realize his position in life at once. Study the relation between the subject and the background; you will realize that he is out of place amid so much finery. He does not live and move among such an array of aristocratic decorations. If you desire to place him in a position suitable to his style and condition in life, you had better fill up and make surroundings of rudeness, and a pig, horse, and bullock. It

Fig. 9. "Relation of Backgrounds to Subjects," *Phila-delphia Photographer* 8, no. 85 (February 1871): 55.

would then be recognized by his 'dear old friend,' who is to be charmed by receiving the shadow of that 'face divine.'"[71] For the urban bourgeoisie, the step up to marble halls, though often a stretch, was not quite as steep as it was for the rural or working-class sitters who also wanted their photographs taken and middle-class aspirations realized. Farm surroundings might allow a friend to identify this sitter, but recognition was not necessarily the point. The photograph showed evidence of the individual having sat for a picture in a professional studio; the background finery provided proof of the circumstances of posing rather than revealed attributes of character.

What critics lamented most of all, in regard to the use and overuse of accessories, was the dulling uniformity seen on studio walls and in page after page of the photograph album. "No visitor can remain long in a friend's house before the album is produced; and, in looking over the pages intended to interest and edify him, good taste is often shocked at the ridiculous sameness of one photograph to another," complained James Mackay in 1871.[72] Families often employed the same photographer for many sittings, either on the same day or for return visits, so an album could represent a large proportion of pictures from a single source. It was not only an issue of taste: photographs seen in albums and photographers' galleries were advertisements for photography as a whole, and poor specimens were seen as denigrating the art.

A series of portraits in the same pose or with the same accessories revealed the photographer's embarrassing lack of artistry. "We are often struck with the utter want of invention exhibited by some operators," a critic noted in an 1864 article. "The continual curtain and the everlasting column weary and fill one with wonder as we turn over the leaves of an album, and we are constantly led to ask, 'Is it absolutely necessary that every member of a family should lean on the same pedestal or stand staring over the same balustrade?'"[73] A double page-spread from a carte de visite album illustrates the kind of formulaic sameness such critics confronted (fig. 10). Four card portraits in a row reveal two boys and two girls with a distinct family resemblance (probably siblings—the two girls are even wearing the same dress), each in a standing pose, right arm down at the side and left arm on a support; all four stare rather blankly at the camera. Three of those pictured lean against the very same chair, clutching its ornately carved frame. The resulting repetition attests perhaps to the uniformity of family, but it also indicates that the photographer adhered to certain formulas in posing and accessories. An 1871 editorial in the *Photographic Times* suggested that the only family resemblance in such pictures was the kinship of belonging to the same photographer. Addressing operators of the less artistic variety, it asked, "Why do you use that same table, and vase of flowers, and foot-stool, and ugly spotty curtain in almost every picture you make? Do *you* like it, or is it your customers who have such a fraternal feeling among them that they want to have all the same 'symbols' or 'jewels' in their pictures as if belonging to some lodge or order?"[74] The assembly-line practices of some photographers befitted an age of incipient mass production and an industry in which pictures were being produced at an unprecedented rate for less and less money. Although the most hackneyed conventions were probably limited to the cheaper operators, the difference between so-called tyros and artistic photographers (and their publics) was one of degree rather than kind. The commercial apparatus of portrait photography imposed itself to some extent upon all sitters and all cartes de visite, with the result that millions of portraits looked remarkably alike.

Customers, although quite taken with the carte de visite generally, were not always happy with their own images in particular. Mary Chesnut, the prominent and socially skilled wife of a southern politician and later member of the Confederate army, recorded her reactions to her picture in a personal diary. On March 26, 1861, she noted that she was to have her photograph taken at Quimby's, a fashionable photographic gallery; three days later she received her picture and her husband's, and complained, "Got my carte de

Fig. 10. Carte de visite album, c. 1860s. Collection of author.

visite. Mr. Chesnut very good—mine like a washer woman."[75] Distressed at looking like a bedraggled member of the working class, she returned to the studio for another sitting the following day, but was still vexed with her photographic appearance. On April 3, Mary Chesnut found the second round of cartes de visite still wanting, calling her likeness "uglier than ever." Whether her dissatisfaction was the product of vanity or a poor photograph cannot be known; perhaps she was like a posing manual's example of "Mrs. Bland," who, consistently displeased with her photograph, returns to the photographer's "in untiring effort to accommodate her mistaken idea of how she looks."[76] Nor did Mrs. Chesnut say whether she finally chose one of the images for copying and circulation, thus presenting herself to her circle of well-connected friends and acquaintances with a carte de visite that did not quite meet her approval. But her power and right to refuse her picture was that of any sitter, who could in this way selectively edit how he or she would be portrayed.

There was another way for customers to edit their images—by viewing the picture in advance of the final print. Edward L. Wilson told his patrons

not to ask to see the negative (which would, he felt, be difficult for customers to understand, and would likely result in confused criticism); instead, he said he would show them a proof, and, if it was unsatisfactory, arrange for a second sitting. With the advent of positive-negative photography, the proof—a rough print, usually not properly fixed and not intended to be preserved— became an intermediary between the sitter and the finished product. The proof was to be inspected by the sitter, who then became a collaborator in the making of the portrait; it could be accepted, rejected, or, in a third and increasingly common option, improved with retouching.

Retouching the negative for finished prints was to be performed with a light hand—a perfect, untouched negative being more desirable than one retouched in any way—and was to be "confined to the removal of defects, without any idea of conferring fresh beauties." In portraiture, "removing freckles, decreasing strongly-marked shadows, and very occasionally giving a little force to lights" marked the limits of acceptable practice.[77] But in an era of retouching, the proof offered very little proof of anything at all. Rough first prints were made with their painted improvements in mind,

and so looked strange to a viewer unaccustomed to the process. One posing manual counseled its readers either to become intimately familiar with the technique or simply to submit to the more experienced photographer, for the proof could be misleading: "Before the recent improvement in photography, technically called *retouching*, a proof bore a tolerably correct resemblance to the finished picture, and was consequently useful and satisfactory to submit as a specimen. But since the introduction of the new method of working over the negative, a proof is of little worth; indeed it has become a source of trial."[78] On the one hand, then, the photographic proof allowed sitters to screen out mistakes or unflattering poses in accordance with personal taste and individual preferences, counteracting the sometimes cookie-cutter practice of portrait photography and controlling the way they would present themselves to the world. On the other hand, however, this screening process—and the subsequent retouching—in effect contributed to the sameness of such portraits, canceling out certain photographic accidents or physiognomic infelicities.

When all of the posing advice, background and accessories options, and retouching are taken into account, it is little wonder that the sitter could become almost unrecognizable to friends and family. The discrepancy between the picture and its original was often characterized in terms of expression, that elusive quality which photographers sought to capture but sometimes stifled in the process. A critique in the *St. Louis Photographer* (in the waning years of studio photography) showed the transformation, in the studio, of the sitter to such an extent that she practically became another person, and the photograph revealed the face of a stranger: "In turning over the albums of our friends, how often we pass the faces of acquaintances and don't know them at all! How is this? Simply because, at the moment when the picture was taken, the original was *unlike herself.* She was nervous, her head was screwed into a vise, her position had been selected for her, and she had been ordered to look at an indicated spot, and keep still. Such a position was like nothing in her real life, and her expression was just as foreign. The features might be perfectly correct, but that inscrutable something which individualizes the face was lacking."[79] In part the fault of a heavy-handed photographer, such a poor representation could also be interpreted as a deficit on the part of his public, who expected a transformation from the everyday when they walked through the gallery doors. In leaving the portrayal of their personalities up to the photographer, sitters subsumed themselves to the standardized ideal. As a chatty posing manual put it, "The majority of persons go to the studio without an idea of what they really are, or what they

really want; depend on the artist for every thought they have, every movement they make; he is expected also to bring each one up to the standard of his beautiful specimens at the entrance."[80]

The resulting photographs were so similar to one another that it is difficult to imagine what they could have communicated to their viewers about the person pictured there. The pose and size were in part to blame for their limited expressive capacity; photographer Abraham Bogardus later recalled thinking at first that the carte de visite was "a little thing; a man standing by a fluted column, full length, head about twice the size of a pin."[81] The full-figure format of the carte de visite—which did change in later years to focus more on the head—at least initially aimed to impart a different category of information than the face alone would allow: it revealed the posture, proportions, clothing, and setting of the sitter. One article on photographic portraits claimed that they held significant social value "not only because they fairly indicate the *personnel* of their models, but because they so faithfully represent textures that we can form a very good idea from a *carte de visite* of the social position of the sitter, and incidentally, from the cut, style, and material of the dress, a very good notion also of their moral caliber."[82] A card portrait might announce to its viewer the higher or lower circumstances under which the photograph was taken, and the sitter's skill and taste in choosing an accomplished photographer, elegant clothes, and appropriate accessories. Its possession allowed one entry into the rituals of middle-class society; without a picture to distribute, one might literally be excluded from an album of friends and family. Above all, the carte de visite revealed the middle-class respectability of presenting oneself to the camera in the first place, and of participating with millions of others in a national fashion.

What cartes de visite could reveal about their sitters can perhaps be understood better by examining the patterns of their use than by looking at the expressive possibilities of individual pictures. The immense circulation of the carte de visite shows just how much these small pictures were valued. In the intimate gesture of giving a carte de visite to another, the donor bestowed a favor upon the recipient; in receiving one, the beneficiary symbolically included the pictured person among his loved ones or social peers. The manufactured poses and expressions, repetitive props, and incongruous backdrops might serve to obfuscate the sitter's individuality, but they also marked him or her as part of a like-minded group. In the act of exchange, on the market of family and friends, the carte de visite gained value; the personal gaze of a loved one could make that picture meaningful.

The Publicness of Posing

When Mary Chesnut, who was so dissatisfied with her pictures, sat for them at Quimby's, her experience and interactions there in the galleries must have been anything but unsatisfactory. Upper-bracket photographic studios were meeting places of high society, and a sitter could expect to encounter friends and acquaintances of her circle. On March 28, 1861, Mrs. Chesnut described in her diary the experience of seeing there several friends gathered for the same purpose: "Breakfasted with Baxter Springs & Mr. Manning. The latter dressed to have his picture taken. Made Mr. C[hesnut] dress & go with me—had his taken. Bought an album. Gen. Means gave me his. Met at the artist's rooms Hal Frasier & his sister, Mrs. Frederick Frasier, Mr. Manning & Gen. Simons. Mr. M. promised me his likeness. Saw there also Miss Susan Alston & her brother. Sally Rutledge walked up with me—& I met Mrs. Keitt, so affected and absurdly dressed."[83] The visitor to the photographer's rooms did not present herself solely to the camera and prospective owners of her photograph; she also presented herself to the scrutiny of other patrons. Just as Mary Chesnut admired some of the acquaintances she saw at Quimby's and passed judgment on others, so would other visitors emulate or judge their peers. Mrs. Chesnut might have noticed still others of her set in frames on the walls of the studio, as examples of the photographer's art (and an enticement for new sitters to follow suit). She surely would have seen photographs of important local and national figures at such an establishment, suggesting that by posing for her picture she was participating in a larger communal activity. If she had been pleased with her own photograph, it might have also ended up on the wall for others to view.

What might seem to be a rather private act had a very public dimension. To present oneself to the camera was to display oneself to various circles of people: the operators at the studio, the intimates who received the picture, and finally their friends and relatives, who would thumb through the album on the parlor's center table. The similarities in furnishings between the photographer's gallery and the domestic parlor further confused the boundaries between the public and private spheres. And the accidentally public nature of the new medium could have a dramatic impact on people sitting for their photographs.

As photography advanced, photographic galleries of the top tier became increasingly elaborate, resembling palaces or museums. A large engraving in an 1861 issue of *Frank Leslie's Illustrated Newspaper* shows the new studio of the famed photographer Mathew Brady in lavish detail, a spacious and

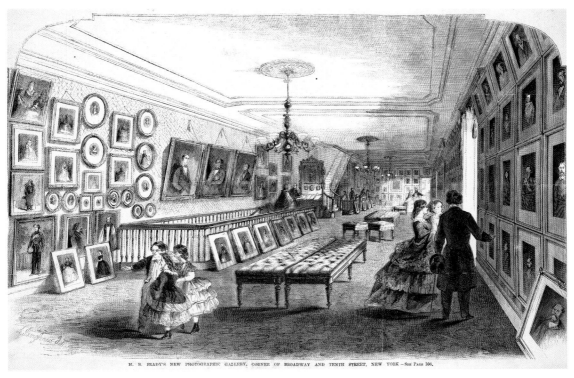

M. B. BRADY'S NEW PHOTOGRAPHIC GALLERY, CORNER OF BROADWAY AND TENTH STREET, NEW YORK.—See Page 106.

Fig. 11. "M. B. Brady's New Photographic Gallery,"
Frank Leslie's Illustrated Newspaper 11, no. 267 (January 5, 1861): 108.

elegant gallery with numerous large "Imperial" portraits hanging on the wall and leaning against the stair railings (fig. 11). A gentleman and two ladies converse in the foreground looking at pictures, and three children are being equally entertained. The accompanying article described the elegant gas fixtures, couches, and carpeting, and mentioned the installation of a ladies' entrance to spare women from passing through the public space in full dress.[84] Few galleries, of course, could approach the splendor of Brady's rooms—most people sat for their pictures in more modest establishments, or even with itinerant photographers—but they were held up in the popular and photographic press as the model for what a photographic space should be.

Even those establishments not so elaborately equipped attempted to replicate the public spaces of the ideal home, filling their rooms with carpets and couches, books and pictures. The photography gallery participated in what Shirley Wajda has called a process of "parlorization." In both the commercial and the domestic spheres, "bourgeois Americans created spaces which reified their desire for group affirmation and exclusion"; these spaces

occupied a shifting ground between public and private.[85] The domestic parlor was a genteel space, separated from the unseemly living and work functions of cooking, bathing, and sleeping, which were increasingly relegated to the back of the house. Both the site of family gatherings and a reception room for visitors, the parlor was where the family put on its public face. The photographer's studio, an unabashedly commercial space, nevertheless imitated the home's parlor in an attempt to make sitting for a portrait more enjoyable, and to attract more customers to the photographer's rooms. The quality of the rooms served to stratify the profession, as patrons would generally frequent rooms that most closely resembled those they maintained at home. As household furniture entered the gallery (and thus the photographs taken there), family albums began to resemble strange houses composed of many rooms, with all the relatives assembled in perpetual parlors; this home would open up only its most presentable spaces to viewers. In blurring the boundaries between home and studio, domestic and commercial space, photographic portraits and the circumstances of their production allowed worldly concerns to permeate personal representations.

The sometimes unintentionally public nature of photography is illustrated in a pair of humorous stories, published in the *American Journal of Photography* in early 1863, by a recent convert to the carte phenomenon.[86] In this remarkable tale, the carte de visite is loosed from its original (human) moorings, taking on a life of its own in public and courting social disaster. It begins on the day before Christmas, when the narrator's wife cajoles her husband into purchasing an album and a handsome picture of himself to put in it. And so the narrator, a modestly successful New York stockbroker named Solomon P. Rodgers, sets out to have his likeness taken. When he arrives at the busy photographer's, however, he finds that he can't have a sitting until January. He trudges to cheaper and cheaper establishments until he finally finds a photographer who can give him a proof that night, with prints by New Year's. As he follows the "Professor" to his parlor room, Rodgers espies the likenesses of other acquaintances of his circle—a doctor, a judge, a colonel—and imagines his own portrait looking as distinguished.

The description of sitting for a picture is typical of first encounters with photography: the painfully long exposure time, the stiff headrest, the coaxing of the face into a suitable expression, the silly technical misunderstandings between sitter and operator. Finally, after a distracted afternoon of waiting, the proof: a "capital likeness," according to the photographer himself. But Rodgers' satisfaction with his own image lasts only until he shows it to a passing acquaintance, who criticizes the proof for making him look too old

and gray. Although his children agree, his little niece Nell says the picture looks even handsomer than Uncle, and so he orders two dozen. When New Year's comes around, Rodgers places his carte portrait in each of the children's stockings, to the delighted reaction of his family. So pleased is he with himself, and with the Professor, that he considers it almost a religious mission to make the New Year's Day calls with his newfound faith, "*armed* and *equipped* with this gospel of the heliographic art,—these illuminated '*tracts* for the times.'"[87] One of his stops is to the home of an old flame, now married, and upon whom he bestows the gift of his carte. To his astonishment and horror, Rodgers later learns that her husband flew into a rage upon seeing the picture in his wife's album, tore it out, crushed it in his grasp, and threw it away. He imagines the future life of this piece of cardboard, and how his picture might be sold as so much paper stock "to reappear again in another form as paper, perhaps an election poster, pasted on the fence boards, or some old pile of bricks on Broadway! What a metamsychosis [*sic*] is this!"[88]

But the wastepaper basket is only one of the places the stockbroker's portrait turns up. Rodgers has some success on the market and photographers line up, besieging him with requests to publish his likeness for their growing galleries of celebrities. Remembering his unfortunate lesson of New Year's, however, he refuses even the most flattering invitation. But then one morning he sees in a storefront cartes identical to his own, labeled "Solomon P. Rodgers, Esq., *The Great Financier.*" Soon he sees it in the window of every print shop, in different variations, quality, and price, even peddled by a German girl on the street. The photographs make him the celebrity for which the photographers took him, as he strikes notice on the street ("That's him; how like the picture!"). He consults the Professor, who swears he made no extra copies and kindly relinquishes the plate and proof; these are, respectively, crushed and cast into the fire. Finally, he enlists the photographer to clear the market of his likeness and find the original from which the numerous copies have been made. The Professor reports back that Rodgers's carte had found its way into the hands of an unscrupulous traveling photographer who, learning of the stockbroker's financial success but facing repeated rejection for a sitting, located Rogers's son Bill and traded him a carte de visite of a danseuse in the Bowery theater for a portrait of his father. With this confession the itinerant photographer reveals both the dogged determination of those supplying the public with its images of national notables and the strange path the carte de visite might journey, even from young family member to shop window.

In many ways Rodgers's experience was typical for the photographic initiate. A member of the growing urban professional class, he had most likely sat for a daguerreotype before, but he had limited experience with the newer positive-negative process (hence his confusion about how long it would take to obtain the actual prints). Like most consumers, Rodgers subjects the proof to a process of judging by members of his community—the photographer, his business colleague, his family—until it is deemed acceptable. (Additionally, opinions are later rendered by strangers in the outside world, taking this public appraisal of the image much further than originally intended.) Rodgers approaches photography with an almost religious reverence, treating his cartes de visite like words of gospel to be shared with the unsaved. His chosen methods of distribution are entirely ordinary—in the children's stockings, through his New Year's Day calls—and even little Bill's trade of his father's portrait for one of a dancer can be seen as representative of many common exchanges of pictures within the closed market of friends and family. (Young Bill took liberties here, not only with the salacious content of the traded picture; the usual exchange would be made by the owner of the picture for one of the recipient.)

For all its typical features, however, Rodgers's encounter with photography also shows the frighteningly extreme possibilities of this now highly reproducible medium. It is photography out of control, or more specifically a man losing control of the circulation of his own image. Photographs intentionally destined for family instead stare back at Rodgers from every shop window, as if mocking the private paths of distribution the carte de visite enabled. Rodgers finds himself everywhere, face to face with his own pirated image, in a strange and seemingly unlimited multiplication of the self. Tom Gunning has argued that photography in its early years was "experienced as an uncanny phenomenon, one which seemed to undermine the unique identity of objects and people, endlessly reproducing the appearances of objects, creating a parallel world of phantasmatic doubles alongside the concrete world of the senses verified by positivism."[89] Drawing on Freud's 1919 essay on the uncanny, Gunning shows how photography partook of its characteristic features: the strangeness of the familiar, the phenomenon of the double, and the factor of involuntary repetition. This normal situation exaggerated out of control makes a rather ordinary portrait strange and almost menacing, as its familiar features look back from inappropriate settings. The perfect and endless doubling made possible only by positive-negative photography seems to create a world of Rodgers-shadows, uninvited ghosts who take on a life of their own. Rodgers's identity is no longer predicated upon any independent

or concrete existence but rather on his resemblance to a picture viewed by more people than ever laid eyes on the man himself—"That's him; how like the picture!"

Rodgers has become a celebrity, not only because of his success on the stock market, but also because of his ubiquitous portrait. If the initial news of his windfall gives him notoriety, and his elusiveness fans those flames, it is the circulation of his picture—his constant presence—that makes him a celebrity; in an age of mechanical reproduction, anybody can become famous if replicated often enough. Rodgers's attempts to remove the pictures from the public eye are naturally futile, because they no longer belong to him; the photographs are public property, just as he is. He has imagined his discarded photograph as taking on new life in some other paper form, recycled as so much cardboard. With the mass production of his photograph, his sense of his image as a commodity reaches its height. As Rodgers becomes a celebrity, his photograph is bought and sold like a sack of flour or bolt of calico, an everyday item of commercial culture. This is the extreme form of carte de visite portraiture, taken to its logical conclusion: photography has transformed him from a private person to a commodity available to all willing to pay the market price. At the end of the story, after the Professor swears that all manifestations of his image have been eliminated from the city, the little German girl sticks her hand within the stockbroker's office door and peddles yet another portrait. Rodgers responds, "Will this visitation of pictures never end? I shall surly die of the surfeit, and on my tomb-stone will be inscribed, 'Died of Cartes de Visite.' I shall only add in conclusion, that I am resigned to my fate. Let no man attempt to resist the onward march of the age."[90]

"Photographic Eminence": Celebrity Cartes de Visite

As Rodgers discovered, celebrities were being made and they were being photographed, both at an astonishing rate. If the ability to have one's own picture taken cheaply to distribute among friends seemed extraordinary, the sudden confrontation, in vast numbers, with the famous of the day was nothing short of astounding. In an 1864 article titled "Photographic Eminence," published in both *Humphrey's Journal* and the *American Journal of Photography*, one writer tried to capture the immense flood of celebrity cartes de visite: "The private supply of cartes is nothing to the deluge of portraits of public characters which are thrown upon the market; piled up by the bushel in the print stores, offered by the gross at the book stands, and thrust upon

our attention everywhere. These collections contain all sorts of people, eminent generals, ballet dancers, pugilists, members of congress, Doctors of Divinity, politicians, pretty actresses, circus riders, and negro minstrels."[91] Celebrity photographs had a role equal to, if not greater than, personal pictures in sparking the carte craze; as early as the summer of 1860, both Anthony's (the photographic supply house) and D. Appleton (the bookseller and publisher) were simultaneously publishing celebrity cartes for buyers who snapped them up for their new albums. By 1863 pretty much anybody who was famous had been photographed for card pictures, and enterprising photographers and publishers sought to record the faces of new celebrities as they were made.

Pictures of national notables were not without precedent in American portraiture, either painted or photographic.[92] Charles Willson Peale, for example, had filled his museum in eighteenth-century Philadelphia with oil portraits of Revolutionary War heroes and black-paper silhouettes of common Americans; a public space with myriad entertainments (including sitting for a profile), Peale's establishment had a similar function to the later photographic gallery. With the advent of the daguerreotype, some photographers began assembling their own collections of heroes and celebrities, national galleries of the era's eminent living men. Daguerreotype portraits could be viewed in the photographer's gallery, or circulated to a limited extent through copy daguerreotypes or lithographs made from the originals. John Plumbe was a pioneer in this field, beginning in 1846 the publication of *The National Plumbeotype Gallery*, a collection of lithographs based on daguerreotypes. Ultimately short-lived (Plumbe's business failed the following year), the series portrayed senators, former presidents, and other celebrities in rather crude likenesses. In 1850, Mathew Brady issued his *Gallery of Illustrious Americans*, which combined a semimonthly portfolio of biographies by Charles Edwards Lester with lithographed portraits from Brady's daguerreotypes, printed by Francis D'Avignon. Mostly images of living statesmen, the lithographs were much more animated and accomplished than Plumbe's, and they enjoyed a warm critical reception, due in no small part to their being taken "from life." Still, only twelve of the intended twenty-four portraits were issued, and sales were not enough to keep the project afloat. Brady had more success with his large (about 20 × 24 inch) "Imperials," photographic prints on paper improved with crayon or watercolor that he introduced in 1856. The imposing size, artistic aspirations, steep price, and limited circulation of the Brady Imperials made them more like museum pieces than the intimate daguerreotypes one might own and view at home.

With the Imperials, his increasing renown as a photographer of the famous, and his new gallery (opened in 1860) Brady's rooms became the place to visit to see the latest celebrity. "In this deep-tinted luxurious room," gushed a reviewer of the gallery, "are gathered the senators and the sentimentalists, the bankers and the poets, the lawyers and the divines of the state and of the nation, kept all in order and refined by the smiling queenliness of all manner of lovely and celebrated women."[93]

Mathew Brady effectively created a national gallery and a national archive of all manner of distinguished and common people. Alan Trachtenberg has justly claimed that Brady, more than any other American, shaped the role of the photographer as a national historian, recording everyday citizens along-side the famous of the day.[94] It was history written as biography, the faces of great men proof of their great deeds. When Brady attempted to sell his vast archive to the Library of Congress in 1871, the argument made by congress-men on his behalf described this national collection of eminent Americans as a Photographic Pantheon, "so comprehensive and national in its character, and so impressive with patriotic and personal associations." The archive, put on display at the Library of Congress, would become a "constant source of national gratification, and its locality the very shrine of patriotism."[95] The committee quoted Thomas Carlyle, who had pronounced a portrait supe-rior in instruction to half a dozen written biographies; the pictures, it was argued, would teach the love of country along with a taste for art, and the government purchased them the following year.

If Brady's archive was a shrine of patriotism and hero worship, it was more the community altar of the public than a private devotional corner. The carte de visite celebrity portrait, by contrast, brought heroes into the home. Pho-tographs of celebrities had been, and continued to be, shown in the relatively public setting of the photographic gallery. But suddenly they could also be found in albums on the parlor's center table, sometimes mingling intimately with pictures of family members. Such private portrait galleries were edited and reproduced in seemingly infinite permutations, and many households could proudly display their own selection of national notables. Trachtenberg has identified a practical difference, in the daguerreotype era, between the large, often formulaic "emulatory" portrait and the more intimate "memo-rial" daguerreotype, which fit comfortably in the hand or pocket. He has argued that the differentiation between the two (seen in terms of size, style, and use) contributed significantly to the separation of domestic and worldly spheres in the antebellum era: pictures of the great, intended for exhibition and reproduction, would be seen by a public in urban daguerreotype galleries,

whereas pictures of the near and dear were held close to the body and viewed in private circumstances.[96] With the carte de visite, however, the two modes merged into one, as the very same image seen large on Brady's walls could be purchased in smaller form by mail from nearly any point in the country. The standardized size and scale, extensive circulation, and personal viewing conditions of celebrity cartes collapsed the distinction between public and private figures and, if we are to follow Trachtenberg's argument, public and private spheres. The personages and worlds of politics, war, theater, and letters had entered the domestic parlor.

Cartes de visite capitalized on the contemporaneity of celebrities first made possible with the daguerreotype: rather than depicting venerable heroes of the American past, they showed the famous of the American present. As an 1861 article on the subject observed: "We are reminded in a manner the most impressive that *carte de visite* miniatures are creations of the present day, portraits of our own actual contemporaries. These photographs are essentially novelties—they belong to the present; with the past, except with so much of it as has been very recently the present, they have no connection whatsoever; as we have said, they are contemporary portraits— portraits of the men, and women, and children of the living generation."[97] With the exception of copy cartes of paintings or lithographed cartes (which might portray George Washington or other sitters whose existence preceded that of the photograph), the card portrait required a living subject to pose for the picture, and implied, through its new format, that it had happened recently. Historian Daniel Boorstin commented on the change wrought by the "Graphic Revolution" upon the status of fame, distinguishing between heroes and celebrities. Heroes, he argued, were self-made men (the great) whose fame had evolved; celebrities (the famous) were created by the media and were the products of instant notoriety, whose common factor and primary achievement was precisely their wide familiarity. Whereas the hero required time, the celebrity was always contemporary.[98] As new celebrity figures emerged, old ones—and their pictures—sometimes lost their currency, in both senses of the word (social and market value). And new ones gained it, as an article reprinted in the *American Journal of Photography* from the British press so vividly demonstrated: "The commercial value of the human face was never tested to such an extent as it is at the present moment in these handy photographs. No man, or woman either, knows but that some accident may elevate them to the position of the hero of the hour, and send up the value of their countenances to a degree they never dreamed of. For instance, after the great fight with Johnny Heenan,

Tom Sayers was beset with photographers, anxious for the honor of paying for a sitting, but his reply was, 'It's no good, gentlemen, I've been and sold my mug to Mr. Newbold,' that sporting publisher having seen betimes the advantage of securing his phiz."[99] Aware of the fleeting quality of fame, shrewd celebrities began to market themselves to photographers, and thus to a new public.

Enterprising photographers and savvy publishers made fortunes distributing the likenesses of the already famous and the soon-to-be celebrated. Daguerreotypists had once secured a sitting by waiving their fee and promising a free daguerreotype from the session, but photographers in the carte era, facing greater competition for celebrities as well as greater rewards from their massively reproduced portraits, eventually began to pay the sitter for that privilege. The traffic in celebrity pictures benefited the celebrity, the photographer, and the profession itself. An emerging public figure could thus help shape his or her own public image, as did Lincoln, who so famously credited Brady's portrait for his rise to the presidency. For the photographer, publishing pictures of national notables represented a new source of income as well as a rise in status. "To obtain a good sitter, and his permission to sell his *carte de visite*, is in itself an annuity to a man," continued the above article on celebrity cartes. "For instance, all our public men are what is termed in the trade 'sure cards'; there is a constant demand for them, a much greater one, indeed, than can be supplied."[100] A collection of photographs of statesmen or the most sought-after actresses enhanced the photographer's standing as well. Celebrity photographers such as Brady, and his successors in the 1870s like Napoleon Sarony and J. M. Mora, who largely focused on stars of the stage, made their reputations as much by the quality of their sitters as by the quality of their art. Ultimately, the happiest beneficiary of the celebrity trade was photography itself; as Barbara McCandless has put it, "The true success of the celebrity portraits was in creating a market."[101] The competition and contrasts between pictures of family and the famous, she argues, strengthened the entire profession, as everyday photographers emulated the techniques and aesthetics of upper-class portraits and elite photographers in turn marketed to a mass public by making their pictures affordable and desirable. Indeed, so marketable were certain celebrity portraits that many were blatantly pirated, the practice of plagiarism merely a by-product of filling a growing demand.

Card pictures of the famous were obtained through catalogue orders, itinerant salesmen or agents, stationery and print shops, booksellers, photographic galleries, popular and photographic magazines, and even friendly

barter. Mary Chesnut, for example, in 1861 reported snapping up celebrity cartes at the photographer's galleries, where she made an appointment for a sitting two days later: "Then to Quimby's, bought 2 dozen of cartes de visite of all the celebrities."[102] "Godey's Arm-Chair," a chatty section of the fashionable ladies' journal, aimed its sights at its female readership, offering a special selection of some six or seven hundred card photographs for albums. Boston publisher G. W. Tomlinson sent out a mailing in May 1864, presumably to potential sales agents, advertising several hundred subjects ranging from current portraits to religious subjects to classical art for ten cents each.[103] In a mail broadside (c. 1865), Salisbury, Bro. & Co. of Providence, Rhode Island, advertised for agents to sell cartes de visite door-to-door. The pitch went: "There is nothing so popular at the present time as carte de visites of these named in this circular. Agents can make twenty dollars per day canvassing their own towns! Anyone can sell them, as they are what every one wants at this time."[104] The best sellers included "Abraham Lincoln, our martyred president," Booth the assassin, and selected Union generals and statesmen; would-be agents could purchase one thousand of the most popular cartes for about ten cents each and expect to sell them for the going rate of up to a quarter. Various publishers sent out circulars for mail-order cartes, plying celebrity pictures along with those of comic and genre scenes, works of art, and views, often sold in thematic groups for special savings on both ends.

The most impressive and successful collaboration between a photographer and a publisher, and that which resulted in the greatest dissemination of celebrity portraits, was that of Brady and the Anthonys. In 1861 the photographic supply house and publishing firm of Edward and Henry T. Anthony purchased Mathew Brady's carte de visite negatives, along with permission to rephotograph his Imperial portraits, for about $4,000; the negatives then became the property of the Anthonys (who also acquired similar carte-negative collections from other sources).[105] The Anthonys distributed the mass-produced card pictures as "Brady's Album Gallery" in a series of elaborate mail-order catalogues to the trade. Their November 1862 circular itemized some two thousand portraits in the following categories: The Army and the Navy; Statesmen, Lawyers, Physicians, Artists, and others; Prominent Foreign Portraits; The Clergy; The Literary World; The Stage; and Prominent Women. These were followed by art reproductions and genre scenes, and then an extensive listing of Brady's photographic views of the war. Moreover, the catalogue promised to update the selection daily to ensure that photographers and other suppliers would have the

most current celebrities in stock. By 1868, the Anthonys' collection of card photographs for sale had swelled to over four thousand images, of which half comprised national and international celebrities.[106] Portraits were now assigned four-digit ordering numbers to ease processing, and cost from $4 to $6 per dozen. To meet demands, the Anthony firm perfected the commodity production of the carte de visite, instituting sophisticated assembly-line practices, with each workman in the large warehouse laboring on a highly specific task in the production process—cleaning negatives before prints were made, albumenizing paper, mounting the pictures on board, and so forth. By the mid-1860s they were printing as many as thirty-six hundred cartes per day.[107]

Elizabeth Anne McCauley has observed that the adoption of the carte de visite as an item of exchange transformed the individual into a malleable commodity.[108] This transformation, however, was different for celebrity and personal photographs. Personal cartes de visite avoided becoming mere commodities by their rather limited circulation and their intrinsic individuality for a certain viewer; by contrast, celebrity cartes were embraced by mass production and the mass market. Family portraits might be distributed widely within a limited social circle, but celebrity pictures represented a potentially limitless circulation. With their stock props and poses, photographs of friends and family began to look the same; Brady's card portrait of Lincoln, which found a home in albums throughout the Union, *was* the same. The vast production and consumption of cartes de visite of the famous may perhaps be thought of as an extension, on a much larger scale, of the same process that produced family pictures: a similar lengthy pose in front of the camera, equivalent studio accouterments, a negative from which could be produced prints in the dozens or the thousands.

Besides sheer numbers of circulation and the general higher quality of celebrity portraits, what most distinguishes cartes de visite of the family from those of the famous is the different kinds of viewing each entailed. Whereas people looked to personal photographs for a spark of recognition or memory, preservation of the departed, or simply a chance to gaze upon the features of a loved one, viewers appealed to celebrity photographs with grander hopes. Celebrity photographs, from the daguerreotype era on, seemed to provide a moral education and blueprint for self-improvement; by the time of the easy accessibility of the carte de visite, they also revealed the status and sophistication of their owners. The perceived physiognomic relationship between noble features and integrity, outer and inner beauty, meant that the photograph seemed to convey the very character of eminent public

figures. "We are not satisfied with knowing what they have done," wrote one commentator on celebrity photographs. "We want to know what they are."[109] It was hoped that seeing these pictures would inspire learning about the great deeds behind the great men, but the presence alone of such elevated figures could also serve to uplift the viewer, as the photographer M. A. Root articulated: "The great and the good, the heroes, saints, and sages of all lands and all eras are, by these life-like 'presentments,' brought within the constant purview of the young, the middle-aged, and the old. The pure, the high, the noble traits beaming from these faces and forms,—who shall measure the greatness of their effect on the impressionable minds of those who catch sight of them at every turn?"[110] The pathway of influence is not made entirely clear by Root, but it is apparent that the mere act of viewing a noble face somehow ennobled the viewer as well. Ideally, a process of imitation and emulation would ensue, in which viewers would strive to be more like the person pictured. In the setting of a photographic gallery, a sitter might find himself on more or less an equal plane as the local or national celebrities arrayed on the wall, having posed for the same photographer at the same studio; the gallery, argues Shirley Wajda, provided a means for the patron to become one of the people displayed, and fostered a sense of cosmopolitanism among visitors.[111] In the setting of the domestic parlor, where cartes de visite of the famous could be passed around among guests, the possession of such pictures signaled the owner's cultural and moral standing. Pictures of literary figures might indicate an elevated mind, whereas Union generals might reveal patriotism, or clergy religious rectitude. In this case, influence would work as much by ownership as by the moral education of emulation.

With the increasing popularity and accessibility of celebrity portraits came a greater familiarity and intimacy as well; as the people became more like them, they became more like the people. The carte de visite, McCauley has said, was a "great equalizer," bringing the famous into the parlor and making them seem more like family than heroes; it sparked a new relationship with the famous of the day.[112] This fact was widely commented upon at the time, as in an 1862 article on the new format: "The universality of the *carte de visite* has had the effect of making the public acquainted with all its remarkable men. We know their personality long before we see them. Even the *cartes de visite* of relatively unknown persons so completely picture their appearance, that when we meet the originals we seem to have some acquaintance with them."[113] As emulation ceded ground to entertainment, the figures with whom the public became intimate may have been less likely to be invited into the parlor, but the familiarity nevertheless increased. An

1865 article entitled "Photography and Popularity" explained this transformation: "Photography has had one curious effect—it has made our remarkable characters familiar to the world. The features of almost everybody with a reputation are as well known now, thanks to the little carte-de-visite and the photographer's shop window, as if we were all on visiting terms with the notorieties. The moment anyone achieves a name, the public wants to have his portrait. The name may not be a very desirable one: a murderer, for example, will sell better than an actor, and an actor better than a statesman; but the taste of this day is for knowing 'what manner of man is this.' And since to be taken, you must sit, it is clear that the notorieties meet the taste half way. The result has been a kind of personal meeting between the public and their leading men, which is good for both."[114] The carte de visite was lauded for its democratic functions in this regard, as it evened out the social playing field and fostered a relationship between the public and its representatives, an acquaintance with public figures being seen as the first step in a participatory democracy. The growing accessibility of celebrity portraits meant that more and more citizens could reap the benefits of the moral uplift based on proximity to greatness.

At the same time, however, an increased familiarity with and indiscriminate access to the public figures of the day lent them less currency as symbols of culture and sophistication. As certain card pictures flooded the markets (the Tom Thumb "Fairy Wedding," for example, or actor Edwin Booth with his daughter), the status of owning one was also devalued; celebrity cartes de visite could always be printed up again if the supply ran low. Indeed, there was such rampant pirating of popular images—as was seen in the story of Rodgers—that exclusive access to some pictures was inherently threatened. But perhaps that was part of the point: in owning the same pictures friends and neighbors did, by integrating them into the family album, participation in a like-minded, communal endeavor may have been as important as the signaling of individual or family identity. The celebrity carte de visite—an object of the market and of the world, domesticated in the parlor—ultimately further confused the already blurry boundaries between public and private spheres. Its currency value lay not only in its status within a certain cultural arena, but also in its ubiquitous circulation.

B. L. WRIGHT,

PHOTOGRAPHER

Canton Pa.

No. 3149

PHOTOGRAPHIE
von
F. Brandseph
in
STUTTGART

GREEN'S
ART
GALLERY

NO. 205 MAIN STREET

JOHNSTOWN.

JOHN F. NICE,

PHOTOGRAPHER,

N. E. cor. of

Third and Market Square,

WILLIAMSPORT,

PENNA.

ALBUMS ON THE MARKET

In an 1872 issue of the Baltimore trade publication *The Photographer's Friend*, an impassioned writer named Nod Patterson, weary of looking at hackneyed family photographs, addressed his photographer-readers thus: "Reader, did you ever visit any house of respectability, without discovering the inevitable photographic album upon the centre table? Did you ever notice in what a peculiar manner the gentle sex turn the album leaves over, dropping here and there a comment on the picture of some acquaintance. It seems strange that every one that we are pleased to visit, should seem to consider we ought to feel a great interest in the pictures in the album, when in fact they are *anything* but interesting to parties not *interested*."[1] To remedy this sorry state of affairs, in no little part caused (he argued) by the shoddy workmanship of certain studio photographers, Patterson urged his readers to encourage their clients to fill albums with higher-quality celebrity portraits and views. He sketched out two classes of album pictures, those of "Miss Domestic" and those of "Miss Enterprise." Miss Domestic, sad to say, forces upon the visitor yellowed prints of Uncle Adolphus, Aunt Jane in an ungainly pose against a dark and cloudy background, and the likenesses of the Reverend Smoothtalk (the minister), Mr. Calico (the dry-goods merchant), and more "family beauties." Patterson painted an unpleasant scene of the album and the album-keeper's accompanying narration, which, in its exaggerated and exasperated tone, is worth quoting at some length:

> First, we visit Miss Domestic; this lady's album is always found on the centre table conspicuously in sight, and no matter how often you visit her, as soon as there is the least *lag* in the conversation, she gives you her album to admire the pictures. . . . The first picture we are gravely informed—"that's grand-pa, papa's father." Grand-pa is copied from an old Daguerreotype, poorly copied too. He is seated *a la statue* by a table, which dwarfs his appearance.

"That picture is papa, when he was a young man," this is also a copy, and "papa" is seen standing by a tall column (not all shown) holding with a tight grasp a large straw hat in one hand, while the other is spread like an American eagle under full sail, over the front of his waist coat. "That picture opposite is *mama*, when she was a young lady; ("mama's" hair is combed smoothly down, way down over her forehead, while her waist looks too long to be continued, and her collar is considerably the most prominent feature in the picture).[2]

He continued for some duration in this vein, pointing to the many technical defects in the posing and execution of the pictures, as well as to the physiognomic defects of relatives and small-town figures who held no interest for the outside viewer. Patterson ultimately lamented that there existed neither a decent photograph nor a celebrated person in this assemblage.

By contrast, Miss Enterprise has on display in her parlor an edifying collection of national notables and views, beginning with the U.S. Capitol and including both Grant and Lee (with autographs), European royalty, Victor Hugo, P. T. Barnum, Niagara Falls, and so on. Moreover, she does not limit her collection of faces to only those most admirable of characters, but chooses to display a variety of important figures representative of the period. A model of proper photographic behavior, she sensibly keeps her album of family and friends tucked away safely in the sitting room. Through her example, Patterson delivered a plea to his fellow photographers, arguing that the tiresome conventions and family eyesores that filled albums and were imposed upon hapless viewers lowered photography in the eyes of consumers and thereby discouraged purchases. Photographers, he argued, should instead encourage their sitters to collect pictures such as those in Miss Enterprise's album. "Who would, after examining an album similar to that of Miss Domestic," he asked, "think of going to become a like subject?"[3]

This fear that the industry might be contaminated by inferior products and lowered prices was a typical sentiment in the photographic press. But what is most remarkable about this editorial is the presumption that the intimate practices of assembling and displaying albums within the home could have such a direct effect on commerce, and that commerce should in turn dictate how individuals—particularly women—kept their family albums. Moreover, by delineating two kinds of album pictures, Patterson really portrayed two kinds of album *owners* and album-keeping *practices*, contrasting not only the contents of the collection but also the sites of display, and even

the verbal tour of the images conducted for viewers. The seemingly private spaces of the home take on varying degrees of publicness here, as even the subtle differences between albums (the family album in the sitting room for relatives, the celebrity and view album in the parlor for visitors) recategorize what we might otherwise consider solely a personal practice of collection and display. The photograph album, in this view, blurs the borders between private and public spheres, individual selection and the directions of industry, the images of family and the portraits of a nation and world.

Photograph albums were by no means the only such household items that confused the boundaries of domestic and commercial life; by virtue of their intimate connection to family and memory, however, they may be a special case. In mid-nineteenth-century America the possessions that filled private life were manufactured increasingly outside the confines of the home and bore the hallmarks of mass production. If the production of goods had previously defined their makers, now it was the consumption of goods that served that function for their owners, and families were consuming more and more mass-market commodities. Furthermore, the home was not the domestic oasis it was made out to be by nineteenth-century writers and critics. In a world of rampant commercialism, the family home was supposed to provide a spiritual and moral shelter from material concerns, a retreat from the growing commodification of life and experience. Middle-class women in particular, presumed to be elevated above the corruption of the marketplace, were expected to shield the family from capitalism's coarseness. But, as Stephanie Coontz has shown, the domestic and commercial worlds were increasingly interdependent, and female consumers—the very people to whom the separateness of the spheres was entrusted—were instrumental in their merging. The creation of such a domestic oasis was itself predicated upon a market economy and competitive labor force, and women increasingly learned their homemaking skills and proper sentiments from mass-circulation books and magazines.[4] In one of the paradoxes of modern life, the cult of domesticity's rhetoric of separate spheres went hand in hand with the growing commercialization of private life.

Walter Benjamin pointed to such changes in his notes on "Paris—Capital of the Nineteenth Century."[5] Examining the locales and spectacles of urban life, he laid bare a dreamworld of consumption and experience mediated by industrial capitalism. In this representative city of a changing century, commodities, no longer linked to a certain use-value, held sway and determined meaning. Photography, for Benjamin, was intricately linked to this shift to modernity, as it enabled an entirely new kind of consumption and created

a market and circulation where there had previously been none. As market manifestations of family history, photograph albums were both agents and symptoms of this transition to a modern dreamworld. They seem to provide an extreme example of what Benjamin discerned was happening with goods and experience all over. From now on, even memories would be shaped by something deeply rooted in commodity and consumption.

What distinguished nineteenth-century objects and images from their predecessors is precisely that which made them indistinguishable from all others around them. Increasingly standardized material goods and mass-produced pictures carried with them the features of mechanization. This cookie-cutter sensibility was an essential feature of the circulation and distribution demanded by modernity, and it posed a challenge to the possibility of individuation through material things.[6] Albums belonged to a class of goods that might be best described as hybrids, which existed somewhere between standardization and personalization, as both commodities and keepsakes. Like fashion plates, the patterns of which provided the models for thousands of women at once but were modified in their actual execution, albums were generic in their empty state and intensely particular once filled. But even when packed with beloved familial faces, photograph albums were extraordinarily consistent, repetitive, and conventionalized. The standardization evident in the photograph album—of album design, card size, and photographic poses, backgrounds, and props—reflected the influence of the machine and of the market, and tempered the individuality of each family's identity.

Albums muddied the distinctions between the public, commercial arena and the private, domestic one as they made their way from the market to the parlor. Through all the steps of constructing an album—having one's photograph taken, purchasing an album, filling it with portraits, and even displaying it within the home—individuals and families collided with the larger commercial world. Far from being strictly private and personal family documents, the photograph albums of the 1860s were guided by the business of photography; they were products of industrial capitalism, churned out by factories and hawked door-to-door. Moreover, while the needs and dictates of the photographic industry and press shaped the formation of family records, albums themselves also exerted a countereffect, allowing that same industry to expand and thrive. The conventions that took hold in purchasing, arranging, and displaying albums—the standards, that is, of picturing the family—cannot fully be understood without taking into account this peculiar intersection of personal and commercial concerns.

"Happy art, that can create a new want, and supply it too!": The Album and the Photographic Industry

The development of the first photograph albums was driven in large part by savvy photographers and publishers who understood that empty pages equaled increased photograph sales, and that albums themselves would be a boon to their industry. As the carte craze flourished, and stacks of pictures piled up in card baskets and overflowed onto the parlor's center table, it became clear to consumers and suppliers alike that a more efficient system of storage and display was needed. Album manufacturer William W. Harding explained, with the inflections of a salesman, the rise of photograph albums as a response to the carte craze: "The discovery and many improvements in the art of Photography created a great demand for some convenient, ornamental, and durable contrivance for preserving its numerous productions. To supply that demand, human ingenuity soon invented the Photograph Album, which was first introduced to public notice at a period the most momentous and eventful in the history of our country, and soon became a very desirable and almost indispensable book, furnishing a convenient method of registering and preserving the photograph portraits of relatives, friends, distinguished statesmen, military and naval heroes, &c., &c."[7] An editorial in *Godey's Lady's Book* echoed Harding's more self-serving assessment. "At a trifling expense we can have the pictures of all those we love, all we esteem, and all we admire and revere of our own family, of great men, of good men; the hero, the patriot, the sage, the divine," they noted. "But then, if we would have these interesting portraits in orderly array, and at hand for inspection, we require a fitting receptacle."[8] Such a receptacle would need to be attractive enough for domestic presentation, and affordable enough for middle-class customers. It would have to accommodate the ever-growing numbers of card portraits, and it would have to be universally accepted—that is, standardized to fit the established dimensions of these popular photographs. Most of all, it would have to be heavily marketed and distributed in order to make it a household standard, a necessary feature of every home, to which new pictures would constantly be added.

The call was first answered in the United States by F. R. Grumel of Geneva, Switzerland, who took out an American patent on a photograph album on May 14, 1861.[9] Grumel's album included the features that would become common to all albums of the period: leaves, or pages, of cardboard with a carte-sized opening so that two photographs could be inserted back

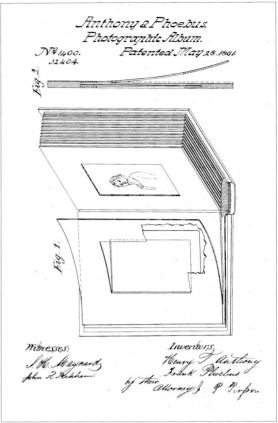

Fig. 12. F. R. Grumel patent for photographic album, May 14, 1861. United States Patent Office.

Fig. 13. Anthony & Phoebus patent for photographic album, May 28, 1861. United States Patent Office.

to back, visible on each side of the page. The cardboard was thick enough so that the pictures would rest flush with the surface of the leaf, and each recessed pocket held a slot for the insertion (and possible removal) of the mounted photographs (fig. 12). All subsequent U.S. patents on albums (there were twenty album-related patents issued between 1861 and 1873, fifteen of them before 1865 alone) would follow this model, making improvements on such features as binding, hinging, matting, or decorative design. A second patent was issued exactly two weeks later to Henry T. Anthony and Frank Phoebus of the Anthony photographic firm; this innovation introduced only minor modifications to the Grumel design but allowed the Anthonys to begin producing albums by the thousands (fig. 13).[10] When a competing concern, C. D. Fredericks & Company of New York, acquired the rights to Grumel's patent, a rights battle broke out between the rival firms. Fredericks placed a notice in *Harper's Weekly* in May 1862 claiming that Grumel had designated

CHAS. D. FREDRICKS & CO.

587 BROADWAY, New York,

AGENTS FOR THE BEST BRANDS OF

SAXONY, ALBUMEN AND PLAIN POSITIVE PAPER.

VISITING CARD 4 TUBE CAMERAS AND BOXES.

ALBUMS for 200, 100, 50, 30, and 20 Pictures. A new and beautiful article for the " Carte de visité."

OVAL VELVET and MOROCCO CASES. GILT FRAMES, and a general assortment of PHOTOGRAPHIC GOODS, which we offer to the trade at liberal discounts.

C. D. FREDRICKS & CO.

Fig. 14. Chas. D. Fredricks & Company advertisement, *American Journal of Photography* 4, no. 21 (April 1, 1862): 506.

him as his sole agent, and warned that all infringements of the card album patent (which comprised "all that is at present sold in this market") would be prosecuted to the extent of the law.[11] But by then it was too late: publishers, booksellers, photographic galleries, and supply houses had all begun manufacturing and distributing albums. And the industry as a whole benefited from—even needed—such blatant plagiarism. For if the new invention was to take hold of the American imagination, manufacturers had to market, alongside their own particular offerings, the *idea* of the photograph album in general; moreover, the rage for albums would have been dampened considerably had there not been enough to meet the need. As Jabez Hughes later declared in the pages of *Anthony's Photographic Bulletin*, "Happy art, that can create a new want, and supply it too!"[12]

Although the first carte albums were rather small and simple, with cardboard covers and room for about a dozen pictures, they rapidly became elaborate affairs. By 1861, manufacturers had begun offering albums that could hold twenty, fifty, one hundred, or even two hundred card photographs (fig. 14).[13] Covers were made of leather with deeply embossed designs and gold patterning. Fancier versions featured French or Turkey morocco leather (later covers appeared in lush velvet), pearl or ivory ornamentation, gilded page

Photograph Albums.

No. 60. English Morocco Album, gilt embossed padded covers, to hold one cabinet or two cards on a page, $1.25 each.

Same as above, larger size, to hold one cabinet and four cards, $1.50 each.

No. 61. English Morocco Album, in brown, red or black, word "Album" stamped in gilt on cover, gilt clasp, all imperials or assorted sizes, $1.98 each.

No. 62. English Morocco Album, plain embossed cover, gilt clasp, all imperials or assorted sizes, $1.75 each.

No. 63. English Morocco album, embossed gilt on cover, to hold all imperials or assorted sizes, $1.94 each.

No. 64. English Morocco Album, antique embossed, word "Album" in hammered letters on cover, for all imperials or assorted sizes, $2.10 each.

No. 65. Silk Plush Album, in red or blue, extension clasp, for all imperials or assorted sizes, $2.63 each.

No. 66. Morocco Album, word "Photographs" stamped in gilt on cover, extension clasps, for all imperials or assorted sizes, $2.85 each.

No. 67. Calf Album, antique and gilt embossed, nickel extension clasp, to hold all imperials or assorted sizes, $3.25 each.

No. 68. Fine quality Silk Plush Album, in red, blue, olive, terra cotta, gilt mountings, extension clasp, to hold all imperials, $10.37 each.

When ordering, give page and number of article. Do not cut book.

Fig. 15. Daniell & Sons Catalogue, 1885.
Strong National Museum of Play, Rochester, New York.

edges, chromolithographic page decorations, an index to the portraits, brass clasps and locks, and the family name or owner's initials lettered in gold on the cover or spine. They ranged in size from about $5^1/_2 \times 4^1/_2$ inches (with one picture per page) up to 11×9 inches or larger, with four cartes per page, and later room for cabinet cards and other formats (see later examples in fig. 15).[14]

If we assume that an object's intended use is evident in and in part determined by its design, we can see that photograph albums were manufactured with certain ideas of how they might be employed. Additionally, as a market developed for these new products, album producers introduced special features in response to customer need, or to differentiate themselves from the herd. Thus an expectation of display was built in to the album's elegant design: small decorative knobs acted like legs to support the album and protect its covers, and cabinet-card models in the 1880s eventually featured presentation stands of multiple varieties (fig. 16). Made to resemble the family Bible (which also had its rightful place on the center table) with its lavish materials and weighty presence, the family album connoted seriousness and seemed to expect a place of honor. One technical innovation was a "chainback," a special kind of metal binding that allowed the album to be opened more widely and more often without damaging the spine of the book; the chain-back also assured that the book would withstand the wear and tear of generations of active, lifelong use (fig. 17). Albums entered the domestic circle with a built-in idea of what constituted a family, as judged by the sheer number of pictures they could accommodate. Most contained space for far more cartes de visite than might reasonably represent immediate family, implying (largely as a reaction to the carte craze) that the pages would be filled with other relatives, friends, and national notables. With a method of assembling photographs that was temporary—users inserted cartes through framed slots rather than gluing them to a page—albums may have encouraged the editing and rearranging of pictures.[15] Clasps on the album's opening, including some with locks, suggested privacy, preservation, and the preciousness of the contents (the latter was also reinforced by the costly materials and gilded designs). Other adaptations included stereoscopic albums complete with a viewer, and music box albums that might play such tunes as "Pretty as a Picture" or "Home Sweet Home."[16]

When photograph albums first reached the United States in large numbers in 1861, they were hailed by the photographic press as novel inventions. Photographic journalists, by no means neutral commentators, delighted in the clever receptacles for the new carte de visite portraits and commended them to their readers, noting the many styles available, as well as the "novelty

Photograph Screens.

Closed. Opened.

No. 220. 5¼ x 6⅝, 6⅞ x 10½, Imit. Alligator, 2 cabinets; per dozen$2 20

No. 81X.

Size 12¾ x 9. (See cut.) Finest Silk Plush, padded round corners, embossed Passion Flower, and new nickel word "Portraits." Blue tint insides, gilt figuring, fine extension clasp, holding 72 cabinets......$4 25

No. 31E.

Size of book 9¼ x 11¼. Finest Silk Plush, padded, with ornamental gold bands, fine tinted beveled insides, new adjustable clasp. Book is attached to a very fine plush easel; holds 30 cabinets, 2 panels, 16 cards..$13 00

The Mikado Album.

ENTIRELY NEW.

EACH LEAF IS BEAUTIFULLY LITHOGRAPHED IN COLORS AND GOLD. MIKADO DESIGNS.

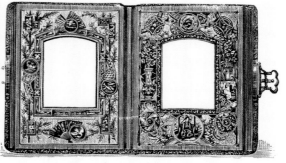

No. 701. Size 9½ x 11¾. Finest Silk Plush, plain padded, round corners, fine extension clasp, holding 36 cabinets; each$5 25
No. 721. Size 9 x 11¾. Finest Silk Plush, embossed, round corners, fine extension clasp, holding 36 cabinets; each 5 00

No. 331E.

Size of Album 9½ x 11⅜. Finest Silk Push, embossed strap on cover, with nickel buckle and buckle holes; very fine tinted beveled insides, new adjustable clasp. The Album is fastened to a plush table, attached to a very fine nickel and plush revolving stand; holds 34 cabinets and 2 panels.
Each....................................$12 50

Clearing Solution.

Alum 2 parts.
Citric Acid 1 part.
Water10 parts.

Fig. 16. N. C. Thayer & Company album catalogue, 1887. George Eastman House, International Museum of Photography and Film, Rochester, New York.

HARDING'S

PATENT

FLEXIBLE CHAIN-BACK ALBUMS.

The superiority of *"The Harding Patent Flexible Chain-Back Album"* over all others heretofore manufactured, will, upon the slightest examination, be apparent to all.

The back, although possessing greater strength, is *more elastic and flexible* than that of any other Album now offered to the public, and is constructed in such a manner, that it *will always keep its original shape, so long as it is not torn to pieces, thus presenting a neater and more beautiful appearance when opened* than any other Photograph Album made.

A LARGE ASSORTMENT OF

PHOTOGRAPH ALBUMS

MADE IN THE USUAL MANNER.

The New Catalogue of 1869–70 embraces a large number of entirely new and beautiful styles.

Pure Gold Leaf only is used in gilding the sides and edges of all Harding's Albums. Straw Boards and Dutch Metal are never used.

CATALOGUES SENT BY MAIL ON APPLICATION.

WILLIAM W. HARDING,

Manufacturer,

326 Chestnut Street, Philadelphia.

Fig. 17. William Harding advertisement for "Chain-Back Albums," *Photographic Mosaics*, 1870.

of the arrangements for introducing the cards, and the felicitous manner in which the portraits are at once displayed and preserved." As a home amusement, the card album was compared to the stereoscope, which also occupied a place of honor on the parlor's center table. Both were welcomed into every family circle by the photographic press, which prophesied that "without doubt, both the stereoscope and *carte de visite* album will never cease to enjoy the hearty and cordial sympathy of every intelligent individual."[17] Even writers in popular periodicals such as *Harper's Weekly* commented on the appeal of the album—which allowed carte collectors to create their own "gallery of friendship and fame"—and noted that the makers of fancy goods

had immediately jumped to design albums, making them "quite universal, and as fast as they are brought to us are taken up with enthusiasm."[18]

In New York, Philadelphia, and other northern urban centers, publishers and photographic suppliers churned out albums by the thousands. The Anthonys established new facilities solely for the production of cartes de visite and albums, employing about fifty young women and an equal number of other workers in a rented floor in the old New Haven Railroad Building manufacturing center. In 1863, Oliver Wendell Holmes took the readers of his "Doings of the Sunbeam" on a remarkable tour of the Anthonys' establishment, where he witnessed and described the fabrication of photograph albums: "The luxurious album, embossed, clasped, gilded, resplendent as a tropical butterfly, goes through as many transformations as a 'purple emperor.' It begins a pasteboard larva, is swatched and pressed and glued into the condition of a chrysalis, and at last alights on the centre-table gorgeous in gold and velvet, the perfect *imago*."[19] (Presumably the album completed its life cycle as butterfly when it was filled with photographs and flitted about the parlor for visitors.) Others detailed the near-assembly-line production methods in more prosaic terms, as did the editors of the *Philadelphia Photographer* in 1870: "A visit to the album manufactory of Mr. H. W. Harding, Philadelphia, gives one a very sensible idea of the immense quantity of albums that are yet sold, not withstanding the cry that their day is ended. Great stacks of albums for the carte, cabinet, and tintype pictures, are there in all the stages of manufacture. An album has to pass through twenty-five to thirty pairs of hands before it is finished."[20] Coleman Sellers, a Philadelphia engineer and American correspondent for the *British Journal of Photography* in the early 1860s, reported on the Lippincott album company, revealing the extent to which the industry was modernized with a division of labor that kept pace with the demands of the market: "Mr. Mitchel [of J. B. Lippincott and Company] says that they employ in this one branch of the business above one hundred hands, and yet they cannot keep pace with their orders; that their stock in store is never large, so rapidly do they send them off. The more elegant and elaborate they make them the more they can sell, as their attention has only been directed to the finer class of goods. They have just completed a very large building on Market Street, and into this new establishment they intend to move their album factory. He showed me various processes of the album making, and said that the printing of the gilt margins to the opening and the punching of the sheets were not done by them, but was a separate business."[21] With over one hundred workers, each performing a specialized task on an album's fabrication, companies like Lip-

pincott's were able to manufacture immense quantities and numerous styles of albums. Standardization of the various formats allowed the vast production and circulation required by the modern economy of commercial photography, and fostered a sameness of appearance among albums. Manufactured like any other interchangeable consumer good—books, bolts of cloth, or a set of parlor chairs—the card album was a product of emerging modern industrial capitalism. Holmes's natural metaphor of a caterpillar's metamorphosis into a butterfly might have been more accurately replaced with one that would include the clanking of machinery and the assembly-line activity of busy hands.

The photograph album proved to be of great importance to the photographic industry. With products that were often faddish, and customers who clamored for the latest technological improvement, the industry (which included photographers, photographic suppliers, and trade publishers) was constantly looking for the next big thing. The daguerreotype had enjoyed a lengthy run in the United States but after two decades had become tired and passé; the carte de visite had risen to take its place. As one journal put it in 1865, "On the centre-tables which once ground under the dozens of daguerreotype cases, we find only the light and graceful album with its hundreds of pictures."[22] An instant fad, but one with long-lasting potential, the photography album was arguably the best thing that happened to the business in the 1860s.

As the editors of *Humphrey's Journal* observed in 1862, the demand for albums sparked by the trade of cartes de visite among friends resulted in happy fortunes for photographic professionals: "In all colleges, academies, and in many large schools, the students and pupils exchange photographs of each other, and this has created a great demand for Photographic Albums, many of which are gotten up with a great degree of elegance. All this helps operators and helps business in the Stock line, and will have a run until something new comes up."[23] Until that something new arrived, the effect of card albums filtered down to photographers and suppliers alike. An article titled "Photography a Progressive Art" pictured a photographic utopia of sorts, with every aspect of life colored by the bounties of photography: "Let us go into the household a moment. Here we find the walls adorned with elegant photographic views and portraits. The album is on the centre-table, of course, well filled. The portfolio is swelling with copies of rare engravings and autographs. The lamp shade is made of six or eight beautiful positive transparencies. The cologne bottle in the toilet chamber is ornamented with a real photographic label. The bridal dress is embellished with real

photographs printed on the rustling, sparkling satin; and the kerchief set off with the tiny doings of our magic art."[24] The album is a given in this scene, one of the few inventions itemized here that made a regular appearance in most homes. If overly optimistic about photography's centrality to everyday life, this passage nevertheless makes apparent the connection between the medium's progress and its use within the domestic sphere. Indeed, writers on the art reminded photographers that their wares functioned as personal publicity long after they were sold. H. Baden Pritchard, who had reported widely on the practices of European photographic studios, urged operators to publish pictures here and there, for "every shopkeeper who sells your pictures, and every purchaser who buys it for his album, advertises your studio."[25] An album could thus be seen not only as a destination for photographic purchases but also as an ongoing advertisement for the operators represented within it. Moreover, the photograph album had a real impact on related industries such as bookbinding, in which technology introduced specifically for album manufacture was appropriated for the advancement of the field as a whole.[26]

At the same time that the album bolstered the photographic industry and furthered sales of cartes de visite, the very saturation of the market with images threatened to undermine new photographic production. Toward the end of 1866, photographers and photographic manufacturers joined voices in the pages of the *Philadelphia Photographer* to bemoan the flagging sales of cartes de visite. The editors complained that card photographs, which had flooded the market, were the victims of their own success. "Something must be done to create a new and greater demand for photographs," they contended. "Photographers in all directions are complaining that trade is dull. The *carte-de-visite*, once so popular and in so great demand, seems to have grown out of fashion. Every one is surfeited with them. All the albums are full of them, and everybody has exchanged with everybody."[27]

The solution to this problem—and to the related ones of increased competition, reduced prices, and a general "degradation of the art"—was found in a new-sized picture then being adopted in England: the cabinet card. Larger than the carte de visite (its mounting card measured $6^1/_2 \times 4^1/_4$ inches, and the print was slightly smaller), the cabinet card was also more expensive, and it gave "artistic" photographers an opportunity to show off their skills. With masterful coordination, the proponents of the new size marshaled their resources and beseeched photographers to make pictures in the new format and display them prominently. They recommended that whenever photographers made a carte de visite of a noted personage they should also make a

cabinet card, place it in the window, and mark it "the new size!" The method was to make the picture ubiquitous, thus forcing the fashion: "Nothing so readily produces an insensible conviction of the truth of any statement, as hearing it constantly reiterated. Nothing will so effectually convince the public of the beauty and importance of the new size, as seeing it everywhere: in specimen cases; in reception-rooms; in publishers' windows. This will create the fashion, and convince the public that the fashion exists."[28]

Most important to this drive to create a new format and thus jump-start the industry was the coordination of the emerging cabinet card with the well-established album. It was crucial that photographers and producers of albums act in concert to maintain a uniform size so that albums could accommodate the cards on an international scale: with no proper place to put their photographs, consumers might simply buy fewer pictures. Later experiments with card formats such as the Victoria, Imperial, and Promenade cards would bear this out; they never caught on in quite the way the carte de visite and cabinet card did, and they are rarely found in albums. When the Victoria Card (a format larger and more elegant than the carte, but smaller and less expensive than the cabinet) was introduced in 1871, some critics complained that it was incompatible with existing albums: "It is useless for framing; it does not fit the old albums," wrote one commentator that year. "Our experience with the cabinet, or imperial card, shows us that the *oi polloi* will not buy their albums over again." (The Anthonys nevertheless did make albums to suit the Victoria Card, for, as they put it, the "interest of the manufacturer is identical with that of the photographer in inducing or pushing the demand for new articles."[29]) With the cabinet card, manufacturers had the foresight to realize that albums would have to conform to both the carte de visite and the new size. "Any diversity in the size would at once dampen the ardor of the public," warned the editors of the *Philadelphia Photographer*. "If, in making a collection, it is found that sizes vary, and will not fit the album, the general impulse given would be materially checked. Hence the importance of photographers acting with unanimity."[30] On the contrary, with empty pages begging to be filled with pictures, new albums would instigate a demand for the new size. The proponents of the cabinet card were already at work, persuading the leading manufacturers to make new, elegant albums to suit the larger format, just as they were urging photographers to join the endeavor. In their editorial in the *Philadelphia Photographer* they noted that the Anthonys had already begun to produce cabinet card albums, as had the Philadelphia manufacturer William Flint, both firms thus assuring themselves first crack at the new class of consumers (fig. 18). The plan

THE CABINET

PHOTOGRAPH ALBUM.

I would respectfully call the attention of the Trade and the public in general, to this beautiful ALBUM, a receptacle for the New Cabinet Photograph, which must have precedence over all others for beauty of size and perfection.

These ALBUMS are made of the finest material, and bound in the best workmanlike manner.

Size, 6 x 8¼. Opening, 4 x 5½.

Send for a sample copy. All Photographers must have a sample of this ALBUM to introduce the New Size Picture.

Liberal discount made to the Trade.

WILLIAM FLINT, Manufacturer,
807 Market Street,
PHILADELPHIA.

Fig. 18. William Flint cabinet album advertisement, *Photographic Mosaics*, 1867.

was ultimately successful; the cabinet card existed alongside the carte de visite throughout the 1870s (many albums included slots for both formats), and then overtook the smaller size until its eventual replacement by the snapshot at about the turn of the century.

More than anything else, this strategy clearly demonstrates the common understanding of an obvious business equation: empty album pages added up to increased sales of photographs. Photographers and suppliers had learned that the album had provoked brisk carte sales, and they knew that it could still be a means of commercial expansion for the trade. The con-

verse of this equation was that without an international standard, the industry could become a photographic Tower of Babel, with no possible basis for the exchange and collection of photographs. As the editors stressed, "Much depends on making it uniform the world around, so that wherever they are sent they will fit the same Album."[31] Standardized and thoroughly mass produced, photograph albums were virtually interchangeable but for their contents (although even those, as we have seen, were almost indistinguishable). They were patented, fought over by competing manufacturers, and turned out in factories like numerous other products of technology and commerce. Designed primarily for the purposes of photographic consumption, albums played a critical part in the expansion of the industry, and their origins can be seen as almost entirely commercial in nature.

Marketing Memories; or, How to Sell a Photograph Album

The glut of photograph albums thrown onto the market was actually good for both consumers and producers. For customers it meant a large variety of styles from which to choose, as well as increasingly lower prices owing to competition. For manufacturers, at least initially, the massive production of albums indicated (just as it ensured) that American families were becoming accustomed to this new way of collecting portraits, memories, and histories. At the same time that they extolled the virtues of their own special wares or particular models of albums—each one, according to advertisements, unique, elegant, and a bargain—manufacturers needed to sell the American public on the *institution* of the family album itself. This term, often seen in the contemporary literature, is meant here to signify something more than simply an object—an object that carries with it established practices of recording, looking, and display.[32] The album can be understood as an institution by virtue of its permanence and omnipresence, and by the way it supplanted all other forms of picturing and recording the family. In order for it to aid the expansion of the industry, the album had to become a household fixture for families nationwide. The concerted efforts on the part of producers and the photographic press to make the album a domestic necessity would both reflect and shape how families responded to and employed albums. The photographic press marketed the album in general by appealing to some very basic—and emotional—themes: the definitions and importance of family, sentiment and loss, fashion and assimilation, and even nationhood and patriotism. At stake here was not only the growth of the photographic industry but also the definition and visual representation of family and home

at a moment when they were changing in response to the Civil War and Reconstruction, westward migration and immigration, and the incipient signs of modernity.

Family albums, in the commercial discourse that surrounded them, seemed to define family itself. The *American Journal of Photography* called the arrival and wide public display of photograph albums a "sign and proof of the best feature in our civilization," claiming that "it tells of the universality and strength of the domestic affections."[33] The new invention, an overnight commercial success, was also framed as a lasting development, one integral to the fabric of the family and of the nation. Notwithstanding the cozy relationship among photographers, supply houses, and the photographic press, it is still striking to note this early enthusiasm and faith in the album's importance to domestic ties. The photograph album had become, at least in the eyes of its most devoted proponents, a "household necessity," central to both the life and the definition of the family. "Each drawing room table has its well-stocked album, which is fast becoming its family historical gallery, and every cottage fireside is made brighter by its embellishment of sun pictures," wrote Jabez Hughes later in the album craze.[34] Whether simple description or a projection of a desired state of affairs, such statements served to characterize the album as a fundamental part of the middle-class parlor. In the preface to his new cabinet card album in 1866, one of the first designed to accommodate the fashionable larger picture, William Flint of Philadelphia made this point even clearer: "The size is admirable, and the receptacle here offered is that which no family could be complete without."[35] Advertising both the idea of the photograph album and his own special wares, Flint implied that the American family's completeness was predicated on the presence of a family album, but even more than that, it was based on a new, bigger, and better album.

Although photograph albums were available for a wide range of prices, their very affordability meant that they were a minimum requirement of bourgeois family gentility. As albums became cheaper and available to ever more purchasers, not owning one effectively ruled one out of both the respectable middle class and the category of family itself. By 1864, *Godey's* could write that "*photograph albums* have become not only a luxury for the rich, but a necessity for the people. The American family would be poor indeed who could not afford a photograph album."[36] This sentiment was echoed throughout the photographic and even the popular press, as the album was marketed as a defining feature of the American household. "Amongst the objects which ornament nowadays not only the parlor or drawing-room table of the rich, but also the humbler home of the mechanic or workman, the photographic

album will certainly not be wanting," pronounced the *Photographic World* in 1872, after the album had taken tenacious hold in the parlor. "If there is a superfluous possession which has become a necessity it certainly must be this one."[37] In its transition from luxury to necessity, the family album became a symbol of middle-class life. Whether the journals were reporting on the reality of the situation or inflating it with hopeful cultural assessments (thus helping to create that reality), the message was the same: owning a photograph album was a requirement for attaining, in the public eye, the status of a proper family.

Pitches for albums in photographic journals (largely to operators) and popular magazines (largely to consumers) played upon the family heartstrings to great effect. By stoking anxieties about familial or national disruptions, they presented the photograph album as the glue that would keep people together. One tactic was to exploit the sentiments of nostalgia and loss, especially involving the Civil War or children. Photographers and album manufacturers employed the same strategies of safeguarding against the dual threats of death and distance—the "preserve the shadow, ere the substance fade" argument—that they had with the carte de visite (and with the daguerreotype before it). With photograph albums, the *American Journal of Photography* declared, "we will always have the power of recalling the features of those that are dear to us wherever they may be; and those who have gone to the spirit land—we will keep their memory green."[38] The card album was to be the receptacle for family memories and histories, an index to the faces and features of loved ones; it was also to be an object of permanence and constancy to shield against the family's dispersal. An article in *Anthony's Photographic Bulletin* extolled the importance of the photograph album to someone who finds himself without loved ones nearby, as if the collection of pictures could substitute for the people themselves. "A good album, well filled, is a valuable addition to one's personal goods and chattels, and no one knows this better than the emigrant or wanderer. In the midst of friends and acquaintances we may hold our family album very cheap, but should a time come when we have to change our place of abode, or, sadder still, when, as we advance in years, our friends depart from us one by one, then we often love, if somewhat regretfully, to turn to the familiar faces, and, pondering over their features, we try to console ourselves for the times that have gone. It is times like this that we appreciate most of all the photographic album."[39] Sentimental tales and appeals to nostalgia were the norm in the rhetoric surrounding photograph albums; more than just advertising an empty book to be filled with pictures, photography's commercial apparatus marketed memories. In

the midst of threats to the stability of the American family through urban-
ization, war, and westward migration, the album was seen to preserve the
domestic unit, and keep it whole. A product of modern technology, it could
also combat the dangers that modernity was imposing on families and sym-
bolize continuity in an increasingly ruptured world.

Some manufacturers even appealed to their customers' patriotism to
advance sales, invoking national unity and a common enemy in the shaky
period of Reconstruction. William Flint's 1866 cabinet card album, for
example, opened with a short preface aimed directly at the owner. In it, Flint
played upon the purchaser's national allegiances, arguing that by buying the
album—and thus, by implication, the pictures to fill it—the reader was sup-
porting American photographers: "The artists of this country have for years
been unappreciated," he wrote, "and their skill being second to none in the
world, they need encouragement, and by giving them the support they justly
merit in this small specimen, there is no doubt, that ere long America will far
surpass the old world."[40] This unabashed appeal to patriotic sentiment just
after the end of the Civil War is notable. What is perhaps even more remark-
able, however, is the belief that something as personal and small-scale as
having one's family photographed and displayed in the parlor would support
not only an entire industry, but an entire nation.

A glance at the tactics of door-to-door salesmen gives particular insight
into the strategies employed to market photograph albums (see an example
of a broadside advertising for agents to sell albums by subscription, fig. 19).
One circular instructed agents in the field on how to sell albums, providing
a series of sales techniques that included both suggestions and prohibitions.[41]
In this case, agents were taught to peddle a particular album (containing
slots for one hundred pictures, including twelve cabinet size, for $2) and
to demonstrate how its features far surpassed those of any other available.
They were also, however, shown how to use many of the same strategies to
sell families on the idea of albums in general. First, they were to impress
upon potential customers that this was the "greatest bargain ever offered in
the world," of a size and elegance that would normally make it much more
expensive. Agents would point out the beautiful and substantial binding, the
Arabesque morocco leatherette, the gilded pages, and the exclusively copy-
righted cover design to prove their product's superiority over all others, and
to "show all what a striking ornament it will be for their center-table." The
pamphlet urged vendors to practice a comparative approach by displaying
their wares alongside other books or albums the family might already have:
"In houses where they have an album, ask for it; then compare with your

Fig. 19. National Publishing Company broadside for subscription photograph albums, c. 1870. Warshaw Collection of Business Americana—Photography, Archives Center, National Museum of American History, Behring Center, Smithsonian Institution, Washington, D.C.

sample, and see how marked the difference; it is always a hundred chances to one that the album brought out, will be a poor, mean [. . .] affair."

If by some chance the bargain argument or the mere effect of displaying the album alongside older ones did not convince purchasers, agents of this company were instructed to appeal to family pride and community status, and tie the very definitions of home and family to the possession of an album. "Explain that such an album is a real household elegancy, and every family should have one and not longer think of being without one," salesmen were taught. "No American home is complete without a fine photograph album, which is a great attraction to all." Agents were to address the man of the house and show him, in a double-pronged attack, why he could not afford to be without the album: "He should keep up with the world and provide the best of good things for his family." (Although women usually kept the family's photograph album and often had control over discretionary household expenses, the man was still considered the head of the family and, in many cases, the holder of the purse-strings; the pamphlet took both men and women into account as customers.) Such tactics played upon both competitive cosmopolitanism and assumed patriarchal responsibilities to further album sales. By purchasing a photograph album, the seller implied, the buyer not only provided for his family but also allowed his family to participate in a group activity that occupied the rest of the world. Another clever approach was to question a man's community relations by stressing the proper treatment of friends and relatives: "He who does not think enough of his friends to honor their photographs with a place in an elegant album, especially now that one [is offered] so cheaply, is not worthy of good friends." In furnishing suitable housing for loved ones, the album was seen to convey its owner's respect and to help foster networks among extended family and friends. Vendors were also taught to identify the most prominent townspeople and sell to them first, "for the reason that all like to follow the example of influential men." All intelligent and refined people, customers were told, were purchasing such photograph albums: "Never take no for an answer, but go right on pleasantly and quietly, making all understand about the album, and the fact that they surely ought to have it in their homes the same as all other thoughtful, intelligent Americans." (The few thoughtful Americans who did not order one on the spot apparently refrained because of "deep poverty and debt"; in cases where money was a problem, agents were to remind customers that albums took about six weeks to arrive—ample time to set aside the money for payment.) The photograph album, in this view, provided assimilation and group membership—not only to that of the familial structure or

even extended family, but also to that of the local community and a nation-hood of like-minded, intelligent Americans. More than merely a record of a single family's history, the card album was portrayed as an object that united families across the country.

Photograph albums were also heavily marketed as gifts for Christmas and New Year's Day. Manufacturers stepped up their advertising of albums around the holidays, and photographers and stationers' shops promoted them in their windows. Although the photographic press was busy convincing people that the album was a necessity, marketed as gifts they also seemed a luxury, and manufacturers made sure to note their albums' elegant and lavish qualities. Typical was this notice from the Anthony company to its photographer readership, who would in turn display albums in their studios: "Our holiday stock is now ready, comprising an almost innumerable variety of velvet, Turkey morocco, and cheaper grades of binding. Many of them are very elaborately ornamented in richly-carved ivory, pearl, and choice woods; others have costly mosaic enamels, bronzes, or exquisite paintings on porcelain for decoration."[42] After the 1862 holiday season, one journal observed, "The most notable thing in connection with the holydays this year is the great display of photographic albums. Not only in photographic establishments and book stores, but also in news stores, in fancy stores, and in all permissible places are seen large numbers of these most beautiful and acceptable presents."[43] During the holidays, the gift of a photograph album combined the religious overtones of Christmas with the markers of home, linking the reverence of the holy family with the celebration of secular ones. The picture of a grandmother happily leafing through her new collection of family photographs on Christmas, as seen in a frontispiece to an 1863 holiday issue of *Godey's*, perfectly illustrates the sentiments associated with albums and their enjoyment (fig. 20).[44] At the New Year, empty pages could symbolize a fresh start, new friends to be made and recorded, and the beginnings of a new family history. Surviving albums indicate that people responded to the suggestions in magazines and shop windows, as many of them bear holiday inscriptions from the donor.[45]

An 1871 pitch in *Anthony's* reminded photographers to stock up on their holiday merchandise, noting, "An album has always, since its introduction, been a favorite gift. Combining usefulness with elegance, it serves also as an ever-present ornament, and forms a souvenir of souvenirs."[46] An album was appropriate for a gift because it was at once so personal and yet so generic: it spoke of a love of family and friends (and perhaps the hope that the giver would be included in the album), but it also was a gift appropriate for anyone,

Fig. 20. Christmas frontispiece (detail),
Godey's Lady's Book 67 (December 1863).

a universal standard that held the pictures of any family. At the height of the carte craze, it was a present that was sure to be welcomed, even if the recipient already possessed one. A more personal gift might include some cartes de visite along with the album, as an 1861 *Harper's Weekly* article suggested: "Could there be a prettier present than an album filled with a choice selection of photographic cards?"[47] For those who wanted to let the recipient personalize the blank pages, albums were advertised as the ultimate gift book, in which the new owner became the perfect editor and every album became a special edition. Gift books were prepackaged anthologies of sentimental prose, poetry, and illustrations, sold annually around Christmas and New

Year's, commercial productions with enough diversity among editions to suit the tastes of many recipients. When albums were sold alongside the books, they took on the attributes of the literary offerings. "As the 'gift book' season approaches, we observe that photograph albums seem to have lost none of their attractiveness," proclaimed *Godey's* in 1864. "These books may well be ranked among the most interesting gift books, inasmuch as every person who possesses one has a special edition, exactly suited to the owner's taste. With the beautiful cover and vacant leaves in our possession, we forthwith proceed to edit the volume for ourselves, by filling it with 'counterfeit presentments' of the friends whom we love, or of the good and great, the heroes, statesmen, and authors whom we admire."[48] These very generic productions would eventually become individuated by the owner, and the gift of an empty album was a partial step in its transformation from commercial to domestic object.

To be sure, there were many different styles of albums to suit varied tastes and pockets, and manufacturers recognized that even as they stoked the desire for albums in general, they also needed to distinguish their own products from others on the market in order to further sales. By 1870, the Anthony company, a leading manufacturer, could alone claim a list of five hundred different styles, holding up to five hundred pictures, both cartes de visite and cabinet cards.[49] Advertisements pointed to the elegance, durability, covers, designs, bindings, and general tastefulness of specific albums. Technical improvements such as the "Flexible Chain-Back Album," which allowed the album to open widely without cracking, or other innovations, like the stereographic or music-box album, were noted in the trade press. As manufacturers introduced ever cheaper albums alongside the extravagant ones, the competition forced them to differentiate their products from those of their adversaries (see a selection from the late 1880s in fig. 21). This kind of marketing paralleled that of selling the institution of the album without detracting from it; rather, each strategy served a complementary function to move the albums out of the warehouse and into the parlor.

The world of consumption was changing, with mass production on a national and international scale, the proliferation of goods distributed through railroad networks, the rise of department stores, and a new kind of advertising. The shift, in the mid-nineteenth century, from a town-crier method of advertising the sheer availability of goods for a local audience to one of educating the consumer about the features of competing products on a regional and even national scale, marked a distinct change in the relationship between goods and consumers. Advertisements, of course, do not necessarily

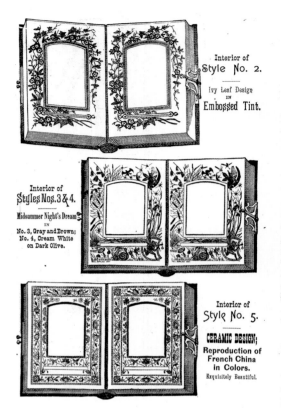

Fig. 21. Scammel & Company album catalogue, c. 1880s. Warshaw Collection of Business Americana—Photography, Archives Center, National Museum of American History, Behring Center, Smithsonian Institution, Washington, D.C.

reflect the way things are; rather, they usually provide a rosy picture of how things ought to be. Those in the photographic trade press are especially suspect in this regard—given the chummy relationship among journals, supply houses, and photographers in this emerging profession—and by the time the carte de visite album arrived on the market, producers had found new ways to address their audience and instruct them about the use and importance of their latest product. But the manufacturers of photograph albums were not peddling sewing machines or hair tonic; instead, by hawking repositories of family history, they were marketing memories. The varied ways of pitching albums positioned potential customers as dutiful family members, loyal friends, and patriotic citizens, and appealed to wartime sentiment and loss in order to make the sale. When albums were portrayed as the defining features of home, family, and middle-class status, commerce infiltrated the home with even more than its usual slipperiness, easily crossing the line

between the storefront and the parlor. The marketing tactics of manufacturers were instrumental in making the photograph album *the* mode of representing the family and the nation in the Civil War and Reconstruction eras. These concerted commercial efforts both reflected and shaped the responses and practices relating to the first family albums.

All the Rage: Consuming Albums

Like any other goods on the market, photograph albums had commercial value before they took on sentimental or social worth. Scholars of material culture have recognized that, in an increasingly commercial society, people construct meaning for themselves through objects. In mid-nineteenth-century America, a person was defined as much by what she owned as by what she produced. In an outline of a material culture framework for understanding consumerism, Ann Smart Martin has described the life of household artifacts that are "quintessential consumer goods": "They represent a negotiation of value and meaning—either actual or market driven—between producer and buyer. The buyer of goods then uses them, invests them with meaning—one or many—and disposes of them. The goods may enter new life as a commodity through the second-hand trade, and, after some years, the museum market."[50] Photograph albums, in this framework, might be considered almost quintessential consumer goods; unfilled albums were acquired much like most other merchandise, and the wide range of prices and ways to purchase albums attests to their increasingly easy and common entry into the household. But carte de visite albums differed significantly from standard items of commerce in that, once filled with pictures, they ceased to circulate. On almost any kind of resale market, an album lovingly filled with images of dressed-up family members would be worth more empty, ready for the buyer to insert his or her own pictures. Still, it is important to understand how the card album's commercial value was initially negotiated: the myriad ways in which albums entered the home from the marketplace, the real and symbolic worth of an album, and how a fashion arose that made them even more valuable commodities.

When they first emerged on the market in the early 1860s, photograph albums seemed to be everywhere. An 1862 commentary in *Godey's Lady's Book* noted that the album fashion in New York had reached national proportions: "At Appleton's crowded counters, during the holiday season, these graceful volumes, in all their styles of binding and gilding, from expensive Turkey antique, with gilded clasp, to simple cloth, with its spray of 'forget-me-nots'

on the cover, were the chief centre of attraction; and, in the midst of home demands, a succession of telegraphic orders were flashed from San Francisco—a duplicate, then a triplicate, until the amount reached nearly $1000. This shows the unprecedented popularity of this new phase of the Heliographic art, which has surprised even the fortunate suggestor of the plan."[51] Albums could be readily purchased at stationers' shops like Appleton's, photographic supply houses such as that of E. & H. T. Anthony, and at photographic studios. Sales agents, as described above, would travel door-to-door in more remote areas, showing their wares to families far removed from the fashions and bustle of Boston, New York, or Philadelphia. Magazines offered albums as premiums for subscriptions, and some companies, soliciting agents to peddle their art prints and other goods, dangled albums as rewards for outstanding salesmanship. Mail-order catalogues, first from photographic specialists and later from general merchandisers, showcased hundreds of styles over which to linger. Combined, these commercial outlets made carte de visite and cabinet card albums accessible to most consumers regardless of their location.[52]

The range of prices at which albums were available also suggests a range of purchasers, and there appears to have been a version for nearly every pocketbook. By 1871, prices ran the gamut from 50 cents to $50. At the low end, small morocco pocket-albums held a dozen portraits, while extra fine Turkey morocco assemblies in the English style led the pack, with room for up to five hundred pictures.[53] When Solomon P. Rodgers, the protagonist of "My First Carte de Visite" (see Chapter 1), is cajoled by his wife in early 1863 to purchase a family album, he does the math:

> The holiday advertisements informed me that albums could be had from $5–$40, and photographs "finished in highest style, plain $2–$3 each, and painted $10–$50." Here I thought I had wife, for in economy—domestic economy, she has her forte. She was silent and thoughtful; while I reckoned up with pencil the items—

> | *Album illustrated* . | *$40* |
> | *2 photos ex. painted**$50*. | *$100* |
> | *2 Gilt frames do.* . | *$50* |
> | *Total* . | *$190* |

> I held up the card, and drank my coffee in silence and triumph.[54]

But Rodgers is not to be triumphant for long, for his son Bill (well versed in the prices of skates and candy) pipes up, "Father, you can get an album for $1.50, just as good as the $40, only the hinges and clasp ain't real gold." His niece Nell adds, "Yes, uncle, and you can get cartes de visite for $3.50 a dozen, and fill your albums full of them, and they are just as nice as any we have in Slickerville." Thus the cost of owning and maintaining an album could range from about $5 or, in many cases, less (the album plus an outlay of a dozen pictures to distribute, with pictures in exchange filling up the pages) through the upper reaches of the market—and the pleasures of participating in a costly fashion could be purchased on the cheap.[55]

Like its inspiration, the carte de visite, the photograph album soon became the rage. As part of her attempts to persuade her husband to acquire an album, Mrs. Rodgers employs the arguments of peer pressure and fashion, wearing down the paterfamilias: "'Husband, all our neighbors are having their photographs taken and purchasing albums for holidays; why not we, too? I'm sure you would look as well as Colonel Jones.' 'Nonsense,' said I, 'we are too old-fashioned people for these modern gimcracks; we have had our day. The Colonel is always running after new sensations.' 'But,' said my wife, 'albums are all the rage—everybody has them. It's the fashion, and we must follow fashion, you know.'"[56] Paradoxically, the fact that "everybody" partook of the fad ultimately ensured the longevity of albums; it was their initial role as objects of an international craze that led to their permanent place in American households. Women's magazines like *Godey's Lady's Book* (whose editor, Sarah Josepha Hale, was the acknowledged arbiter of American feminine tastes) advised readers in 1864: "As it is an art that all can enjoy, and the pleasure seems innocent and perhaps improving, we say to the friends who ask our counsel, follow this fashion."[57] Professional journals urged photographers to ready themselves for an increased demand for albums. "This fashion is reasonable; and there is little doubt that it will become a permanent institution," counseled the *American Journal of Photography* in 1861. "We therefore advise our readers to be prepared for it, with suitable instruments and the albums."[58]

The carte de visite album was new, modern, and extremely stylish in northern urban centers, and the fashion was imitated elsewhere in the country. Fashion plates in the most prominent magazines portrayed women in the latest finery, sometimes holding albums as stylish accessories. An 1863 fashion plate from *Harper's Monthly*, for example, shows a woman seated in elegant dress with an open album on her lap, looking dreamily off into the distance (fig. 22). This sketch follows in the portrait tradition of representing

FIGURE 2.—HOME TOILET.

Fig. 22. "Home Toilet,"
Harper's New Monthly Magazine 26, no. 156 (May 1863): 864.

women absorbed in a book, usually to symbolize education or religious refinement (although many cartes de visite featured the self-referential pose of women gazing into photograph albums). Another, an advertisement of children's fashions from *Godey's* competitor *Peterson's Magazine*, depicts a mother standing next to her son and daughter with an album in her left hand and a carte de visite in her outstretched right hand; the son appears to have an album as well, but it might also be a Bible or other book (fig. 23). Women were intended to copy these styles, which were pronouncements on the latest European fashions, by sewing dresses themselves or by hiring a seamstress. Poorer Americans emulated the fashionable upper classes by employing cheaper fabrics or remodeling old garments according to new pat-

INSERTIONS AND EDGINGS.

CHILDREN'S FASHIONS FOR NOVEMBER.

Fig. 23. "Children's Fashions for November,"
Peterson's Magazine 42, no. 5 (November 1862): n.p.

terns, using economical measures to appear stylishly attired; even the most up-to-date ladies personalized the latest styles by choosing their own trimmings and fabrics.[59] These mass-produced fashion plates, blanketing women's magazines and setting a national standard of taste, were thus altered in practice to conform to varying preferences and pocketbooks: women personalized the basic model but followed fashion scrupulously nonetheless. By the turn of the century, philosopher Georg Simmel was able to articulate the contradictory tendencies of fashion as hovering somewhere between imitation and social adaptation, on the one hand, and dissimilarity and contrast on the other. "Thus fashion," he wrote, "represents no thing more than one of the many forms of life by the aid of which we seek to combine in uniform

spheres of activity the tendency towards social equalization with the desire for individual differentiation and change."[60] When photograph albums came to stand for cosmopolitan style, the trend filtered down as something to be imitated and also made one's own. Just as American women clipped fashion plates with styles direct from Paris out of the pages of *Godey's Lady's Book* and copied them with varying degrees of faithfulness to the original, so they also purchased albums fresh from the factory and filled them with personal portrait galleries, each different from the rest but conforming to the general fashion of album-keeping.

Evidence of the craze suggests that albums were an amusement enjoyed primarily by young women, who were highly susceptible to the vagaries of fashion. A tongue-in-cheek 1862 article in *Vanity Fair* commented on the very unladylike behavior of a few southern women who made faces at Union soldiers, turned their backs on them, and urged their children to spit at them. The author recommended a series of punishments for such insolence, depending on the age of the offender and the nature of her crime. If convicted of "Vituperation in the 1st degree," a lady aged sixteen to twenty was "to wear large-figured calico for six months, and to be deprived of her Photograph Album."[61] (The author acknowledged that some of the penalties might be severe, but "enforced, they would, without a doubt, put an end to the aggressions to which the Union troops are now everywhere subject.") The dual threat of unfashionable attire and loss of a photograph album seems enough, to this northern commentator, to ensure or coerce proper behavior; depriving a young lady of her photograph album would be tantamount to denying her access to her social circle.

The *American Journal of Photography* noted in the same year that an "elegantly bound album, containing some thirty or forty so-called 'likenesses,' has become one of the indispensable ornaments of every lady's table," but complained that the owners of the books were continually pressing acquaintances to sit for their portrait to add to those of "other victims" within the album's pages.[62] The voracious quest of certain young ladies to fill albums grew to comedic proportions as the fashion reached its apex. A satirical 1862 essay in *Vanity Fair* titled "Lady Beggars" described the plight of the women searching for pictures—and the men forced to supply them:

> Give a woman a photographic album and she will know no peace, nor give her friends any, until every page is filled with a *carte de visite*. Now, when we consider that all ladies have from one to five albums, and that each album has a capacity for from twenty to

one hundred card pictures, and that the proportion of ladies in this geographical section stands, according to careful computation, three and one-fifth ladies to one gentleman, we arrive at the cheerful fact that the girl gender is actively engaged in dunning the other gender for several million heads. . . . It matters not whether the damsels have known a man five minutes or five years, it is enough for them that they know him, and that he carries a head. . . . Of course where so much pains is taken, considerable success is achieved, and it is not uncommon to see Miss Clotilda or Miss Carrie in possession of five hundred photographs. We happen to know a young female who can show thirty eight John Smiths, twenty six John Browns, twenty John Greens, seventeen John Whites, forty or fifty miscellaneous names, and two hundred and ten portraits of persons whose names have escaped her memory. She is still gathering, and now, with praiseworthy precaution, writes the title of each individual represented. Where the mania will stop is hard to say.[63]

The article went on to propose legislation protecting male citizens from the "fair mendicants," but barring that, insisted that the paupers be forced to wear a tin sign over their chest proclaiming, "Please Assist a Poor Photograph Beggar." Although expressing genuine anxieties over the lack of marriageable men at a moment when many would have been joining up at the front, this tongue-in-cheek description portrays them as mere collectibles in a feminine market of exchange.

What began as a stylish trend would become an enduring presence in homes throughout the country. The emergence of the album as a national novelty for faddish young women paralleled its growth as a permanent form of familial recordkeeping, even if the album's role as keeper of the family flame would seem to exist in direct opposition to the whims of girlish fashion. Marketers recognized this contradiction and so pitched the album as both the latest thing and a lasting thing, a marker of both current femininity and domestic obligation. Like any other object subject to fashion's ebbs and flows, a photograph album quickly and easily became a status symbol, an indicator of its owner's cosmopolitanism. But albums did not increase their owner's status by means of rarity, provenance, or even cost, as might be the case with a sought-after dressmaker, a new pattern from Paris, or an expensive silk fabric. It didn't matter (or at least not much) whether the owner purchased an album from a stationery store, photograph gallery, magazine,

or mail-order catalogue, whether she paid 50 cents or $50. What gave an album (and its keeper) distinction occurred on a different marketplace, the social one of carte exchange. As these commercial goods gained meaning in the home, sentimental and social value supplanted market value. Yet even the practice of maintaining and displaying albums in the domestic sphere was not immune to the interventions of commerce. Album manufacturers and various critics cared a great deal about what happened after women purchased albums, filled them, and brought them into the parlor.

How to Keep a Photograph Album

Nod Patterson, whose plea to "Miss Domestic" and example of "Miss Enterprise" began this chapter, was not alone in telling women across the United States how to maintain and display a family photograph album properly. By 1872, when Patterson published his hints, the photograph album had become a fixture in the home, surrounded by its own, entrenched practices for more than a decade. Articles and advice on this new domestic object—its symbolism and worth, its proper place and contents—spilled into the pages of the popular and photographic press. As national figures such as Abraham Lincoln rubbed shoulders with family members in these cardboard pages, and publishers likened the purchase of an album to patriotic support of the country's photographers, the act of buying, keeping, and displaying an album took on implications beyond the individual family unit. The conventions of filling and exhibiting photograph albums were tied up both with definitions of family and with the workings of commerce. It is not surprising, then, that the same tactics used to sell albums would be employed in advice on how to keep them.

The purchase of an album would readily translate into buying photographs, and the owner of an album, having made that first step, was entreated to fill it up. Although those who maintained albums were usually women or adolescents, the industry occasionally appealed to a father in his role as head of the family. An 1865 article in *Humphrey's Journal* noted that in a family in which a child has died, there remains an "eternal infant." But, it went on, with photography, one could have an eternal infant "without the intrusion of death." The article urged men to have their families photographed often to chart the faces and figures of childhood: "By having his family photographed once a year, Paterfamilias may, for a trifle, preserve all the looks they ever wore—Jack's progress from the juvenile pinafore to the shooting coat and the turned-down collar of manhood—Miss Mary's growth through

all its charming stages."[64] The article envisions the potential future of a family album, predicting children's maturation into bourgeois adults of proper appearance and status. The carte de visite's cheapness and reproducibility would come to benefit the family and the photographic industry equally, as annual portrait-taking became more encouraged and eventually more common.

Once the album was filled with pictures of dear friends, family, and eminent figures of the day, it was a collection to be preserved and protected. One editorial (reprinted in *Anthony's* from the *London Photographic News*) titled "Keep Your Albums Locked" exhorted owners of albums to save their contents from the grubby hands of domestic servants who might page through the pictures, and from the nimble fingers of carte thieves who could abscond with a treasured portrait. The photograph album, in this case, represented more than a collection of prized likenesses; it was also a display piece to be handled gently. The article provides a glimpse at the care that might have been taken in assembling such an album: "You yourself have been very careful with that album, for it contains selections, from previous books, of your best friends, probably, and your best photographs. You leave it on the table, as it is a handsome book, and a present from a friend, but you never let the children have it without you are by to see it is properly taken care of. And yet, as we have said, with all your precautions the leaves become soiled, and the portraits thumbed and marked."[65] This album, unlike the singular family collection many households possessed, has been selected and assembled from the prize pictures of previous albums; this article at once identifies the album as something precious and suggests a different kind of consumption and display that would entail the purchase of more photographs and more albums. With its explicit instructions to keep the album safe under lock and key—and away from the domestic servants—this editorial expands the purview of a photographic journal beyond trade secrets and professional tips and into the intimate recesses of the home.

One of the most striking prescriptions on how to fill a photograph album can be found not in the press, but inside the pages of an album itself. Published in several editions by a Dr. A. H. Platt in 1864 and revised in 1865, this genealogical album came with slots for cartes de visite, ample room for physical and personal data, and explicit instructions for its use (fig. 24). (The citations and discussion below are from the 1865 version, currently at George Eastman House.) Its title, as written on the opening page, reveals the full scope of Platt's project:

REGISTER OF
WIFE.

Name
Birth-place
Nativity (date)
Descent
Father
Mother
No. Bro's and Sis's
Education
Occupation
Politics
Religion
Marriage

AUTOGRAPH.

Stature
Weight
Habit
Complexion
Color of Hair
Color of Eyes
Health
Time of Death
Disease
Place of Death
Age
Interred

REGISTER OF
SECOND CHILD.

Name
Birth-place
Nativity (date)
Descent
Father
Mother
No. Bro's and Sis's
Education
Occupation
Politics
Religion
Marriage

AUTOGRAPH.

Stature
Weight
Habit
Complexion
Color of Hair
Color of Eyes
Health
Time of Death
Disease
Place of Death
Age
Interred

Fig. 24. *The Photograph Family Record*, 1865 (pages for "Wife" and "Second Child"). George Eastman House, International Museum of Photography and Film, Rochester, New York.

7

The Photograph Family Record,

OF

HUSBAND, WIFE, AND CHILDREN;

ADAPTED TO

RECORDING IN A PLAIN, BRIEF AND INTELLIGENT MANNER,

The Name, Birth-place, Date of Nativity, Descent, Names of
Parents, Number of Brothers and Sisters, Education, Occupation,
Politics, Religion, Marriage, Stature, Weight, Habit,
Complexion, Color of Eyes and Hair, Health, Time and Place
of Death, Disease, Age and
Place of Interment of Each Member of Any Family,
With Album Leaves for the Insertion of Photographs of the Same.

The album has separate pages for the father, mother, and up to eleven children. On the right side of each page-spread is room for two cartes, presumably to record loved ones' appearances at different stages in life. On the left is the designation of the family member ("Register of Wife," "Register of Second Child," etc.); space for his or her authenticating autograph; and lines for the various characteristics (cited above) to be filled in.[66]

In the wake of the Civil War (we learn from the extended preface to the album), Dr. Platt worried that the widows and orphans of those who gave their lives in battle would be unable to prove their relationship to the deceased, and so lose the lands and pensions due them by the government. He viewed this photograph album as part family history and part legal document, arguing that a "family record, such as this is intended to be, would set the matter forever at rest." In order to accomplish this goal, the album had to function as a certificate of authenticity, with the text and images corroborating one another. A concern with proof and legitimacy pervades the text of the album, not only in the exquisite specificity of the physical details, but also in Platt's instructions to the album-keeper. For example, he urged the head of the family to date the photographs and provide the age of the person at the time the picture was taken, and was equally cautious regarding the matter of the family member's signature: "When, by reason of death or absence the autograph of an individual cannot be personally affixed to the register," he advised, "it may be obtained from a letter or other document, and neatly pasted on the leaf, in the place assigned to it." The authenticity of the signature mattered more than the means by which it was obtained or its actual inscription in the album. Furthermore, Platt advised users to insert two marriage certificates into the album. Although not found in the extant

albums, these would have included one for the magistrate uniting the parties, and another for the married couple to preserve. Thus, the album takes on the function of legal witness as much as family remembrance, its autographs and photographs securing present property and past lineage.

Besides playing on fears of losing land and patrimony, this album also invokes loss and absence, calling to mind sentimental memories of deceased friends and family. The foreword to the album opens with these arresting lines: "Few things in life are so dearly and universally cherished, as the fond recollection of departed friends. Gifts and keepsakes, of comparatively trivial value while we enjoy the society of the donors, are treasured like jewels, when death or distance deprives us of their company." Placed carefully in the slotted pages, photographs would recall the features of dear ones, returning them to life for the viewer. (Or at least, that would be one of the functions of an album in general; this album was particularized to the family, and the "departed friends" Platt mentioned would have had to reside elsewhere.) At the end of the book, blank pages are supplied for recording memories, with two different purposes in mind. They could, Platt wrote in an undisguised appeal to maternal emotion, serve the memory of a mother who had lost a child in infancy and wanted to record the events of the baby's brief life. Alternatively, the pages might hold a record of military service, thus linking a family history (and, in many cases, a family death) with a national event. The album plays upon personal and national anxieties: again and again, the album's owner is reminded of loss, and the album—even as it perpetuates that loss—is set forth as its antidote.

Perhaps of even greater importance than the legal potential or memorial function of the album was its ability to reconstruct families' genealogies, to serve at once as a monument to the past and a legacy for the future. Platt sensed a deficiency throughout the families of the country, one in which heritages and histories stood to perish entirely; with this book he intended to provide a useful system for the many families who desired to record their past. What individual would not rejoice, he argued, to obtain an accurate genealogical history of his father's family, and that of his father before him? The problem was that, up until then, there had simply never been a proper vehicle for its recording: "There is now no work especially adapted to recording either the leading physical peculiarities of the individual, or the simplest events in the history of the family; and with the single exception of occasionally a meagre memorandum in a family bible, there is nothing that can claim to be a substitute for it, and rarely do we find a family that possesses any correct information as to its own private history or genealogical descent. . . . We

can account for the fact in no other way than that there has been no convenient means for collecting and preserving such information." There is little of the traditional genealogy here: no heraldry, no mention of titled origin or Old World connection, no *Mayflower* ancestor. What Platt was interested in—and what he believed everyday Americans to be interested in as well—was a limited record of at least a few generations back, a record that supplied some details about what these relations were like. In this kind of genealogy, physical peculiarities take center stage; at a moment when outward appearance was linked so closely with inner character, it was important to learn not only the deeds and social standing of one's ancestors (a textual or oral history), but also the way they looked. The photograph was uniquely capable of providing this information, and was the most appropriate vehicle—in its affordability and availability—to furnish a large number of families with the kind of genealogy all families, not just the most prestigious, possessed. *The Photograph Family Record* represents a break with previous notions of lineage and descent, allowing even the most humble of households to obtain and maintain a past.

Having established the preservation of personal histories as a desirable thing, and having played upon the sentimental memories of deceased friends and family and the very real fear of losing lands and patrimony, Dr. Platt suggested a few reasons why the reader should purchase more than one of these albums. First, genealogies of other branches of the family could be obtained by sending additional copies of the album to relatives all over the world, to be filled up and returned. (Presumably every family would do this, sparking a proliferation of albums, some circulating, some remaining at home.) Furthermore, not only the head of each family, but each child therein, could have his own record of the whole web of relations, which could be handed down to future generations. Information that would otherwise be forever lost could now be preserved, Platt maintained, and the "general collection of such knowledge, by a whole nation, like the American people, will aid materially in the important study of Hereditary Descent." This album, then, had scientific as well as social merit. Finally, *The Photograph Family Record* was available in different styles, "to suit the varied tastes of the multitude," and was to be available only by traveling agents, not in bookstores. Platt closed his passionate treatise on the recording of genealogy with his own personal plug that called for business-minded people to sell the album exclusively by subscription throughout every county of the United States. The modern reader senses Platt's anxiety about a disappearing past but cannot help but note that this is put to the service of increased sales.

Once purchased (for whatever reason), the album dictated its own assembly. The owner was urged to date the photographs (either on the back of the picture or below, if it was placed permanently in the book); sign the appropriate space for autographs; and fill in the blank pages with prescribed remembrances. On the subject of second or third marriages, Platt was understanding but adamant, stating that each album recognized only one husband and one wife and their offspring; each additional marriage would require a separate family record (again, perhaps conveniently, requiring an additional purchase). The wife was even told how exactly to write her name so that her maiden name would always be clear to future readers seeking genealogical facts. Although the album itself has less to say about the use and display of the accompanying photographs, on the written text it states its rules clearly: "The writing should be legible and the wording specific."

Platt in effect proposed two definitions of family—one legal, which related to inheritance of property, and the other scientific, which related to inherited characteristics. At stake in these elaborate instructions was more than producing an authentic document for a court of law, more even than recalling the features of departed loved ones. Platt envisioned the collection of this material as a national project—an infinite number of private genealogies adding up to a nation's history, a permanent record of a country's past. In its circulation and repetition through children and extended family, the album expanded its scope beyond the private household; each individual family, in filling in the record, acted as a link in this chain. Furthermore, these genealogies were maintained through an archival technology only now accessible to more than just the higher levels of society. "It is obvious, therefore," Platt wrote, "that before an accurate lineal record can become general among us, some appropriate work, especially adapted to the purpose, must be placed within the reach of all classes." This appropriate work, now made possible through affordable photography, could be purchased by nearly all families, thus allowing a much wider target audience than could have been reached previously.[67] Platt's album, and others like it, helped create a desire for a visual past on the part of those who had no genealogical heritage in the traditional sense. It was these commercial products of a new technology—the unprecedented availability of proper vehicles for recording the facts and features of generations—that allowed such a desire to flourish. With his careful instructions on how to use and maintain *The Photograph Family Record*, Platt hoped to ensure that the recording of a national past and widespread sales would go hand in hand.

Given the specificity of the album's instructions, and the imminent danger of losing both past and patrimony, it is all the more surprising that the family who owned this album chose to disregard Platt's directions entirely.[68] Not one of the pages is filled in with accurate measurements of height and weight, details of complexion and build, or facts of education and political leanings. The page for the wife's record has been claimed by cartes representing specimens of both genders, and that of the second child has suffered a similar fate, showing a bearded young man and a woman with careful curls on her forehead. It seems as if the family who owned this album simply found in it a convenient and readily available home for their photographs, and probably placed them in the book as they were acquired, proceeding with their own way of keeping a family record.

It is unclear to what extent some album owners ignored the structures imposed by the commercial apparatus of photography and the dictates of the photographic and popular press. Surviving family albums such as these, however, reveal that not all advice translated into convention. The suggestions on the part of Dr. Platt, Nod Patterson, and others who wanted to shape the practices of album-keeping shed light not on the actual conventions of their maintenance and display in the home but on what was at stake beyond the confines of the parlor: the survival and expansion of the photographic industry and the preservation of a genealogical and national past. Indeed, the instructions regarding control of pieces of this vast archive—detailing who was allowed to view and keep photographs, as seen in the injunction to keep one's prized album locked and out of the hands of servants and pilferers—represent an intrusive step into what was formerly the domain of the private and domestic. When owners of albums ignored the instructions or published requests it was not necessarily a snub or act of resistance against the impositions of commerce; rather, such disregard revealed the limitations of the market in shaping behavior.

Album manufacturers and the press proffered ideals of the nineteenth-century photograph album while the collecting and display practices of consumers often revealed different realities. Album producers, suppliers, and even the press projected models of family that were predicated on the presence of a family album. Behind every set of prescriptions on how to keep a personal album, every intervention into the private parlor, was a series of more public issues that ranged from supporting an industry to defining the family to recording a nation's past. Nod Patterson chose Miss Enterprise as his ideal, for it was women like her who encouraged the improvement and expansion of the photographic industry. The cartes of national notables and

landmarks that Miss Enterprise displayed were the kinds of pictures sold by the thousands, infinitely repeatable in albums throughout the country. But it was Miss Domestic whose album would withstand the test of time; compilations like hers, pictures of purely personal value reproduced on the scale of a dozen, would become the family album norm. The world of enterprise shaped the rise and proliferation of photograph albums, but their meaning was produced within the realm of the domestic.

ALBUMS IN THE PARLOR

Yes, this is my album,
But learn ere you look:
That all are expected
To add to my book.

You are welcome to quiz it
The penalty is,
That you add your own portrait
For others to quiz.

—PRINTED ON A CARTE DE VISITE

These charming verses, which opened many a portrait collection, chart the social course for those who might view a photograph album, or donate their own images to fill it (fig. 25). In the poem, the visitor to the parlor finds a key requirement of the etiquette and conventions of album-viewing: namely, that every new viewer will have to relinquish his or her carte to add to the pile. In this fashion visitors added to an accumulation of pictures that seemed to grow with every showing, and the observer in turn became the observed. This ritual was one of community and inclusion, as the viewer gained entrance into the social world pictured within an album's pages both by leafing through it and by reciprocating and becoming a participant. Collecting cartes and maintaining an album thus became collective activities that formed and fostered bonds of identification and belonging. As the circles expanded, what we might now think of as an album strictly for family actually encompassed a much broader community, often show-casing extended family, friends, local personages, and national celebrities. The extent to which the album form demarcated social boundaries can be seen in a humorous variant of this poem (published in the pages of the British *Punch Magazine* in 1864), satirizing pushy viewers of albums who asked for

portraits and offered their own for inclusion. In contrast to the cheery plea to add one's picture to the group to be quizzed by others, this poem made plain that there was a reason the viewer's carte was not yet part of the collection:

> Yes, here is my Album
> And my Affidavit:
> If you beg for one picture,
> I'm blessed if you'll have it.
> And don't offer your own,
> But just take it for granted,
> That if not in the book,
> It's because you're not wanted.[1]

The album's cover could as easily be slammed shut as opened to outsiders, a pointed reminder that the flip side of this communal coin was social exclusion.

The notion of "penalty" in the carte's poem derives from an earlier era, in which visitors were badgered to enter original verses or drawings into autograph albums and commonplace books. The poem itself is cleverly lifted from a popular request found in albums in the first half of the century, as in an autograph album of 1838–52, which contains these written lines on its opening page:

> Come, look in my Album, there is not a page
> But has something I hope to amuse or engage;
> Say, quiz it and welcome, the penalty is,
> You must leave here a trifle for others to quiz.
> Come, ransack your brains for a page or a line,
> And book it, pray book it, and let it be mine.[2]

There exists an entire genre of complaints about having to fill up the pages of ladies' albums, whose owners besieged visitors for lines of genius. The social pressures involved in this early album ritual seem to have been fierce, in part because the contributor knew that young women would "quiz" verses as evidence of wit, culture, or perhaps certain thinly masked sentiments. With the carte de visite the penalty was more easily answered; many writings attest to the use of portrait albums to fill conversational gaps, and demonstrate that they were a relief compared with their antecedents, which forced inventiveness from the visitor. The change in a single word—from literary

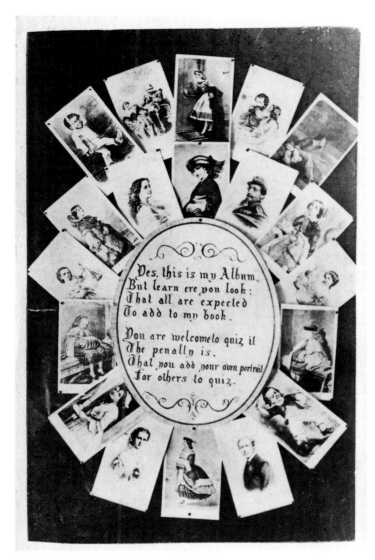

Fig. 25. Mosaic carte de visite, c. 1860s.
Collection of the late Peter Palmquist.

"trifle" to "portrait"—marks a significant shift in the way albums came to be used and understood. In the transition from a textual record to a visual one, photograph albums borrowed forms and practices from their predecessors, adopting (even as they altered) the customs of scrapbooks, literary albums, and Bibles as they took tenacious hold in the parlor.

As the viewer added his or her portrait to the collection it would be examined, or "quizzed," by those who had earlier left pictures as their penalties. What exactly would such an interrogation reveal? These poems imply that

an album would hold answers for the viewer. The critical inspection of a carte de visite is of an entirely different nature, however, than that of a few lines of verse. With character made so seemingly apparent in a photograph, quizzing was a matter of visible proof. Moreover, the conventions of the carte de visite ensured that these tiny pictures looked nearly identical, and the commercial necessity of standardization meant that albums across the nation all resembled one another. So if such a quizzing were to reveal any meaning, that meaning would have to be created in the act of looking, within the domestic space of the parlor. Through personal arrangements, narratives told and implied across pictures, and other means of inserting individuality into an album—that is, through the practices of maintaining and viewing photograph albums—families attempted to differentiate their stories in the face of sameness.

The varied practices of arranging, displaying, and sharing the first photograph albums in the domestic parlor allowed albums to present the self and create a visible past and future. In this chapter I explore the photograph album's origin in Bibles and genealogies; the transition from textual documents to visual ones and how that transformed family records; the conventions of collection and domestic display (including the varying ways women personalized albums); the narratives that albums occasioned and the practices of explaining a personal album collection to a wider community; and the function of albums in creating and recalling both personal memories and national histories. Whereas the mass production of albums and their contents defined sameness, the everyday use of albums in the home allowed the creation of individual meanings. Even as the shared rituals of keeping and looking at carte de visite albums fostered the bonds of community and belonging, the presence of an organizer and a viewer of an album made each experience a personal one. The home and its activities, particularly those of the parlor, became the means of individuation of what was a standard commodity; there, ubiquitous and uniform collections of cartes de visite became cherished family albums.

Visible Genealogies: From the Chronicle to the Carte

Barely a year after the first carte de visite albums began circulating on American soil, the editors of the *American Journal of Photography* noted a clever innovation. Some enterprising Philadelphia Bible publishers had contrived a way to use the carte craze to sell more family Bibles, by devising Bibles with special pages for family photographs: "In the Bible . . . they insert, as usual, blank leaves, suitably headed and divided for notices of births, deaths, and

marriages. Such records in a family Bible constitute good evidence in our courts of law. In addition to these they are introducing the novelty (patent applied for) of placing several cardboards, perforated for the reception of small photographic portraits, to follow the family register, thus accompanying the record with resemblances of the loved ones whose names are entered there. The idea is ingenious, and will, no doubt, meet with favor. The specimen alluded to is a superbly-bound quarto illustrated Bible, in clear pica type, with index, concordance, metrical version of the Psalms, with places, after the register, for the reception of thirty-two *cartes de visite*."[3] This kind of Bible marks a definitive shift in the keeping of family records, from a written chronicle to a visual—and visible—compilation. Bibles had long been a common, if informal, way of marking the family milestones of births, deaths, and marriages; scrawled in the book's opening leaves or in between the Old and New Testaments, inscriptions could serve as a legally valid document. Even relatively humble households might record family events in the pages of the Bible, imitating religious narratives with their own secular chronicle of Abraham begat Isaac, and so forth. A sentimental poem called "My Mother's Bible" spoke for numerous American families when it said, "For many generations past/Here is our family tree."[4] In the middle of the nineteenth century Bible publishers formalized this popular practice by inserting preprinted family record pages with lines for generations of family additions and departures. These editions, often containing lavish illustrations, were marketed as special family Bibles and were intended to be heirlooms as much as religious books.

The notion of adding photographs to these pages, then, was a logical step in the secularization of family records. Commercially, it made sense: many publishers of Bibles moved fluidly into the album trade, and often advertised both sorts of books together (fig. 26). "Photograph Album Family Bibles" merged the two perfectly, and manufacturers were able to employ the sentiments of both religion and family in their appeals to the customer. The American Publishing Company, for example, proclaimed in an 1869 advertisement that its Photograph Album Family Bible "is adapted to family wants—every family should have it—it fills a void long felt in family circles, and we anticipate for it a large and rapid sale."[5] For keepers of these photographic Bibles, including cartes de visite among their pages must have seemed like progress, a convenient and more satisfying way of recording the family. With portraits alongside inscriptions such a book truly became, the advertisement continued, "what it purports to be, a Family Bible."

When photographs began to be included in these compilations, however, an entirely different kind of record ensued. In one such Bible, published in

Fig. 26. Samuel D. Burlock and William W. Harding advertisements for Bibles and albums, in Edward T. Freedley, *Philadelphia and Its Manufactures: A Hand-Book of the Great Manufactories and Representative Mercantile Houses in Philadelphia in 1867* (Philadelphia: E. Young, 1867).

1868 by William W. Harding, carte de visite portraits coexist with inscribed names and life events (fig. 27). The "Deaths" section includes eleven names, most dated retrospectively (all in the same, earlier, hand) from 1817 to 1858, with other entries apparently added as the deaths occurred; alongside these are portraits of the living (a seated man, a standing woman, and a tintyped baby), which fill the next page. In the 1860s, when the carte de visite was still quite new, a pictorial record such as this was emphatically of the present—with eyes toward the future—whereas genealogical inscriptions predating photography could extend as far back in time as a family's memory would allow. The American family Bibles of this period that contain both

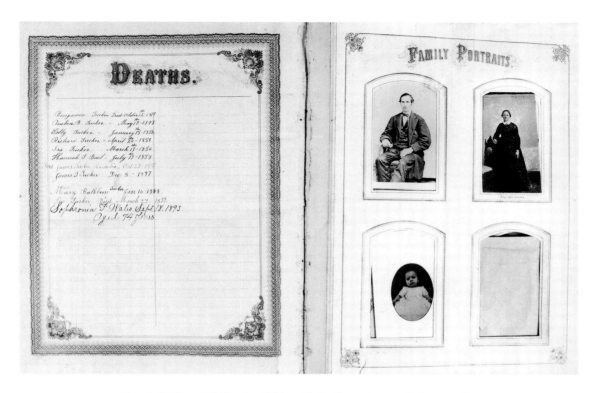

Fig. 27. William W. Harding Bible with family register and photographs, published 1867. American Bible Society Archives.

text and photographs are the ones that most clearly illustrate this extraordinary transition between written genealogies and visual ones. As enterprising publishers began inserting cardboard pages with slots for cartes de visite along with the written family record, the list of family names was transformed into a series of family portraits.

As the nineteenth century wore on, photograph albums gradually replaced Bibles as the repository of family histories. In this transition, however, the family album retained and imitated some of the Bible's functions, drawing on that book's earlier traditions as it made its way onto the parlor's center table and, by extension, into the family's center. A memoir of pioneer days in the 1860s reveals how the family Bible and album together could transform a humble settler's cottage into a home, joining domestic comfort with religious faith: "A corded bed with a patchwork coverlet stood against the west wall; my own trundle-bed was pushed underneath," Albert Jerome Dickson wrote in his journal. "At one side stood the chest of drawers with a braided rug in front. . . . The flour barrel was converted into a 'center-table' whereon reposed the family Bible and photograph album

with their white lace covers."[6] Along with the family Bible, the newer photograph album was the embodiment of family and home, whether placed in a modest cabin or the most elegant parlor. Family albums had, from their beginning, adopted the look and feel of Bibles, with all their heavy weight, elegant leather covers, gilded pages, and brass clasps, which were themselves throwbacks to medieval prayer books. Some albums even invoked scripture explicitly, as on the title page of one 1860s Philadelphia album, which shows an open Bible at the bottom and the command, under nesting doves, to "Love one another" at the top (fig. 28). Adopting the appearance and conventions of the family Bible lent albums cultural authority, religious respectability, and a sense of permanence and preservation. If the scripture told long histories of families—indeed, it could be considered the ultimate genealogy, its readers the children of the first parents, Adam and Eve— then family photograph Bibles and albums echoed that chronicle with the most recent generations.

The remarkable shift of the family chronicle from Bible to album was not lost on contemporary commentators, one of whom referred to the photograph album as "an illustrated book of genealogy" and predicted that it would "supersede the first leaf of the family Bible."[7] As albums made their way into the parlor, they also augmented many of the functions performed by the family Bible, including bringing the family together for the shared viewing of pictures (formerly the communal reading of biblical passages) and carving out heroic figures for moral emulation (the personalities of arts and politics, seen in celebrity cartes de visite, joining the heroes found in scripture). But most importantly, it was now the modern and secular photograph album, and not the Bible, that acted as the institutional memory for a family's past.

Elaborately detailed "Family Registers," on the market at mid-century as paper documents without photographs, provided space for more information than a Bible would reasonably contain, such as physical and health-related characteristics, education and occupation, and religious milestones. Such forms were even circulated as inserts in popular magazines to reach the broadest possible swath of people.[8] The addition of photographs to these registers, as in the Platt genealogical album discussed in the previous chapter, meant that records of families from the 1860s and onward were more comprehensive and specific than anything their ancestors could have imagined. This new household record, in which images and text justified each other, fed a positivistic desire to see and verify—and thus to *know*—the person pictured there. These albums attempted to describe all aspects of a person,

Fig. 28. Album opening page showing Bible. George Eastman House,
International Museum of Photography and Film, Rochester, New York.

not just his life dates and lineage, and the picture drew attention to the visible characteristics of the sitter rather than to life events. Eventually, photographs replaced text and photograph albums replaced genealogical albums as the household record of choice.

Photograph albums radically changed the nature of family history by making it visible; telling was supplanted by showing. The photographs included in a family Bible, and later in the album, did not parallel the chronicle originally told in writing—that is, the pictures did not depict baptisms, weddings, and funerals, following the markers of birth, marriage, and death. Instead, such pictures were intended to represent the person as a whole, both his outward features and inner temperament. If taken frequently, the

portraits might chart growth and change over the years; if made only rarely, a family member might be portrayed in a single representative image. In either case, the "begats" of the Bible now translated into visual evidence of familial connection, the recording of specific milestone events gave way to a portrayal of general character, and textual notation transformed into visual representation. The album completed the process begun with the insertion of photographs into family Bibles, and marks a particularly modern shift from an oral or textual tradition to a visible one: what had been a list of names, dates, and events had now become a history of appearances and physiognomies. A family connection once made plain through shared last names was now made tangible through common hereditary characteristics. The chronological specifics of family milestones transformed into the visible details of hair, eyes, and the shape of a face, and written proof of birth or marriage, permissible in a court of law, ceded to evidence and identification of an entirely different sort.

Oliver Wendell Holmes, in his 1863 assessment of photography for the *Atlantic Monthly*, noticed the often striking family resemblance in his observations of the goings-on at photography studios: "Another point which must have struck everybody who has studied photographic portraits is the family likeness that shows itself throughout a worldwide connection. We notice it more readily than in life, from the fact that we bring many of these family-portraits together and study them more at our ease. There is something in the face that corresponds to *tone* in the voice—recognizable, not capable of description; and this kind of resemblance in the faces of kindred we may observe, though the features are unlike."[9] The scrutiny that photographs encouraged, especially when placed side by side in an album, allowed for an unprecedented degree of comparison; a certain physical quality of belonging to a group made itself more apparent on the page than it might have been at even a family gathering. The features of heredity could be observed over time and distance and charted for all to see, with babies resembling one another across generations, or far-away cousins sharing the cut of a jaw or bridge of a nose. With the evidence of bloodlines on such visible display, the common family album shared its format—and perhaps its ideology—with eugenicist album projects. Albums such as the *Life History Album*, devised by the father of eugenics, Francis Galton, in England in 1884, sought to help families assemble visual records that were personal in scope.[10] In Galton's scheme, each child would receive his own album at birth; along with a family medical history and updated charts of height and weight, two pictures would be inserted into its pages every five years. Ideally these photographs

were to be consistent enough in size and format to be compared fruitfully and accurately. Understanding that mental and physical characteristics were transmitted from parents to children, Galton realized that such an album would be valuable not only to a family's descendants but also to the study of heredity and eugenics on a much larger scale. As in the common parlor album, when photographs supplemented or replaced textual notations, this newly visible genealogy showed the value of belonging to a group bound by lineage. This distinctly modern means of recordkeeping set the stage for documenting not only scientific or sociological studies, but also future family histories and memories.

Parlor Practices: Arranging and Viewing Albums

In one of the sentimental stories that amused the female readership of *Peterson's Magazine*, a partially filled carte album introduces a young man to his love. Frank Fields is an intelligent but uninspired law student who arrives at the post office while unclaimed packages are being auctioned. Somehow drawn to a small white parcel addressed to "Fannie Wharton, Philadelphia," Frank finds himself, two minutes later and fifty cents lighter, in possession of what he assumes is a book. Instead, it is a photograph album, and this relatively early (1864) description of its contents provides rare insight into the hierarchies of display commonly employed in album-keeping:

> Opening the paper, my purchase proved to be a handsome photograph album, bound in claret-colored velvet, with a gold clasp, and on the cover a small gold shield, upon which were engraved the initials "F. W. and H. E." Of course, I looked inside. There were only six pictures, blanks being left for future insertions. The first was evidently taken from a painting, and represented a tall, handsome gentleman standing beside a horse; this was marked, in the same bold hand as the cover, "Father." "Mother" followed, a fair, elderly lady, in a white cap and black dress. Then came a handsome copy of father, young and stalwart, standing erect by a chair, and looking the impersonation of frank, young manhood. "Howard" was the signature. "Nellie" came next, the loveliest vignette, evidently the portrait of a very beautiful girl of some seventeen or eighteen summers. The next was a group, a gentleman and a lady, marked "George and Rosa;" and the last, a wee little face set in lace, was "Rosa's baby." This was all.[11]

For the purposes of the romantic narrative, it is the carte of the comely "Nellie" that is important, and Frank keeps returning to her picture until he has fallen quite in love with the image. As lucky coincidences do happen in the pages of ladies' magazines, he meets the fair original of the picture, improves under the guidance of her sensible brother (Howard Emory, or "H. E."), and wins the lady. The album, we later learn, was to have been a birthday present from Howard for his betrothed, Fannie, who broke off the engagement and never claimed the package.

The unclaimed album in this story not only acts as accidental matchmaker; in its original intention as a courting gift, it also encapsulates a family narrative that was never to take place. Howard has carefully arranged the photographs to tell a story of families past and future. Beginning with a picture of his father (when young) and then his elderly mother, the album continues to show the progeny of that union, starting with the future patriarch and ending with the newest grandchild. The next set of empty slots would logically have been filled with cartes of Fannie's parents and siblings, in the same fashion. The remaining blank album pages would await a wedding portrait, perhaps, and then cartes of infants squirming in christening gowns on bearskin blankets—the future, potential family. One imagines, due to the sheer quantity in which card pictures were ordered, that this album would have come to exist in similar form in the homes of the Emorys and the Whartons and their children, each parlor table bearing a version of its own family with the same cartes de visite in roughly the same hierarchical order.

Howard's gift album also contains subtle messages about genealogy and status that would have been appropriate to a couple embarking upon marriage. The few photographs included, such as the copy of a painting of the father (since the sitting probably predated photography), which reveals a handsome gentleman alongside his horse, advertise gentility and social distinction; the mere fact of owning an oil portrait already establishes the family as one of means. (Significantly, this was not enough for Fannie, who in the story abandoned Howard for an aged millionaire.) The worth of the various Emory family members is apparent and visible in their photographs, as the sitters are by turns described as "handsome," "fair," "frank," and "beautiful." Their inner characters, the story reveals, live up to the surface descriptions. With its attractive covers, gold clasp, and initialed shield (itself a reference to heraldry), the album belies the maxim that you can't judge a book by its cover. The brief visual genealogy contained here is the basis for matrimony, reminding us that marriage is a union as much of families and properties as of hearts.

At the same time that photograph albums were cherished keepsakes and intimate collections of family, they also functioned as advertisements of their owners' character, social networks, and status. How individuals organized and displayed these family collections mattered to different degrees. Within the album, photographs were often arranged according to certain prescribed patterns of placement, usually beginning with the family's patriarch and matriarch, and continuing through the rest of the relatives, according them the status in the album that they held within the family circle. One commentator in a photographic journal remarked on this pattern in 1878, toward the end of the craze: "The contents of albums . . . bear a most distressing similarity. First come the old folks, then the immediate members of the family, afterwards a collection of friends and acquaintances, and finally, if these are not sufficient to fill up the pages, there will be likenesses of theatrical or other public characters."[12] This formula is a combination of family hierarchy and random collection practices; the album was seen to be filled as much by the desire to construct a family tree as by the urge to acquire portraits in great numbers.

Although commentators in the photographic and popular press prescribed certain ways of maintaining a photograph album—to separate family photographs from celebrity portraits and views, for example, or inscribe physical characteristics in obsessive detail alongside the pictures—there were almost as many practices of ordering photographs as there were album-keepers.[13] "The beginning is made with portraits of the members of the family and friends, but soon a collection is made up for a second album, or a picture-book," an 1872 article noted. "Christmas or birthday presents furnish a part of the contents; occasional purchases selected from the shop-windows supply the rest."[14] Some albums distinguish relatives from the relatively famous, but others allow them to mingle within the book's cardboard pages. Beginning with England's Queen Victoria and Prince Albert, some albums go on to track European royalty and actresses; some collections contain exclusively Civil War generals. In other cases, Abraham Lincoln or Tom Thumb gazes out from a carte on the same page as elderly aunts and white-clad babies. A young woman might keep her own personal collection of photographs of her beaux and school chums, albums whose contents would mirror those of her close friends. Albums do sometimes begin with the patriarch and matriarch and then fan out from the immediate to the extended family, but they also sometimes have seemingly no apparent order or hierarchy. Some keepers of albums probably held on to a sufficient number of cartes before entering them in the book, or later replaced them in the proper sequence, while

others most likely simply slid them into slots in the order in which they were acquired. An article in *Scientific American* at the beginning of the album craze observed that different arrangements resulted depending on who ordered the photographs within the pages: "Sometimes the grandfather and grandmother occupy the honored place of the first pages, while father, mother, brothers and sisters, uncles, aunts and cousins complete the collection and constitute the most truthful, beautiful and perfect gallery of family portraits. In other cases the school-girl acquaintances fill the pages in all varieties of smooth cheeks, soft eyes and carefully dressed hair, the collection being spiced with an occasional curling mustache or well-brushed pair of whiskers."[15] An album could also house a special collection, chosen from among earlier albums, showcasing the most accomplished portraits or the closest of friends. The advice to "keep your albums locked" came from a writer who assumed that the book in question contained "selections, from previous books, of your best friends, probably, and your best photographs."[16]

All of this is not to say that the arrangement of pictures within an album held no meaning for its owner or viewers; on the contrary, the evidence of many and varied practices indicates that the organization of an album was an intensely personal activity. The fact that no single, unifying arrangement obtained, moreover, should not obscure the various patterns or tendencies that do emerge from the album.[17] For every randomly compiled collection was one that concentrated on a family or social hierarchy; for each small display of intimates there could be an impressive gallery of national figures. The single portraits and insertion slots lent themselves to a fluid arrangement in which different groups could be formed on a page, each with a different meaning—or no meaning at all. In any case, significance emerged from the album's whole—the assortment, the juxtapositions of pictures on the page—not through the individual portrait. Common to all these albums is that their contents, selected for inclusion based on a variety of reasons, were a reflection of their owners—who they thought they were or how they wanted to be seen.

These assortments of pictures could be quite revealing about the tastes and social horizons of their collectors. An 1864 article in the *Philadelphia Photographer* described the kinds of self-expression that might occur in some rather personally tailored albums: "Our bachelor uncle may secretly collect a hundred baby pictures, and arrange them according to style of expression, putting those expressing fear, or revenge, or hate, or obedience, or incorrigibility, together, then gazing at them meditatively, chuckling within himself what a blessed thing it is *not* to be a father. . . . The devotee may have pictures

of his pastor or priest in numbers, and the patriot collections of his favorite heroes."[18] This rather obsessive kind of collecting, whether common or not, mimicked other domestic collections found in the parlor. Less pictures of loved ones than specimens—like ferns and grasses, carefully documented and placed in a scrapbook in scientific order, or shells mounted by shape on the mantel or under glass bell jars—such assemblies reveal that album collecting was an extension of the impulses to accumulate, document, and preserve that were already at work in the Victorian parlor. John Elsner and Richard Cardinal have isolated the themes of collecting as "desire and nostalgia, saving and loss, the urge to erect a permanent and complete system against the destructiveness of time."[19] The accumulations of everyday objects—from natural history collections like terrariums and geological specimens to the amassing of books, magazines, and lithographs—educated their collectors in a variety of ways while at the same time creating an indoor microcosm of the surrounding world. At their categorized and ordered extreme (all generals, judges, or actresses, for example), photograph albums helped structure the world and domesticate it in the parlor, preserving it against change.

It is impossible to comprehend the social functions of the Victorian photograph album without understanding the context of the parlor in which it was viewed and to which it was inextricably tied. Besides being the site of domestic collecting and display, the parlor was where visitors were received and entertained. A semi-public, semi-private space, it was also where families displayed *themselves* to others. The parlor was distinguished from the family sitting room, which was a more private domain. As a contemporary guide to home decoration remarked, "It is in the parlor therefore that we find the choicest treasures that the house can afford, that will tend to the hospitable entertainment of guests, just as in the sitting-room, or living-room are gathered the dearest tokens of love for the family circle."[20] More often than not, however, the middle-class family used only one room, the parlor, for a variety of functions both public and private. The furnishings of the parlor advertised the dual poles of cosmopolitanism and domesticity, or, as Katherine Grier has termed it, "culture and comfort."[21] Collections of natural specimens demonstrated knowledge of the sciences, and portraits of eminent figures testified to worldliness. By contrast, the center table, where the album was usually placed, might house sentimental objects, such as family Bibles and hair wreaths, emphasizing family-centered domestic life. In the parlor, social networks were cultivated, status was on view, and home met world.

The photograph album enabled a new kind of self-presentation to others, and a new excuse for that display. As the noted French literary figure

Ernest Legouvé put it, "Photographic collections . . . are found on almost every centre-table, and each one is both the portrait of those who are placed therein, and of the one who composed it."[22] Most albums were designed to be exhibited, with celluloid beads on the bottom that elevated the volume and protected the lavish covers, bindings that enabled it to remain wide open, and elegantly designed pages that attracted the eye with their opulence. Cabinet card albums of the 1880s and 1890s, even more elaborate than their predecessors, often included display stands or pedestals; some even opened up to a mirror, reflecting the viewer's face back to her and in effect placing her image among those pictured (fig. 29).

When photograph albums were placed on the parlor table in front of guests, what was on display was much more than just a collection of photographs. Middle-class respectability was on view in these pages, as sitters, by the mere fact of posing for the camera, emulated their oil-portrait betters, participated in a national pastime, and took advantage of the photography gallery's genteel props and backdrops. The album replicated the public spaces of the house, showing each family member "at home" in a multitude of elaborate parlors. With no kitchens, bathrooms, or bedrooms in this "house," the album took on the form of a kind of idealized home in which family members comported themselves with the utmost propriety.

By displaying certain social or celebrity cartes de visite, album-keepers also exhibited the extensive social networks of a shared circle; political identifications, as certain figures represented party beliefs or wartime affiliations; and aspirations to character or culture as reflected in photographs of the artistic, literary, and intellectual personalities of the day. Perhaps what was most on display in the photograph album, however, was the status conferred by ownership of particular cartes de visite. A British article reprinted in Boston's *American Union* in 1862 threw into sharp relief the way in which albums advertised their owner's social standing and "claims of gentility":

> Those albums are fast taking the place and doing the work of
> the long-cherished card-basket. That institution has had a long
> swing of it. It was a good thing to leave on the table, that your
> morning caller while waiting in the drawing-room till you were
> presentable, might see what distinguished company you kept, and
> what very unexceptional people were in the habit of coming to
> call on you. But the card-basket was not comparable to the album
> as an advertisement of your claims of gentility. The card of Mrs.
> Brown of Peckham would well to the surface at times from the

Fig. 29. Cabinet card album with stand and mirror, c. 1880s. George Eastman House, International Museum of Photography and Film, Rochester, New York.

depths to which you had consigned it, and overlay that of your favorite countess or millionaire. Besides, you could not in so many words call attention to your card-basket as you can to the album. You place it in your friend's hands, saying: "This only contains my special favorites, mind," and there is her ladyship staring them in the face the next moment. "Who is this sweet person?" says the visitor. "Oh, that is dear Lady Puddicombe," you reply carelessly. Delicious moment![23]

Whereas a carte de visite of Abraham Lincoln or Edwin Booth might reveal only one's ability to pay for a picture on the open market, a picture of Lady Puddicombe (in this case, presumably donated by the sitter herself) demonstrated one's admission into an elite social circle. The hierarchies of display might just as easily be governed by the impression the owner desired to convey to her visitor as by chronology or other ordering principles. As

well as serving as a portrait of its maintainer's social connections, the photograph album also acted as a social gatekeeper. In contrast to the way in which the endlessly reproducible carte de visite produced a lack of control over one's own visage, the album allowed its makers authority over who could be received into this private club.

The presentation of an album to a visitor might be met with varying degrees of delight or dismay; this depended, generally, on the owner of the album and the pictures within its pages. As much as people liked putting themselves (and their sentimental, social, or status connections) on display through their albums, viewers did not always appreciate sitting through the performance that resulted. As we have seen with the complaints about Miss Domestic's garrulous tendencies and shoddy photograph collection, the experience could be a trying one. The editors at *Appleton's Journal* protested that because the poor quality of photographs rarely did justice to the originals, "one of the most painful tasks in the world is to be called upon to examine a friend's album."[24] Another writer provided a different point of view, that of the album's owner. Photograph albums of beautiful women and famed men held little lure for this owner; what was important was how visitors treated her prized collection of loved ones: "But the pictures of my pure and tried friends, those who have stood by me through the joys and ills of a checkered life, are tenderly kept, and it irks me to see them turned over by indifferent hands."[25] Collections such as these were intended for the eyes of intimates. Such private displays had a limited range of exposure, which is likely how most visitors would have preferred it.

Another category of album collections—that of celebrities, views, or even local personages—moved beyond mere display, achieving the status of domestic entertainment. Etiquette manuals and home decorating guides classed albums with games, philosophical toys, and other objects of amusement for entertaining guests in those awkward periods after dinner, or simply during ordinary visits. In a chapter on "Dinner Company," etiquette expert S. Annie Frost suggested: "The ladies upon leaving the dining room, retire to the drawing-room, and occupy themselves until the gentlemen again join them. It is well for the hostess to have a reserve force for this interval, of photographic albums, stereoscopes, annuals, new music, in fact, all the ammunition she can provide to make this often tedious interval pass pleasantly."[26] In a guidebook on homekeeping, advice for entertainment in the parlor included the following: "Place boxes of games, scrap-books and portfolios filled with pictures, photograph albums and objects of amusement, such as the stereoscope, kaleidoscope, and microscope, in appropriate places, and place chairs

near them."[27] The photograph album seemed the perfect antidote to potential boredom, diverting guests by allowing them to scrutinize the faces and fashion of the famous, or remark upon views one had been fortunate enough to experience personally. "If the cook happens to be late for dinner (and cooks generally are), [hostesses] will find how invaluable these 'Heads of the People' are, and what agreeable reading they will supply to even the hungriest, as its illustrated pages present some new feature at every turn," proclaimed the *American Journal of Photography*. "A photographic album is the most amusing anteprandial friend that a lady could have in her establishment."[28] By bringing subjects right in front of the viewer for gossipy dissection, the album became a potent weapon in the arsenal of amusements.

There seemed to be a common Victorian fear that uncomfortable silence would overcome guests. Moreover, in certain circles the social and intellectual pressures to be witty, especially in verse or riddle form in a lady's album, seemed enormous. The photograph album came to the rescue in two important ways: first, it relieved visitors from having to supply original verses or otherwise display cleverness; and second, it was perceived to actually spark small-talk where there might otherwise be none. "People in an ordinary drawing-room think there is a sort of plot to find them out if any demand is made on their intellect; and to write verses, or even to copy correctly a piece of poetry out of a standard author, is dangerous and embarrassing," editorialized *Godey's Lady's Book*. "In photographs all is plain sailing. All that has to be done is to make gossiping remarks about other people, and this is a duty to which the most timid intellects feel competent." Everyone could find at least *something* to say about a collection of photographs and the sitters pictured therein, whether that something was complimentary or subtly malicious. The album's promise lay in its ability to provoke conversation, as *Godey's* summed up: "It is this fund of easy small-talk which will be the real foundation of the permanent success of photography as a fashion."[29] This kind of talk—part gossip, part parlor chatter, part edifying cultural discussion—would have sounded very different from the private family narratives that were recounted while flipping through family photographs at a less public moment. As we will see, however, even those most intimate stories might serve the same function of public display.

Talking Through the "Fotygraft Album"

In a humorous send-up of the family album written in 1915, Rebecca Sparks Peters, age eleven, walks a new neighbor through her family's "Fotygraft

Figs. 30 and 31. Cover and page from Frank Wing,
The Fotygraft Album (Chicago: Reilly and Britton, 1915).

Album" (fig. 30). The unsuspecting Mrs. Miggs has paid a visit while Rebecca's mother is out, and the girl entertains her as she has seen adults do: "Let's see," she says. "S'pose we set on th' sofa and I'll show yuh th' album, so's yuh'll kinda begin t' know some of our folks." A typical exposition of her "folks" goes like this, as they look at a cabinet card portrait of two boys (fig. 31): "Them's Willie and Freddie Sparks. They was cute little fellers but it's awful t' think th' way they turned out, pa says. Willie's an editor and Freddie's a lawyer, and they work together jist fine. Willie gets into trouble, and Freddie, he gits him out."[30] It's a scene familiar to all owners of family albums and all obliging visitors: the talking through of the stories that

accompany family pictures. Here, however, Rebecca ends up spilling all of the family secrets that she has obviously overheard from her parents and relatives but which are supposed to be kept away from outsiders. This is the very private version of the more public family history the album displays, and surely scandalized poor Mrs. Miggs.

Parodies are often very revealing. Although Frank Wing's *Fotygraft Album* and a later sequel, *The Fambly Album*, were written in the snapshot era, they hark back to the nineteenth century's cabinet card stiffness, and serve up only the generation of Rebecca's elders.[31] The books primarily caricature the album's awkward poses and the airs put on for the camera, hard-featured

relatives and quirky local celebrities, and the lack of sophistication of a family whose dialect undermines its pretenses. But there is also much we can learn from Rebecca's prattling about the function and structure of the narratives that knit together early photographs and created meaning for viewers of albums. The young girl is playacting at what she has seen her parents do, and her mishap highlights the dual function of the family album: first, to construct a visual and historical past for ourselves, a narrative of identity cemented by its retelling; and second, to entertain others (here, in neighborly fashion) and explain to them who we are. The structure of this chronicle is show and tell, pointing to sitters and explaining something about their past and how they relate to (and perhaps illuminate) something about the teller. Each page in this book ends with Rebecca telling her new neighbor, "Turn Over!"—turn the page, continue the story. The act of exposition creates two parallel narratives, which the girl comically confuses: one public, largely photographic, displayed as evidence for all to see, and the other more intimate and reserved for family, of an oral or textual tradition, filling in photographic gaps with stories.

The accumulation of anecdotes and identifications elicited by the photograph album added up to a larger family narrative, and the stories occasioned by the viewing of albums contributed meaning to what might otherwise be a standardized, repetitive family record. By telling and retelling stories in these earliest photograph albums—by "talking through" photographs within families, and between families and outsiders—viewers of albums personalized pictures and used them to shape their histories. The practices of looking at and narrating photograph albums fundamentally altered the way family histories were told in two critical ways: by making a familial past visible in the first place, and by linking private narratives with public ones.

As images replaced text in family records, and visible facts took the place of historical facts, the narrative of a family's past also altered. The descriptive photographs in the first family albums must have provoked recollections more easily than did the basic inscriptions in, for example, a genealogical album. At the same time, however, users of the new photograph albums required more oral information in order to fill in the narrative gaps created by the lack of text. Unlike their counterparts of the post-Kodak era, nineteenth-century albums contained individual studio portraits instead of personal snapshots of group events; although middle-class sitters were newly able to pose for the camera more than once in their lives, sitting for a picture was still a rather unusual and important affair. Nevertheless, the remembrance occasioned by the album would not be that of the photographic sit-

ting, unless it was under particularly unusual circumstances; it would more likely be an illustrative story that had nothing to do with the time or place the person was photographed. The clues to the particulars of time and place that might exist in snapshots—birthday candles, say, or a newly decorated living room, or the backdrop of Niagara Falls—are absent in these pictures. Such clues usually serve to spark a memory or story, but cartes de visite contain no such details other than the studio setting or the dress of the time. The portrait thus had to represent not a moment of a person's life but the person herself: her character and her life as a whole. Looking at a carte de visite in an album, for example, a viewer could accurately remark, "*That is* Aunt Edith, a very good likeness," but not "That is Aunt Edith at cousin John's wedding—remember how she danced?" The narrative contained in (or suggested by) a nineteenth-century family photograph album had to fill in substantial blanks about the lives and personalities of the people pictured there, weaving portraits of individuals into a story of a group.

As shown earlier, the standardization necessary for mass production caused carte de visite and cabinet card albums to look very much alike. Sitters may well have welcomed the opportunity to look like their peers and fit so easily and interchangeably in these volumes. Viewers of albums, however, needed to individualize these otherwise unexceptional pictures, and to distinguish their album collections from the others that graced parlor tables in homes across the nation. They had to transform a commercial production into a personal family history. This occurred in the intimacy of the home, in repeated moments of reception; the ritual leafing-through of the photograph album provided the occasion for the retelling of old stories. Even though the album's format was the same, and the chronicle was likewise structured by the sequence of pictures, each family's story was different in the particulars. The narrative would become one of the means of this personalization, the event in which the unique was acted out.

Once assembled in an album, photographs seemed to take the form of a narrative, no matter what the organization, because of the sheer fact of their being sequential; that one followed another implied a beginning, a middle, and an end. A viewer might "read" the pictures one after another, turning the pages like a book, linking the pictures into a cohesive story, as did Rebecca in her repeated command to "Turn Over!" This "reading" took the form of a demonstrative pointing and telling, marking the person pictured in a way that simply listing names could not: "*This* is cousin John." The sitter's very visibility suggested a kind of proof and presence, his existence and appearance a fact. As Roland Barthes has put it, "The photograph is never anything

but an antiphon of 'Look,' 'See,' 'Here it is.'"[32] A story called "The Awful Photographic Album," from a nineteenth-century book of American humor, shows the typical form that this kind of narration might have taken in respect to the first photo albums. In the tale, a man paging through a family album proudly declares: "Oh, yes I said; I always enjoyed looking at photographs. Photographs and autographs I just doted on. I am a man accustomed to family photograph albums. You can't fool me on them. I have sat up with them from Halifax to Denver, and I know them by name and sight. Pa and ma and that's grandpa and that grandma, and here's Uncle George, and this is an aunt of pa's, she's very wealthy and has no children and pa is her favourite nephew; and this is a young lady I went to school with, and this is his [*sic*] brother Henry, and this is cousin Sue, and this is Aunt Hattie's baby and this is a young man Henry went to school with . . . oh, my son, you can't strand me on photograph albums. I know just where the family ends and the strangers file in."[33] He continues on and on in this vein, getting everybody "right" except for himself, comically failing to recognize his own picture. Having seen the various permutations of his family's larger album and heard the stories, the man is able to identify the sitters and key details. Even in parody the declarative mode of the photograph album is tied up in its performance with viewers, a public identifying of who's who on the page.

Of course, there was always the danger that the private and public tales would mix, as when Rebecca Sparks Peters spills the family secrets to Mrs. Miggs. This danger was often characterized by class differences, seen for example in a cartoon titled "A Reasonable Excuse," in which a mistress chastises her domestic servant, Bridget, for not having made up the fire (fig. 32). The girl responds, by means of an apology, "Oh, ma'am, I was looking at my Photographic Album, an' forgot meself entirely!" It seems clear that she has lost herself in her *employer's* large family album, leafing through the private pictures for her own amusement and blurring the boundaries of both social class and family.[34] The editorial called "Keep Your Albums Locked," which urged families to guard their precious collections of portraits from the "dirty fingers of the domestics and their friends," imagined the scene that might take place in the album owner's absence, as the house servants page through the portraits, violating the sanctity of the family unit inside. In a cheaper imitation of the oral retelling of family history that accompanied the family album, the domestics point to the pictures and tell their own version of the story: "'This is missis, in that new yellow gown of hers; and this is missis again when she was a young 'un.—This is a picture of that gent, what comes here very often, wearing a red tie, and a short pipe; you

A REASONABLE EXCUSE.

Mrs. Brown.—"Why, how is this, Bridget? Nine o'clock, and the fire not made yet!"

Bridget.—"Oh, ma'am, I was looking at my Photographic Album, an' forgot meself entirely!"

Fig. 32. "A Reasonable Excuse,"
Harper's New Monthly Magazine 30, no. 177 (February 1865): 406.

know, him as gave me a half-a-crown one Sunday, that I bought a parasol with.—Oh! ain't I grand? Here's master in his long ulster, smoking a cigar. And this,' etc. One can well imagine the conversation that goes on as the leaves of one's album are turned over."[35] The servants, in this imaginary scene, mimic what they have seen their betters do, inserting themselves into the stories and distorting the narrative even as they echo it. Even more than thumbing through the pictures, it is the appropriation and bastardization of family tales that are meant to disturb the reader and owner of a proper family album. This article suggests, perhaps unwittingly, that the retelling of album narratives instructed the working classes on how to keep their own

family histories, and initiated a process of assimilation whereby they could enter a larger community of family pasts and begin to participate in a collective narration of history. But the admonishment to keep one's intimate pictures away from the help also serves to underline those class distinctions and stake a claim to those stories.

The public and private narratives occasioned by photograph albums intertwined and blended in innumerable ways. On the one hand, stories for public consumption were made visible in the album's pages. These might include the heroism of a soldier in his uniform, the joy of a new addition to the family, or the displayed status of a celebrity portrait or view. Viewing such pictures was acceptable Victorian entertainment. On the other hand, those things that were generally absent from the album's many photographs—servants, pregnancy or disease, the workplace, or even parts of the house that were simply not parlors—were stricken from the visual narrative. The relatives excised from the photograph album, for whatever reason, would also effectively be written out of a family's history. It would be up to the accompanying oral narrative, now so readily occasioned by the presence of photograph albums, to fill in those gaps—or perhaps to perpetuate them. There had always, certainly, been private narratives reserved for the family, but now for the first time there was also a visible one to display for others.

When the first photograph albums began to be filled with cartes de visite and to take their place in the parlor, the stories they occasioned must have been different from those in the "Fotygraft Album" in certain important ways. For one, the tales must have been fresher; a generation had not yet intervened to make the pictures part of the past. This was the moment when stories—about extended family that lived far away, perhaps, now able to be photographed and inserted in a family album (and thus into a family narrative) for the first time—would emerge for future generations. Their inclusion in the album would necessitate an explanation, a retelling. By the time someone like Rebecca leafed through the pages, the connection to the people pictured therein would be more tenuous, a connection borne of wisdom received through repeated anecdotes and ritual viewing, not through experience.

The rise of the first photograph albums marks a critical transition between an essentially biblical way of *telling* family histories and an unprecedented visual *showing* of a familial past and present. From this moment on, our memories of family would be shaped as much by how someone looked in a photograph as by what he did; visible character would parallel remembered stories, and when the stories were forgotten, the photographs would remain

as mute testimony. Susan Stewart, in her analysis of the souvenir, notes that the narration of photographs gives them their meaning but ultimately itself becomes a feature of the past: "The silence of the photograph . . . makes the eruption of that narrative, the telling of its story, all the more poignant. For the narration of the photograph will itself become an object of nostalgia. Without marking, all ancestors become abstractions, losing their proper names."[36] Albums became the occasion and the means to tell and retell these stories, but they also changed the narrative by adding a public dimension to them. Moreover, it was through the act of identifying, describing, and explicating the people in a family album to others that these rather standardized collections could take on personal meaning. Without the demonstrative pointing, without the anecdotes, the album remained mute, and nearly indistinguishable from the many others that graced parlors across the nation.

Crafting Albums

Those who maintained albums also employed other strategies to individuate their family collections. Against the dictates of the press and the standardization of photographs and albums, women—who most often purchased and kept these objects—could also personalize their family albums through craft skills learned in the home. Where the influence of the machine ended, that of the hand began, as women occasionally drew around, cut and pasted, collaged, or otherwise manipulated the images within.[37] Such behavior may be read as an attempt to rally against the conformity imposed upon family albums by the necessities of mass production; a different kind of production could take place in the home. This domestic production might best be understood as one of meaning, a kind of creation that encompassed the arranging, displaying, and interpreting of machine-made albums and their contents. But it might also be extended to those rarer occasions when album-keepers physically intervened, through means of artistry and craft, in the recording and presentation of their familial and social circle.

The pages of magazines such as *Godey's Lady's Book* or *Peterson's* are filled with craft projects that were intended to embellish both the parlor and the person, from bonnet trimmings and decorative frames to terrarium displays. Albums were not exempt from this urge to beautify, even though they came complete already, with velvet covers and gilded pages. In its debut issue in 1879, for example, the journal *Art Amateur* (whose opening editorial began, "To domesticate art and make it a part of the household is one of the most strongly pronounced tendencies of our time") included instructions for an

album cover with an embroidered monogram.[38] On display in such albums were not only the social connections paraded within, but also a degree of the album maintainer's inventiveness and domestic skill. Angela Wheelock has suggested that it was the domestication of technology, not art, that early albums accomplished: with their soft covers, which echoed the fabrics and furnishings of the parlor, they helped to mediate between the commercial photographic studio and the privacy of the home, and provided a means for women to translate worldly technology into the domestic sphere.[39]

In an essay on nineteenth-century European ladies' albums, Anne Higonnet has argued that such projects were a means of female self-expression, representing not women's lives but rather their attempt at self-definition within the boundaries of specific gender conventions. The images drawn and painted in albums, often by serious amateurs, portrayed a variety of female social experiences, from visual travelogues and landscapes to scenes of appropriate domestic occupations, often among groups of friends or family. As painters of pictures or assemblers of ready-made elements, women compiled a whole that was greater than the sum of its parts. The collective image that emerges reveals women's gendered roles—daughter, sister, wife, mother—within a distinctly feminine, if relatively public, world. Through albums, women were able to project selected aspects of their gender identity and hide others, consciously playing a role as much as being reflected by the images they created. "Women were performing in their images," Higonnet writes. "The images themselves were their performance."[40]

If we can extend Higonnet's conception of the artistic maker of albums and album images to the selective consumption and ordering of photographs in family albums, then the more mundane American carte de visite albums can also be seen as instances of (usually female) expression. Even acknowledging the differences between the serious amateur and the mere collector of images, and between painting and ready-made photographs, we can still approach photograph albums employing Higonnet's argument. Like other women's albums, photograph collections reveal only the most social of domestic spaces, as the parlor is repeated over and over again in the photographer's studio. Each presented image acts as an individual piece within the assembled puzzle of the whole, be it the family or a representation of one's social circle; if there is a performance here, it is that of a collective. Expression—although diminished because of the formulaic dictates of the carte album, with its framing, page decorations, and basic photograph position already established—takes the form of consumption and selection, assemblage and juxtaposition.

This limited form of creativity around photograph albums—skills of purchasing rather than making, editing rather than originating—is indicative of a larger shift away from an economy of production toward one of consumption. As invented lines of poetry and handpainted watercolors gave way to printed articles and fashion plates torn from a new feminine press, other kinds of album collections were already showing the intrusion of industry into the domestic realm of sentiment. Commonplace books and scrapbooks, in contrast to earlier ladies' albums filled with verses and drawings, featured the album owner as consumer rather than creator.[41] Commonplace books were among the earliest household albums, and they were kept mostly in the first half of the nineteenth century. Composed of extracts from printed materials such as newspapers and magazines, such books maintained a literary and self-cultivating flavor, as each owner could serve as the editor of his or her own anthology. By about the middle of the century, responding to a surge in available printed matter, scrapbooks supplanted commonplace books. Scrapbooks were popular with men as well as women, and children also enjoyed collecting colorful scraps and lithographed cards; an 1880 guide to keeping scrapbooks suggested that it was an activity appropriate for the whole family, individually or collectively.[42] The album ritual was transformed from one of literary skill and personal creativity to one of selection and consumption, a shift that was only emphasized with the advent of the photograph album. Watercolors and verses had previously been markers of taste and accomplishment, but now mass-produced celebrity cartes signaled cosmopolitanism or refinement; expression in ladies' albums had previously taken the form of craft and invention, but the owner of the photograph album now found creative outlets in selecting and editing. With this transition, there was less room for artistry: maintainers of carte de visite albums could embroider covers, not create elaborate invented worlds.

Still, some album owners resorted to more drastic means to express what was impossible within the constraints of the standardized, mass-produced album and studio photograph. In a carte de visite album from the Baltimore area, dating from the early to mid-1860s, a series of photographs that look almost identical (see fig. 10) is punctuated by one that looks very different (fig. 33). This collage seems to be a small memorial to a child who has died young, and was probably constructed by his mother. A hand-tinted photograph of a boy of about eight, head resting on his hand, has been cut out and stitched onto a light blue valentine with a lace-mesh interior. A colored flower surrounds his torso, and scattered leaves frame his head. At the top of the image, above the boy's head, is a golden cut-out circle, a halo

that marks his place in a better world. Although postmortem photographs, especially of children, were not uncommon at the time, this image seems special: its difference among the photographs seems intended to call out to the viewer and revive the memory of a lost child with a sensitivity that surpasses that of untouched postmortem images. Carefully cut out and lovingly assembled, this memorial collage is an artistic creation inspired by mourning and remembrance. The family album has been transformed from a common receptacle for photographs into a place where fantasy and invention can play, albeit within a limited range; the arranger of the album has become its artist-creator.

Personal Memories, National Histories

Sweet, life-like shadow, by a sunbeam printed—
 And thou are mine, and ever mine shall be;
Earth's pictures bright, though like the rainbow tinted,
 Are not so dear as this, my friend's, to me.

Here I can see a friend I fondly cherish,
 Though time and space divide me from my friend;
This I can keep, although that friend should perish,
 Nor dream of parting 'til life's journey end.

Time cannot change the brightness of those tresses;
 Years cannot dim the luster of that eye;
That brow is safe from change by time's caresses,
 And dear the thought—thy picture cannot die.

These lines from an 1868 poem in *Peterson's Magazine* were typical sentimental fare for a women's journal in the years immediately following the Civil War.[43] Like the "Secure the shadow, ere the substance fade" photographic pitches of the daguerreian era, such poems pointed to one of the chief values of photography at the time: preserving loved ones even after death. That the photograph would long outlast its living model was one of the main reasons young soldiers sent home tintypes from the front, and wives and mothers carefully collected cartes in albums, often with the additional memory trigger or relic of a lock of hair, which incorporated a physical piece of the person pictured (fig. 34).[44] Although to a modern eye these photographs may seem stilted, formulaic, and nearly indistinguishable from one another, to

Fig. 33. Collaged memorial photograph from
carte de visite album, c. 1860s. Collection of author.

Fig. 34. Album page with tintype and lock of hair, c. 1860s.
Photographic History Collection, National Museum of American History,
Smithsonian Institution, Washington, D.C.

the bearer of a loved one's picture the immediacy of the person canceled out anonymous studio trappings and transcended the stiff pose. Photographs held intense personal, sentimental associations for their viewers, meanings that escape not only the modern collector or historian but even the relative removed by a mere generation, thumbing through the portraits without an anchoring memory of the people pictured therein.

An 1871 editorial in *Appleton's Journal* noted that an appreciation of a photograph, particularly one of lesser quality, often necessitated prior knowledge of the sitter. Arguing that poor photographs did little justice to their models, it maintained, "If we are acquainted with the original, our recollections supply what the picture omits; but no one who first sees the photograph of a face has more than the distant impression of what that face really is."[45] The photograph was thus incomplete without a remembering viewer, who supplied it with a living significance. Just over fifty years later, Siegfried Kracauer came to some similar conclusions about the difference between photography and memory. In his 1927 essay "Photography" he posited that in modernity, photography replaces memory just as information supplants meaning. Memory is selective, personal, full of spatial and temporal gaps, replete with repression and emphasis, and reiterated through community and narration. Photography, by contrast, is composed of an accumulation of details of equal significance, anchored in the specificity of time and place and forced to remain there. For Kracauer, photography consisted of surfaces and description, while memory involved depth and meaning; he thus found memory images at odds with photographic ones, not complementary.[46]

The Victorians, however, found photographs to be aide-mémoire, keys to recalling the faces and characters of loved ones distant or departed. But as photographs increasingly became the chief means of remembering the past, their specific detail seemed to supplement hazy recollection in the very way that Kracauer observed. Nevertheless, contemporary viewers were aware, as the editorial above suggests, that the imperfect art of photography could not *replace* memory; in fact, it often seemed to *require* memory in order for pictures to make sense. Carte de visite portraits demanded narration, often of a collective nature, especially because they were taken relatively infrequently and displayed none of the character of moment and setting that would become the hallmark of the snapshot. The photograph album acted as a catalyst and occasion for remembrance. It is because of this that we can begin to understand just how viewers of albums in the nineteenth century could find personal significance in pictures that were made to conform to the standards—both photographic and social—of the day.

One of the reasons Kracauer found the process of thumbing through old photographs so disturbing is that the link to the past (and thus first-hand memory) had been severed. By 1927, the picture of the old grandmother at which he gazed had been emptied of meaning, memory, and narrative, without a human connection to the time of its taking. Like many other writers on memory and photography, Kracauer located the temporality of the family

album firmly in the past. Walter Benjamin, Roland Barthes, and the authors of a spate of recent books on family pictures have all taken the position of the modern viewer, and look back at what has become a relic or memorial.[47] At the time of their emergence in the 1860s, however, family photograph albums were the height of novelty; their contents were emphatically of the present and acted as daily reminders for the living. Moreover, many family albums looked toward the future. Articles urged readers to date their photographs for posterity, genealogical albums served as records for descendants, and the blank pages of albums (such as the unclaimed one in the post office story above) implied the arrival of future generations. At that particular moment, at the cusp of modernity, photography and memory were not yet separate. The album's temporality lay in the present, even the future, and the way memory was employed in its viewing was very different from the way we encounter family albums today.

In the nineteenth century, the more appropriate context for the collection of reactions toward photographs of a present that was rapidly slipping away might be *sentiment* rather than memory. The culture of sentiment—a way of experiencing the past and present, particularly at a moment of change exemplified by westward expansion and civil war—pervaded parlor life.[48] Expressed through poetry and fiction, parlor memorials of relics and bell jars, sentiment was a fixture of domestic, feminine life; it involved romantic love, family affection, and female friendships. Sentiment also intersected with the more public instinct of preservation that fueled nascent historical societies, genealogical organizations, and museum collections. To place albums within the context of sentiment rather than memory is to attempt to see what these objects meant at the time of their first use, at the peculiar conjunction of technology and nostalgia that characterized the 1860s and 1870s. It is also to historicize the memorializing impulse rather than approach it from the position of the modern scholar or viewer of photographs.

Poems on the topic of family albums often tend toward the maudlin but seem overwhelmingly concerned with the fact that photographs live on long after their originals. Consider the 1878 poem "The Family Album," by "Sioux" Brubaker, which contains the following verses:

> In pensive mood, I turn the album leaves,
> And, with a gentle joy, I there behold
> The pictured faces of the young and old,
> And those for whom my longing spirit grieves.

> Thus often when with weary cares opprest,
> I take the family album from its place,
> To muse upon some well-beloved face,
> Within the silent tomb, for aye, at rest.[49]

Or these lines, handwritten onto the introductory page of her album by one Ella E. Walters:

> Here may your wandering eyes behold
> The friends of youth, the loved of old;
> And as you gaze, with tearful eye,
> Sweet memories of the years gone by
> Will come again, with magic power
> To charm the evening's pensive hour![50]

In both cases albums provide a human presence now lost, restoring the departed to life. The present has rapidly faded into the past, as if the mere act of photographing loved ones and arranging the pictures in an album consigned them to an earlier time. (Or perhaps it was the act of writing a poem about albums that placed them so emphatically in a sentimental, or nostalgic, mode.) The poems suggest that the album's role was to comfort as it recalled memories, and that the volume itself would be pulled out on numerous occasions to serve this function.

Still, memory—or even sentiment—may not be the only operational term when discussing nineteenth-century photograph albums, regardless of their use as commemorative objects. Maudlin poetry notwithstanding, viewing albums involved a host of functions that did not necessarily include memory: self-presentation, status, social and community connections, genealogy, and preparation for the future. The person paging through an album might not know all the friends and relatives pictured there, much less remember them; to engage with the album, it was enough to point out a family member or recognize him as somehow significant. Moreover, it is important to try to understand what, exactly, these pictures were records *of.* What was being remembered or memorialized in these images? What the photographs portrayed, in the most basic sense, was the act of sitting for the photographer in a highly constructed setting, the sitter manipulated to achieve a pleasing picture. The intention, however, was to produce a *likeness:* a record of character and substance, transcending the moment to represent the person as whole. Unlike a snapshot, which is specifically rooted in time, place, and event, a

portrait must be particular as to personality but general as to setting. From there, the viewer can extrapolate the details, filling in the specifics with his or her own memories of the sitter. What the carte de visite portrayed and what the person thumbing through the album remembered were not necessarily (or even usually) the same; to the standardized portrayal the viewer had to add identification, recollection, and narrative in order to derive some significance from a picture. But because the viewers and sitters were, at the outset of the album craze at least, contemporaneous, the problem that Kracauer outlined was not yet a danger, and memory was just as frequently put to the service of photography as photography was to memory.

Personal memories were beginning to intersect with national histories as both took photographic form in households across the country. In a common nineteenth-century metaphor, the United States was seen to be one great, extended family. This family was enduring a particularly wrenching time in the midst of a war that literally divided homes as it divided the nation. In this household, at least in the North, Abraham Lincoln was the patriarch, and American citizens his children. This rhetoric reverberated in America's photograph albums, which embraced more than just one immediate family. Cartes de visite of far-off relatives could be sent through the mail, shrinking the distance that divided extended families in an era of increasing mobility. Friends, local personages, and even national figures might enter the pages of the nineteenth-century family album. Albums composed entirely of celebrities became national portrait galleries in miniature, allowing their owners to collect, edit, and arrange the figures according to their own preferences or narratives. Although some writers, such as Nod Patterson, advocated keeping two separate collections of photographs—one of the famous and another of the familiar—celebrities such as Civil War generals, stars of the stage, and P. T. Barnum's famous human curiosities might still make their way into the family album, mingling intimately with the portraits of loved ones (figs. 35, 36). As aunts and actresses rubbed shoulders among the album's pages, what resulted was a kind of national album, in which everyone was related, part of a great American family. By collecting widely reproduced celebrity photographs and placing them alongside those of humble family members, the owners of carte de visite albums inserted themselves within a national context, and made their own national identity visible in a newly personal way.

Collecting the portraits of national figures was a way of making sense of the Civil War and the process of nation rebuilding that followed.[51] Ambitious projects such as Mathew Brady's or Alexander Gardner's albums of the war—elaborate portfolios that showed the dead strewn upon fields in the

Fig. 35. Emily C. N. Pullman, carte de visite album with Abraham Lincoln and family photographs, 1860–1879. Chicago History Museum.

aftermath of battle scenes, or companies of soldiers at camp—also brought the war into the parlor. Although Alan Trachtenberg has argued that such compilations, while technically books or portfolios, share an archival mode of discourse with the common album and thus invite the viewer's mediation and narratives, they are in fact quite different in terms of scope and audience. The intimate, affordable carte de visite album made the war seem more personal—if less horrific, perhaps—than did the grand visions of Brady or Gardner. Several collections of cartes of military figures still exist in album form today; to arrange and categorize Union forces as one would family members surely provided a different kind of immediacy and control than looking at Brady and Gardner's war albums. As Andrea Volpe has shown, *collecting* is closely related to the *collective*, and gathering cartes de visite into an album helped preserve a "coherent cultural narrative of national identity" when it could only be imagined, and at the same time revealed national figures as fragments to be rearranged and refigured.[52] Placing portraits of generals alongside loved ones in family albums (Sherman and Grant are favorites in many extant northern albums, Jackson and Lee in southern ones) also shrank these oversized heroes to the scale of family members even

as they elevated the civilians with whom they shared a page.[53] Moreover, the remarkable number of portraits made before a soldier headed off to the front—and the subsequent absence of that father or son from an album, or his altered presence after service—served as frequent reminders that this national event was already being felt in the parlor.

"The Carte de Visite Album," a self-described "comic song" from around 1864, lampooned the curious situations that could arise when celebrity cartes found themselves with unusual bedfellows in the album's pages. In this imagined album—which included all the notables of the moment in battle, stage, or print—the nation took shape, but in strange form: actor Edwin Booth nestled with spiritualist and medium Cora Hatch, abolitionist Wendell Phillips sat alongside a female slave, and Barnum's Giant hovered above young opera singer Adelina Patty. It is in the album's representation of the Union and Rebel armies, however, that things get the most confusing and begin to take on the greatest significance in terms of picturing the nation. The song is written from the northern point of view and takes glee in imagining Abraham Lincoln standing above a rogues' gallery of southern generals, and Confederate leader Jefferson Davis and his men "all stuck, where they soon will be, under our own brave Sherman." (The geography of the photograph album is quite literal here, as one carte's placement over or under another denotes the equivalent social treatment in life.) Finally, the song's last, hopeful stanza compares the photograph album to the American nation, which will soon, through General Sherman's prowess, be rid of the rebel insurgency:

> For, might soon our nation's space
> He'll free from rebel thralldom,
> And traitors then shall have no place
> In Uncle Sam's big Album![54]

"Uncle Sam's big Album"—the reconstructed United States after a northern victory—will include all of these representative figures of American life, with the notable exception of the southern traitors. The carte de visite album, in this song, is so obvious a metaphor for the American nation that the lyricist provides no explanation: as a collection of national figures made visible, intermingled in incongruous and often humorous ways, the album easily stood for a fragmented and diverse population united under some abstract idea of nationhood.

This was not, of course, the first time that a national portrait gallery of eminent men had stood for the entirety of the nation. Charles Willson

Fig. 36. Carte de visite album with Tom Thumb's wedding
juxtaposed with family portraits, 1860s. George Eastman House,
International Museum of Photography and Film, Rochester, New York.

Peale's eighteenth-century museum of oil portraits and silhouettes helped set the stage for the nation-building activity of celebrity worship that found its logical extension in the wave of nineteenth-century daguerreotypists and photographers making celebrity pictures. The most famous photographic assemblage of national personages was created by Brady, whose large Imperial portraits of the era's notables graced his gallery, and whose card portraits of the same personages filled albums by the thousands. The primary difference between the two formats was the way in which the important figures of the day were collected and viewed. Whereas oil paintings or Brady's Imperials were made to fit the heroic scale of a gallery wall, cartes de visite gave heroes the same familiar dimensions as loved ones. Portrait galleries were public places, whereas albums were viewed within the confines of the domestic parlor. In the case of the album, the owner acted as curator of his own gallery, editing the collection and placing well-known figures in greater or lesser proximity to family. With celebrity cartes in seemingly infinite quantities, each household had the possibility of organizing and displaying some permutation of this national album. As one article of the time put it, "These *cartes de visite* . . . multiply national portrait galleries *ad infinitum*. . . . They form portrait collections, on a miniature scale, but with an unlimited range and in every possible variety—family collections, collections of the portraits of friends, and celebrities of every rank and order."[55] By collecting images of the nation's heroes and characters, citizens participated in the creation of a national visual iconography at a time when the concept of the "United States" was undergoing redefinition.

Moreover, it was the possibility of mingling the famous and the familiar that made albums so instrumental in emphasizing the idea of a national family. Judging from surviving albums, it was just as common to insert celebrity cartes in family albums as it was to separate them into their own portrait galleries. The fact that this became accepted practice suggests the equivalence of such photographs: a picture of Abraham Lincoln or a picture of Aunt Hattie was above all a portrait, meant for display in an album. Although the mass-produced celebrity carte and the cherished family photograph were valued for different reasons and imbued with different associations, both formed a regular and integral part of what was becoming a rather extended "family" album. The inclusion of a celebrity portrait in a family album might hint at cosmopolitanism, connections to the worlds of art and literature, or an alliance with a certain political viewpoint. But more than that, it indicated that our private narratives were inextricably linked with public ones, and that all of these people, made visible in photographs and assembled together for

the first time, were part of the same history. Both personal memories and national histories were beginning to take shape visually and together, first in daguerreotypes and then—much more prolifically—in cartes de visite.

If albums did help define some kind of "national family," one way they did so was through the shared experience of viewing the same images in the same way. The practices of collecting, assembling, displaying, and viewing celebrity cartes de visite in albums, repeated in households throughout the country, reiterated and reinscribed the visual construction of the nation. In Benedict Anderson's noted analysis of the origins of national consciousness, a nation is an "imagined community" in which most members are aware of the existence of others even if they never meet.[56] According to Anderson, this awareness occurs with the advent of print-capitalism, primarily through the construction of other readers simultaneously perusing the national press or same popular novel. The private ceremony of poring over a newspaper, for example, is performed on a mass scale, which allows the single reader to recognize the multiple readers performing the same ritual. The same might be said of celebrity cartes de visite, which were produced in such enormous numbers as to pervade the country at nearly the same moment. The recognition that others might possess the exact same images in their personal collection—"If I am looking at a photograph of Lincoln in my album, might someone else be too?"—surely linked album owners through both commodity and ritual. Moreover, the persistent patterns of presentation (of dress, pose, lighting, props, backgrounds, and so on) that helped produce a visual sameness also promoted at least the appearance of belonging to a larger community. Sitters who presented themselves to the camera would find their own standardized appearance in the pictures in others' albums, and would see the patterns of display within those pages repeated in parlors throughout their towns.[57] In the awareness of ritualized behavior and practices—although nobody else is viewing *my* family, everybody is simultaneously looking at *his own*—viewers of even the most personal pictures might have felt a link to a larger community.

The joint creation of the final product that we know as family albums can be seen as taking place at once in the photographer's studio, the manufacturer's factory, and the album-keeper's home. In the factory and studio, the interests of commerce and mass production combined to create a standardized commodity in which all products resembled one another; it remained for the domestic setting and its occupants to give these volumes meaning. Albums and their contents were differentiated from one another on the level

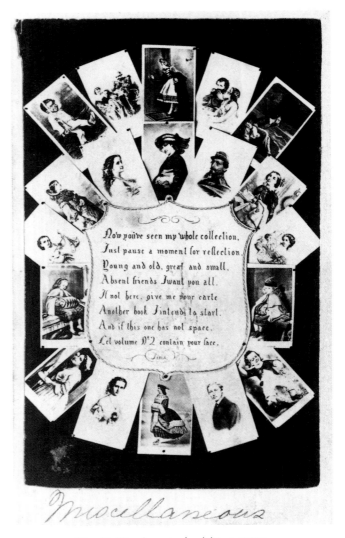

Now you've seen my whole collection,
Just pause a moment for reflection.
Young and old, great and small.
Absent friends I want you all.
If not here, give me your carte
Another book I intend to start.
And if this one has not space,
Let volume N°2 contain your face.
Finis.

Miscellaneous

Fig. 37. Mosaic carte de visite, c. 1860s.
Collection of the late Peter Palmquist.

of individual viewers, who brought memories of the sitters pictured there and often added their own performative histories and stories to the act of viewing the album. Album-keepers also attempted in various ways—through arranging and editing photographs, collecting certain kinds of pictures, or inserting handcrafted elements—to lend personal meaning to a compilation that was rather limited by the realities of commercial production. Because of this tension between individuation and conformity, the family photograph album functioned at once as a means of differentiation and belonging, as cumulative, smaller-scale family memories added up to a nation's history.

The lines that began this chapter charted the social etiquette and conventions of album-viewing, laying out for the viewer the rituals of community inclusion inherent in turning the pages of a photograph album. What we now think of as the Victorian family album was in fact defined in much broader terms than those of the immediate family. The parlor album was not just a book of photographs; it was also a link to the past and to the future, a display of status and social connections in the present, a family genealogy and, in a collective sense, a national history. Once the album was full, however, the ritual of donating a portrait as the price of its viewing became moot. Fortunately, many album-keepers began second albums to accommodate the growing numbers of images marked for inclusion in this extended "family" album. This poem inscribed on a carte de visite (fig. 37) would have graced the last page of an album, as a companion piece to the opening verse:

> Now you've seen my whole collection,
> Just pause a moment for reflection.
> Young and old, great and small,
> Absent friends, I want you all.
> If not here, give me your carte
> Another book I intend to start.
> And if this one has not space,
> Let volume No. 2 contain your face.[58]

THE DEMISE OF THE CARD ALBUM, THE RISE OF THE SNAPSHOT ALBUM

In the wreck of an old worn album
That a child unearthed at play,
I found this little picture—
A leaf from a long-closed day.
That face of boyish beauty
Must now be lined with care;
And the locks of raven blackness
Must gleam with a silver hair.

In this 1884 poem from *Peterson's Magazine,* the author stumbles upon a cherished tintype in a family album that had been hidden among the attic's debris.[1] The album is taken as a relic of the past, a worn wreck whose images hold the possibilities of a generation—a lifetime—before. By the mid-1880s, the carte de visite, the tintype, and the slotted cardboard album had already existed for over two decades and had been thoroughly incorporated into parlor and family life. At the time of its assembly, an early photograph album would have represented the present and future, a collection of the most beloved or important portraits of the day with room for expansion as the family grew or the social landscape changed. A viewer looking back in 1884, however, might have found it quaint and dated. It was the eve of the Kodak snapshot, which would usher in an entirely new kind of picture, photographer, and sensibility, and with them a changed photograph album.

As Victorian aesthetics gave way to modern ones and the sentiment of the parlor yielded to the more casual associations of the living room, carte de

visite collections were replaced by albums of snapshots. Photograph albums would continue to serve the functions of defining a familial past and present, and bringing together a family unit for remembrance and storytelling. But now snapshots, in astonishing numbers, would also begin to map out individual histories. As the carte album gradually fell out of favor and ceded its spot on the parlor table to the snapshot album, records were transformed. The new album shared many of the practices and presentations that originated in the Victorian parlor, but it exploited the new potential for narrative and expression found in the snapshot. It is instructive to analyze this moment of both continuity and change to throw into relief the card album's features, accomplishments, and limitations. By examining how and why the first photograph albums became passé, what characterized the transition away from the card album and toward other kinds of memory collections, and how the new albums changed the representation of families and individuals, we might better understand the functions of America's first photograph albums.

In his 1883 book for professional photographers, H. Baden Pritchard explained a lull in the portrait business with the heading "A Faded Carte": "The family album and the albums of notables have lost their interest, and everybody is tired of looking at the portrait of his grandmother on the first page, and at that of the late Grand Duke of Somewhere, on the last. Most of the pictures are soiled, some are faded, and all have an old-fashioned, by-gone appearance that is the reverse of inspiriting; a sameness pervades the whole volume, for one photographic portrait closely resembles another in tone and treatment."[2] By the mid-1880s this sentiment was surely echoed by the many patrons who had come to view the once-modern carte de visite as worn and shoddy. The stiff poses of the sitters signaled an earlier era, one of headrests and determined stillness in the face of lengthy exposures. Moreover, the subjects of those photographs—and their previously fashionable attire and stylings—had ceased to be the latest thing. Edith Wharton, in her 1912 novel *The Reef,* used the metaphor of the carte de visite to describe Madame de Chantelle, an old and formidable lady of society: "She was a woman of sixty, with a figure at once young and old-fashioned. Her fair faded tints, her quaint corseting, the *passementerie* of her tight-waisted dress, the velvet band on her tapering arm, made her resemble a 'carte de visite' photograph of the middle sixties. One saw her, younger but no less invincibly lady-like, leaning on a chair with a fringed back, a curl in her neck, a locket on her tuckered bosom, toward the end of an embossed morocco album beginning with The Beauties of the Second Empire."[3] As both Pritchard and Wharton point out, it was not only the images that seemed dated: it was also their assemblage

in an album. Whether a collection of French society ladies or the common hierarchies of family ancestors, the album's familiar patterns had themselves become passé. The sameness from one album to another made the enterprise seem tired.

Although the card album continued to be a mainstay of the Victorian parlor, new methods for displaying photographs abounded. An article in *Art Amateur* in 1880 suggested that rather than keeping pictures shut tight in albums, fashion dictated a more casual approach: "Photographs are more frequently now seen in frames, or put about a room, than in albums. They are to be seen on mantel-shelves, often unframed, among the ornaments, or resting against the glass or wall; and sometimes a small table, originally intended for the display of china, with a glass top, is devoted to them."[4] Just as fashion had ushered in the photograph album as a national craze, it was quietly escorting it back out the parlor door when newer styles took hold. Moreover, the parlor itself was changing. By 1910, authors of home furnishing advice manuals were promoting the living room over the parlor as a space for the family to congregate.[5] Sentimental objects were now to be relegated to private quarters, removed from the relatively public display the parlor facilitated. In a shift away from the overstuffed Victorian sensibility that characterized the second half of the nineteenth century, a more casual manner of living, entertaining, and presenting oneself and one's circle through pictures took hold.

This transition happened slowly, and albums did remain in use as well as in favor. This was particularly true of albums containing larger cabinet card portraits, which were popular well into the twentieth century. But the album that remained in the family was often kept away from the daily activities of the parlor, or was a completed (rather than ongoing) collection. The example of Rebecca Sparks Peters is instructive. *The Fotygraft Album* and *The Fambly Album*, both parodies, were written in 1915 and 1917, respectively. At that moment, the cabinet card album was still being trotted out to unsuspecting visitors in order to give them a tour of the family's past. Rebecca, a child whose photograph is not even in the collection (all the pictures are of family members at a younger age), can still relate to this album and to the process of looking back at and explaining the collection of ancestors and locals. But she has to lug the bigger album down from upstairs, where it is kept as a dusty archive rather than as an everyday component of the parlor's furnishings, and her explanations of the family history are at a narrative remove, as she parrots the stories she has heard but never lived herself.

The carte de visite album may have also grown tired because the carte de visite itself had outlived its usefulness to families. Pritchard complained

that part of the reason for photography's perceived decline was the simple fact that fewer people remained unphotographed: "When photography first got within reach of the masses," he wrote, "there were three distinct generations to be photographed: the coming, the passing, and the present. It is not so now. There is only the rising generation to be depicted, and hence a third of the work to be done."[6] The craze to photograph everyone, even retroactively (a small trade existed solely for reproducing daguerreotypes in carte form for albums), had now been fulfilled. Historian William Culp Darrah suggests three different reasons for the fading popularity of the carte de visite: halftone illustrations displaced the carte as a source of amusement; the postcard took over the market for scenic views; and the box camera and roll film (and with it the ability to take one's own pictures) replaced the studio portrait for family photographs.[7] For all the above reasons, industry began to move on, and those changes were echoed in the habits and parlors of American families.

In the period between the card photograph and its ultimate replacement by the snapshot, the lack of standardization complicated the inclusion of photographs in albums. Although there was some continuity with the cabinet card into the twentieth century, the increasing options for photographic formats and sizes meant that the cardboard-page slot album was on the verge of obsolescence. As early as 1875, *Anthony's Photographic Bulletin* noted the plethora of available sizes and suggested that perhaps the scrapbook was a more appropriate receptacle than the traditional album: "It is rarely that a photographic album now-a-days, suffices in a household for the reception of pictures, and many people have a scrap-album in which pictures of all sizes are mounted according to the owner's taste. An ordinary album will only allow for the reception of cartes and cabinets, and, therefore, no other photographs can be purchased than prints of these particular sizes."[8] In contrast to the constraint imposed by the card album's standardization, the freedom to mount images of different sizes in any order or permutation must have been attractive. A later (1917) advertisement for a Kodak album also underscored this point (fig. 38). It depicts a modern couple on a couch paging through an album alongside a vignette of a young couple in nineteenth-century dress doing the same fifty years earlier, as if to say that the album's functions—of preserving the past and enlivening the present—remained, but that the format had been updated. This album was offered with different sizes of openings, so that purchasers could "Keep the Portraits of [Their] Heroes" alongside those of their friends. The advertisement explained the demise of the traditional family album as going hand in hand with a new, and

Keep the Portraits
of your Heroes.

GIVE them the care they deserve, securely held in a substantial album along with the pictures of your other friends.

The multiplicity of sizes in which portraits were made sounded the death-knell of the old-fashioned family album—the album that still contains the portraits of the bearded soldiers of the sixties. Its gorgeous red plush cover would have gone anyway, but the album itself would have lived except for the fact that it could not accommodate its stiff, unyielding self to the heavy mounts and the wide variety in sizes and shapes in which portraits came to be made.

Dame Fashion decrees now-a-days, however, that prints shall be delivered loose in handsome folders or lightly tipped by the corners on thin mounts, from which they are easily removable. This makes it possible to preserve them permanently in an album and we have provided one for the purpose.

The clever thing about the **Eastman Portrait Album** is that each opening provides, by means of masks, for two or more different sizes of prints, thus accommodating 87% of all the sizes now made.

They provide for 48 prints and will accommodate extra leaves to double this capacity.

There is nothing of the gaudy about them. The covers are black grain leather with the one word, "Portraits," gold stamped in the corner. The leaves are in neutral tints; the workmanship excellent.

Sold both by "The Photographer in your town" and photographic dealers. A little circular describing them in detail will be mailed on request.

EASTMAN KODAK COMPANY, ROCHESTER, N. Y.

Fig. 38. Kodak advertisement from *Saturday Evening Post*, 1917.

fashionable, lack of uniformity in photographic production: "The multiplicity of sizes in which portraits were made sounded the death-knell of the old-fashioned family album—the album that still contains the portraits of the bearded soldiers of the sixties. Its gorgeous red plush cover would have gone anyway, but the album itself would have lived except for the fact that it could not accommodate its stiff, unyielding self to the heavy mounts and the wide variety in sizes and shapes in which portraits came to be made."

That variety and multiplicity was due largely to a new photographic format that would change the practice of photography in tremendous ways. With the slogan "You Press the Button, We Do the Rest," George Eastman's Kodak camera, introduced in 1888, ushered in a revolutionary method of making pictures. No longer was photography in the hands of professional studio photographers, with their posing manuals, overstuffed chairs, and painted backdrops. Instead, the box camera and roll film allowed the most untrained amateurs to take pictures in the settings of their choice. It was sold with a roll of stripping paper film that allowed for one hundred circular pictures 2 1/2 inches in diameter; no focusing was required, the shutter was released by pushing a button, and the user advanced the film by turning a key. Once all the pictures on the roll were taken, the customer shipped the entire camera back to Eastman's factory, where it was unloaded, restocked with a fresh roll of film, and returned with prints.[9]

Kodak photographs, later called "snapshots" after the hunting term, differed from their carte de visite predecessors in pronounced ways. They were made in a casual fashion, most often by friends or family members; with a more intimate relationship to the sitter, snapshots resulted in a more informal and spontaneous depiction than did card portraits. In contrast to the comparatively low frequency of visits to the studio photographer, snapshots might be made over and over again, with tens or hundreds of pictures resulting. The accumulation of pictures over time added up to a more complete portrait of a person, who could now be seen at work or at play, with friends, relatives, and pets, abroad on vacation or at home in front of the family car. Such pictures no longer did the cumulative work of portraits—that is, they were not single images meant to represent the person as a whole—but instead acted as fragments that shifted depending on the circumstances. Snapshots, rooted in time and place, became pictures of events (weddings, vacations, picnics, bicycle rides, and so on) as much as of people. By contrast, the carte de visite had effaced time and place with artificial backgrounds that took little notice of the seasons, all in order to focus on the summary presence of the sitter.

Just as the carte de visite had done three decades earlier, the Kodak photograph helped produce an innovative mode of collection and display.[10] The new albums that arose to accommodate the snapshot heralded a break with Victorian style even as many of the album's rituals remained the same.[11] Featuring streamlined covers and paper pages, snapshot albums rid themselves of heavy cardboard leaves with slots for insertion, and eschewed plush covers with brass clasps that recalled Bibles. Weighty connotations of seriousness and preciousness gave way to a more lighthearted and forward-looking

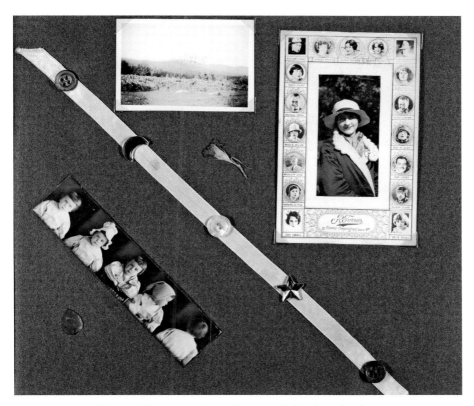

Fig. 39. Album page, through 1930s. Collection of author.

approach. Often black or dark gray, the unadorned pages bore the look of the machine more than the gilded outlines of the domestic parlor. The album photograph no longer adopted the framing conventions of painted portraiture, with embossed vignettes or passepartouts of gold design, but instead stood out against the dark page with a simplicity that would later become a hallmark of modern photographic display.

During this shift from standardized cardboard mounts to the varied paper formats that characterized turn-of-the-century photographs, the contents of albums exhibited a great deal more variety than they had previously. In many extant early snapshot albums, both carte de visite portraits and snapshots are included, along with postcards, clippings, and other scraps (fig. 39).[12] Annotations—about trips, events, characters—sometimes filled the pages as well. No longer limited to the portrait-gallery layout of pictures predetermined by the evenly spaced slots in the cardboard pages, album-keepers found a new freedom. As Marilyn F. Motz has pointed out, in a study of albums kept by women at this transition period, "The creator of this new type of album could arrange photographs symmetrically or asymmetrically,

could overlap photographs, could place photographs at any angle, could cut the photographs into any shape desired, and could combine the photographs with anything flat enough to fit into an album."[13] This ability to manipulate, cut, collage, order, and juxtapose photographs stood in direct contrast to the constraints imposed by the more staid card album.

Much more than their card-portrait predecessors, the new snapshots and albums allowed the construction of a narrative. With sequential pictures of events and places rather than portraits, and often an accompanying text, albums could become more like books, with a beginning, a middle, and an end. The creator of the snapshot album might include telling scraps, like postcards, newspaper headings, or plant specimens; she might assign humorous captions or sketch cartoons around the images. Whereas earlier albums seem to have occasioned tales with their very gaps, as stories arose in parlors to provide background to the studio portraits, by contrast the newer snapshot albums held more information and were often more self-contained. Although the storyteller's function was never entirely superseded—captive visitors today still endure the tales behind the pictures in a family album— later incarnations rarely required the services of a narrator just to make sense of the pages' inhabitants and stories.

The increased opportunity to include so much material in an album also gave rise to many new, specialized versions. By 1903, the *New York Sun* could observe, "This is an age of albums. A score or more of different kinds of albums, portfolios, memory books and diaries are in current use."[14] The article cites albums of plays and operas, one of restaurants, another of balls and parties, the guest book, wedding albums, travel albums, albums of news clippings and public events, genealogical albums, and humor albums. This phenomenon mirrors the state of affairs before the arrival of the carte de visite, when the variety of scrapbooks, commonplace books, and autograph albums had not yet been swept away by the unifying force of the card album craze. With a glut of snapshot photographs and an impressive array of subject-oriented albums, the once catchall category of "family album" had branched into more specialized functions.

In the process, the single album that traced the history and genealogy of the whole family now splintered into multiple albums unique to each individual member of that unit. After the arrival of the Kodak, the enhanced potential for self-presentation and personal narrative—along with the sheer number of images—meant that the maintaining of one's *own* album was much more common. A catalogue of albums, dating from around the end of the century (see fig. 21), made this clear with a headline that announced the pho-

If it isn't an Eastman, it isn't a Kodak.

The Story of the

KODAK ALBUM

It's the intimate, personal story of the home—a picture story that interests every member of the family. And the older it grows, the more it expands, the stronger its grip becomes; the greater its fascination.

Ask your dealer or write us for "At Home with a Kodak."

EASTMAN KODAK COMPANY,
ROCHESTER, N. Y., *The Kodak City.*

Fig. 40. Kodak album advertisement from *Companion* Magazine, 1915.

tograph album as "An Indispensable Possession for Every Person." "One Dictionary, or one Family Bible, may prove sufficient for a *whole household*," the advertisement claimed, "but every *individual* takes delight in the ownership of an *Album* of Portraits of friends and relatives."[15] While one family album had once contained the entire family's past as a cohesive whole, now a series of different but related pasts began to seem a more appropriate record for the times. Individualized albums helped bring about an increased potential for self-expression in album form, especially for women. Marilyn Motz has found that although albums had traditionally been tied to family unity, they were also a means of constructing an identity apart from that family. "Like autobiographies," she argues, "such albums presented women's constructions of their lives as they saw them and as they wished to have them seen by others."[16] In many cases, this was achieved by subverting or parodying the very conventions that the family album helped to establish. The

notion of "the" family album, itself relatively recent in the album's history, provided a backdrop against which individuals might create their own stories.

Although the snapshot increasingly allowed for this kind of self-expression, more often than not snapshot albums celebrated the cohesiveness and conventionality of family. As the sociologist Pierre Bourdieu observed of many twentienth-century albums, "There is nothing more decent, reassuring and edifying than a family album; all the unique experiences that give the individual memory the particularity of a secret are banished from it, and the common past, or, perhaps, the highest common denominator of the past, has all the clarity of a faithfully visited gravestone."[17] That past was made common (and visible) through photograph albums, and it was through albums that it would be kept sacred. In a 1915 Kodak advertisement, two grandparents, a mother, and a young boy and girl crowd around the family album (fig. 40). "The Story of the Kodak Album," the caption reads, is "the intimate, personal story of the home—a picture story that interests every member of the family. And the older it grows, the more it expands, the stronger its grip becomes; the greater its fascination." Now that there was a pictorial past to view (rather than only a pictorial present, as in the carte de visite era), there was more distance between the viewers of an album and those pictured within, and that distance often occasioned storytelling. A generation after the first family albums joined the Bible on the parlor table, the album's role came to be divided between recording the people and events of the day and memorializing ancestors. The snapshot album had a dual function: to record an individualized present and a communal past. In commemorating the family, it took on the work of group memory that had been performed by the carte de visite album.

And yet, as commentators on albums noted in 1903, with all of the printed and photographed information that entered modern albums, there simply was not as much need for memory to fill in the blanks: "The modern album-keeper has the advantage over her progenitors in that photographs, printed notices of interesting places and printed accounts of society doings and gay events are abundant. The old-fashioned girl had to charge her memory with much that the new-timer has already recorded for her."[18] The budding socialite of the early twentieth century could refer to an album to hold what her mind could not. It is here that Kracauer's warning—that photography was replacing memory just as information was supplanting meaning—begins to make more sense. The glut of facts and pictures that might now fill an album (or several, as we have seen) altered the relationship between the collection and its collector, and changed the telling and memorializing functions of the

album. This was not solely a technological development but also a social one; the Kodak and its album became more appropriate means of recording and reliving an increasingly complex experience of modernity in turn-of-the-century America.

Today's photograph album may well be virtual, its viewers half a world away from each other. But even digital cameras, smart phones, many online storage systems, and social networking sites still employ the term "album" to denote a group of pictures brought together for the purpose of organization, narrative, or sharing. Although the format is strikingly different, this contemporary manifestation has its origins in the carte de visite album. The card album of the nineteenth century first assembled family pictures in book form, creating a grouping that was greater than the sum of its parts. It first made this collection available for public display in the parlor, allowing album owners not only to create a record of their past but also to show that record to others. And in the carte de visite album there originated the kinds of storytelling that link family photographs with family memories. These functions were all in place long before the arrival of the snapshot, and they continue to define photograph albums even today.

Ask people the first thing they would save if their house were on fire, and they will almost certainly say their family albums. Although even today's albums, when still compiled—featuring smiling couples, tourists in front of familiar monuments, and children posed with toys—are just as formulaic and repetitive in their own way as carte de visite albums were in the nineteenth century, they are still intensely personal to each album's owner or viewer. Photograph albums have come to represent our past and our present, our ancestors and our friends. The album is more than a collection of recollections, a repository for faces and the stories they inspire; the album is us, ourselves.

At a moment when self-presentation is so technologically mediated, it is all the more important that we understand the conventions, functions, and meanings of albums, and to do that we must start at their beginnings. In looking back at the varied and complex history of the first family albums, it is clear that these collections were outlets for real concerns about the world. They were means for Americans to assimilate changing definitions of family, home, and nation, and to comprehend the new features of modernity; in turn, nineteenth-century albums helped shape these notions. Today, we continue to understand the world—and our own place in it—in no small part through the pictures we take and, especially, the pictures we keep.

INDEX TO PORTRAITS.

1
2
3
4
5
6
7
8
9
10
11
12
13
14
15
16
17
18
19
20
21
22
23
24
25

APPENDIX: PHOTOGRAPH ALBUM POEMS AND SONGS

THE CARTE DE VISITE ALBUM
A Comic Song written for Tony Pastor. Air: Chanting Benny
H. Demarsan, Dealer in Songs, Toys, Books &c., Chatham, N.Y., c. 1864
Collection of the Western Reserve Historical Society, Cleveland

Of novelty this is the age,
 It matters not what it is;
But Albums now are all the rage,
 Filled up with Cartes-de-Visite.

I looked in one, 'twas neatly bound,
 And filled with art's creations—
And men and women there I found
 In curious situations.

CHORUS
But things will get mixed up, you know,
 Though small mistakes we call 'em,
In putting Cartes-de-Visites in
 A fashionable Album.

There Edwin Forrest first I saw,
 Stuck close to Julia Daly,
And Laura Keen under George Law:
 Mrs. Stowe with Horace Greely,
Dan Bryant over Ellen Grey:
 You'd really ought to seen 'em,
And Ada Menkin, young and gay,
 Was next to Johnny Heenan.

CHORUS

Then famous Doctor Tumblety,
 The knight of pill and pestle,

Stuck in a corner there you'd see
　　Along with Madam Restell.
Young Booth just by young Cora Haten,
　　He cut a pretty figure:
With Wendell Philipps sticking to
　　A woolly female nigger.

CHORUS

Fernando Wood and Fanny Fern
　　Were in a corner shady,
While Gideon Welles his turn came next,
　　Close to the famed "French Lady!"
Then Barnum's Giant, gaily dressed,
　　A monster huge and fat, he,
Although much larger than the rest,
　　Was next to little Patty.

CHORUS

Our army, too, the honor shared,
　　From General to sutler:
There was old blackguard Beauregard
　　Put under General Butler;
There was Johnston, Yancey, Toombs and Lee,
　　And Wise, so famed for drinking.
But over this Rogues' Gallery
　　Was honest old Abe Lincoln.

CHORUS

There was Colonel Ellsworth, hero true,
　　Columbia's martyred son, sir,
With Lyon, Lander, Sedgwick, too,
　　Along with Washington, sir.
There was Jeff Davis and the crowd
　　Who now his staff is swelling,
And all stuck, where they soon will be,
　　Under our own brave Sherman.

For, mighty soon our nation's space
 He'll free from rebel thralldom,
And traitors then shall have no place
 In Uncle Sam's big Album!

MY ALBUM
By Ella E. Walters
Ella Walters Album
Collection of the George Eastman House

Within this book, your eye may trace
The well-known smile on friendship's face;
Here may your wandering eyes behold
The friends of youth, the loved of old;
And as you gaze, with tearful eye,
Sweet memories of the years gone by
Will come again, with magic power
To charm the evening's pensive hour!
Some in this book have passed the bourne
From whence no travellers return,
Some through the world yet doomed to roam
As Pilgrims from their native home,
Are here, by nature's power enshrined,
As loved memorials to the mind,
Till all shall reach that happy shore,
Where friends and kindred part no more.

THE FAMILY ALBUM

By "Sioux" Brubaker

St. Louis Practical Photographer 2, no. 3 (March 1878): 84

In pensive mood, I turn the album leaves,
And, with a gentle joy, I there behold
The pictured faces of the young and old,
 And those for whom my longing spirit grieves.

For some have passed the way we all must pass,
And since long years have mouldered in the tomb,
Those darling ones, whose memory, like perfume,
 Floats o'er the spirit as we sigh, alas!

And some are far away across the sea;
Afar from home and friends, in foreign lands,
May-be to die without a mother's hands,
 To smooth their death bed pillows tenderly.

Between these album lids of blue and gold
The pictures of these friends are fondly placed,
More true and life-like than were ever traced
 By any of the master hands of old.

And there, for there is naught that I possess
More highly valued than this album here,
Which grows more precious yet, year after year,
 Like memories of some long past blessedness.

Here are my sainted parents, side by side;
Old age has given them their silver hairs,
And many wrinkles, brow of many cares—
 My father stern, my mother gentle-eyed.

And here are all my uncles and my aunts,
Old-fashioned men and women, true as steel,
Whose faces show the pious love they feel
 Towards heaven for the mercies heaven grants.

And here is she who ruled my boyish heart;
Sweet smiles about her lips forever play;
Her head is tipped in a coquettish way,
 As if to note how sped God-cupid's dart.

And here we are, my loving wife and I,
Our darling children grouped about our knees,
Such lovely children as one seldom sees;
 And one of them, sweet Maud, has passed on high.

And here are all the merry girls and boys,
My comrades in sweet childhood's golden days,
Who shared with me the glorious school-ground plays,
 Replete with life's most pure and precious joy.

Thus often when with weary cares opprest,
I take the family album from its place,
To muse upon some well-beloved face,
 Within the silent tomb, for aye, at rest.

And lovely faces of the fragrant yore,
Like radiant angels float before my soul,
And from the past drift to a fairer goal,
 Where we shall meet to part, ah! never more.

THE ALBUM
Harper's Weekly (May 24, 1879): 410

My photograph album? Certainly,
You can look, if you wish, my dear;
To me it is just like a grave-yard,
Though I go through it once a year.
Any new faces? No, indeed. No,
I stopped collecting some years ago.

And yet, Jeannette, look well at the book:
It is full of histories strange;
The faces are just an index, dear,

To stories of pitiful change—
Drama and poem and tragedy,
Which I alone have the power to see.

Ah! I thought you would pause at that face;
She was fair as a poet's lay,
The sweetest rose of her English home,
Yet she perished far, far away:
In the black massacre at Cawnpore
She suffered and died—we know no more.

And that? Ah, yes, 'tis a noble head!
Soul sits on the clear, lofty brow;
She was my friend in the days gone by,
And she is my enemy now.
Mistake, and wrong, and sorrow—alas!
One of life's tragedies—let it pass.

This face? He was my lover, Jeannette;
And perchance he remembers to-day
The passionate wrong that wrecked us both
When he sailed in his anger away.
Heart-sick and hopeless through weary years,
At length I forgot him—despite these tears.

That handsome fellow? He loved me too;
And he vowed he would die, my dear,
When I told him "No"—'tis long ago:
He married the very next year.
That one I liked a little, but he
Cared much for my gold, nothing for me.

Brides and bridegrooms together, dear,
And most of them parted to-day;
Some famous men that are quite forgot,
Some beauties faded and gray.
Close the book, for 'tis just as I said—
Full of pale ghosts from a life that's dead.

NOTES

INTRODUCTION

Epigraph: Walter Benjamin's comments on albums can be found in "A Short History of Photography," reprinted in *Classic Essays on Photography*, ed. Alan Trachtenberg (New Haven: Leete's Island, 1980), 206.

1. Benjamin, "Short History of Photography," 211.

2. Early histories of photography are reviewed in Martin Gasser, "Histories of Photography, 1839–1939," *History of Photography* 16, no. 1 (Spring 1992): 50–60. A more recent overview is Douglas R. Nickel, "History of Photography: The State of Research," *Art Bulletin* 83, no. 3 (September 2001): 548–58. An exception to this art historical model, and which does address carte de visite albums, is Robert Taft, *Photography and the American Scene: A Social History of Photography, 1839–1889* (New York: Dover, 1938).

3. See, for example, Geoffrey Batchen, "Vernacular Photographies," *History of Photography* 24, no. 3 (Autumn 2000): 262–71 (part of a special issue on vernacular photography), as well as Batchen's *Forget Me Not: Photography and Remembrance* (New York: Princeton Architectural Press, 2004). Vernacular photography has also been the subject of exhibitions at the Metropolitan Museum of Art, the National Gallery of Art, and the San Francisco Museum of Modern Art, among other institutions. Album practices have been covered in Liz Wells, ed., *Photography: A Critical Introduction* (London: Routledge, 1997), and Michel Frizot, ed., *A New History of Photography*, English-language ed. (Cologne: Könemann, 1998).

4. These studies generally bypass the decades before the Kodak, in which many of the conventions of bringing together pictures in a family assemblage were established. It seems to be the opinion of many scholars that family photography begins with the snapshot, because it was then, they argue—as people began to make their own pictures—that photography became intimate, personal, and expressive. For more on snapshot albums, see Audrey Linkman and Caroline Warhurst, *Family Albums* (Manchester: Manchester Polytechnic, 1982); Jo Spence and Patricia Holland, eds., *Family Snaps: The Meaning of Domestic Photography* (London: Virago, 1991); Philip Stokes, "The Family Photograph Album: So Great a Cloud of Witnesses," in *The Portrait in Photography*, ed. Graham Clarke (London: Reaktion, 1992), 193–205; Annette Kuhn, *Family Secrets: Acts of Memory and Imagination* (New York: Verso, 1995); Marianne Hirsch, *Family Frames: Narrative Photography and Postmemory* (Cambridge, Mass.: Harvard University Press, 1997); Marianne Hirsch, ed., *The Familial Gaze* (Hanover: University Press of New England, 1999); Barbara Levine and Stephanie Snyder, *Snapshot Chronicles: Inventing the American Photo Album* (New York: Princeton Architectural Press, 2006); and Sarah Greenough et al., *The Art of the American Snapshot, 1888–1978* (Washington, D.C.: National Gallery of Art, 2007).

5. These generally focus more on the biographies of their makers. For example, see Marilyn F. Motz, "Visual Autobiography: Photography Albums of Turn-of-the-Century Midwestern Women," *American Quarterly* 41, no. 1 (March 1989): 63–92; Sarah McNair Vosmeier, "Seeing the South: Family Photograph Albums and Family History, 1860–1930," *Southern Quarterly* 36, no. 4 (Summer 1998): 10–19; and Angela Wheelock, "Icons of the Family: Nineteenth Century Photograph Albums," in *Michigan: Explorations in Its Social History*, ed. Francis X. Blouin and Maris A. Vinovskis (Ann Arbor: Historical Society of Michigan, 1987).

6. See Elizabeth Anne McCauley, *A. A. E. Disdéri and the Carte de Visite Portrait Photograph* (New Haven: Yale University Press, 1985); and *Industrial Madness: Commercial Photography in Paris, 1848–1871* (New Haven: Yale University Press, 1994); Steve Edwards, *The Making of English Photography: Allegories* (University Park: Pennsylvania State University Press, 2006); Shirley Teresa Wajda, "'Social Currency': A Domestic History of Portrait Photography in the United States" (Ph.D. diss., University of Pennsylvania, 1992); and Andrea Volpe, "Cheap Pictures: Cartes de Visite Portrait Photographs and Visual Culture in the United States, 1860–1877" (Ph.D. diss., Rutgers University, 1999).

7. See Reese V. Jenkins, *Images and Enterprise: Technology and the American Photographic Industry, 1839 to 1925* (Baltimore: Johns Hopkins University Press, 1975) for how the economic and marketing changes of the nineteenth century affected the business of photography.

8. Karen Halttunen, *Confidence Men and Painted Women: A Study of Middle-Class Culture in America, 1830–1870* (New Haven: Yale University Press, 1982), 29.

9. For more on the interrelatedness of the commercial scene, see Jenkins, *Images and Enterprise*; William and Estelle Marder, *Anthony: The Man, the Company, the Cameras* (Plantation, Fla.: Pine Ridge, 1982); Taft, *Photography and the American Scene*; and entries on individual journals in *Encyclopedia of Nineteenth-Century Photography*, ed. John Hannavy (New York: Taylor and Francis, 2008). Photography journals reprinted essays and articles from a variety of sources, popular as well as scientific, and they traded articles liberally with European publications (especially England); as much as possible, I have marked those sources that initially derived from elsewhere.

10. Edwards, *Making of English Photography*, 4; this book provides a nuanced critical look at the nineteenth-century photographic press in England.

11. Some scholars, such as Allan Sekula and John Tagg, have argued that studio photographs and albums are the flip side of another kind of archive, the police file, noting that these twin registers acted both honorifically and repressively—as a privilege or as a burden—in archiving society. See Allan Sekula, "The Body and the Archive," in *The Contest of Meaning: Critical Histories of Photography*, ed. Richard Bolton (Cambridge, Mass.: MIT Press, 1992), 342–89, and John Tagg, *The Burden of Representation: Essays on Photographies and Histories* (Minneapolis: University of Minnesota Press, 1993).

12. Benedict Anderson, *Imagined Communities: Reflections on the Origins and Spread of Nationalism* (New York: Verso, 1992).

13. "Photomania," *Harper's Weekly* 5, no. 216 (February 16, 1861): 99.

14. *Oxford English Dictionary*, 2nd ed., prepared by J. A. Simpson and E. S. C. Weiner (Oxford: Clarendon, 1989), 1: 298. In ancient times, the album was a tablet on which public notices were recorded.

15. *The Friendly Repository and Keepsake of Mary Eliza Bachman*, 1831–1839, Winterthur Museum and Library, Doc. 722 (66x065). Poem inscribed "To Eliza" (March 1832), page 57.

16. Bill Nye, "The Baneful 'Photographic Habit,'" *Boston Globe*, undated newspaper clipping; reproduced by Kathleen Collins in *History of Photography* 10, no. 1 (January–March 1986): 71–72.

17. At the time of this writing, some of the most prominent social networking sites include Facebook and MySpace (social), LinkedIn (business), and Flickr (photo sharing).

CHAPTER ONE. THE CURRENCY OF THE CARTE DE VISITE

1. Oliver Wendell Holmes, "Doings of the Sunbeam," *Atlantic Monthly* 12 (July 1863): 1–15; reprinted in *Photography: Essays and Images*, ed. Beaumont Newhall (New York: Museum of Modern Art, 1980), 69. The terms *carte de visite, carte, card photograph*, and *card picture* were used interchangeably.

2. Holmes, "Doings of the Sunbeam," 69.

3. On early American family portraiture and material culture, see Karin L. Calvert, "Children in Family Portraiture, 1670–1810," *William and Mary Quarterly* 39, no. 1 (January 1982): 87–113; idem, *Children in the House: The Material Culture of Early Childhood, 1600–1900* (Boston: Northeastern University Press, 1992); and Margaretta Lovell, "Reading Eighteenth-Century American Family Portraits: Social Images and Self-Images," *Winterthur Portfolio* 22, no. 4 (Winter 1987): 243–64.

4. On American miniatures, see Robin Jaffee Frank, *Love and Loss: American Portrait and Mourning Miniatures* (New Haven: Yale University Press, 2000); on silhouettes, see Alice Van Leer Carrick, *Shades of Our Ancestors: American Profiles and Profilists* (Boston: Little, Brown, 1928); and Shirley Teresa Wajda, "'Social Currency': A Domestic History of Portrait Photography in the United States" (Ph.D. diss., University of Pennsylvania, 1992).

5. Some excellent overviews on the daguerreotype in America include Merry A. Foresta and John Wood, *Secrets of the Dark Chamber: The Art of the American Daguerreotype* (Washington, D.C.: National Museum of American Art and Smithsonian Institution Press, 1995); Beaumont Newhall, *The Daguerreotype in America* (New York: Dover, 1976); Richard Rudisill, *Mirror Image: The Influence of the Daguerreotype on American Society* (Albuquerque: University of New Mexico Press, 1971); and Keith F. Davis, *The Origins of American Photography: From Daguerreotype to Dry-Plate, 1839–1885* (Kansas City: Hall Family Foundation and Nelson-Atkins Museum of Art, 2007).

6. "The True Artist," *Daguerreian Journal* 2, no. 8 (August 15, 1851): 216; on the Scovill "family case," see "Family Cases," *Humphrey's Journal* 10, no. 10 (September 15, 1858): 147.

7. Newhall, *Daguerreotype in America*, 67.

8. The definitive study of the carte de visite in France, and its originator Disdéri, is Elizabeth Anne McCauley's *A. A. E. Disdéri and the Carte de Visite Portrait Photograph* (New Haven: Yale University Press, 1985). For the carte in England, consult Steve Edwards, *The Making of English Photography: Allegories* (University Park: Pennsylvania State University Press, 2006) and Audrey Linkman, *The Victorians: Photographic Portraits* (New York: Tauris Parke, 1993), 61–81. On the carte de visite in America see two thorough dissertations: Wajda, "Social Currency," which looks more broadly at portraiture in the attempt to discern how photography helped map out status relations; and Andrea Volpe, "Cheap Pictures: Cartes de Visite Portrait Photographs and Visual Culture in the United States, 1860–1877" (Ph.D. diss., Rutgers University, 1999), which sees the carte de visite as a means by which Americans understood the Civil War, national identity, and a modern economy. See also William Culp Darrah, *Cartes-de-Visite in Nineteenth-Century Photography* (Gettysburg: W. C. Darrah, 1981); Dan Younger, "Cartes-de-Visite: Precedents and Social Influences," *CMP Bulletin* 6, no. 4 (1987): 1–24; and Andrea Volpe, "Carte de Visite Portrait Photographs and the Culture of Class Formation," in *The Middling Sorts: Explorations in the History of The American Middle Class*, ed. Burton J. Bledstein and Robert D. Johnston (New York: Routledge, 2001), 157–69.

9. McCauley, *Disdéri and the Carte de Visite*, 34. Later carte de visite fashions focused on head and shoulders, often vignetted.

10. Jabez Hughes, "Carte de Visite Portraits," *Humphrey's Journal* 13, no. 12 (October 15, 1861): 187.

11. Charles Waldack, *The Card Photograph: An Appendix to the Third Edition of a Treatise on Photography* (Cincinnati: H. Watkin, 1862), 5. Early examples of mounted photographs used as calling cards can be found from the 1850s, a bit smaller in format and with the name printed on the front, but they are not the standardized cartes de visite imported from Europe; one is reproduced in Younger, "Cartes-de-Visite."

12. S. A. Frost, *The Laws and By-Laws of American Society* (New York: Dick and Fitzgerald, 1869), 150. Mrs. H. O. Ward, in *Sensible Etiquette of the Best Society, Customs, Manners, Morals, and Home Culture* (Philadelphia: Porter and Coates, 1878), devotes fully forty-five pages to the particulars of the card ritual, with advice on whom to leave cards for, how many, by whom, folded or not, what hour to visit, who should return visits, what to do in cases of mourning or the newly married, what to wear for receiving and visiting, who stands or sits, etc.; see pages 53–97. See also *The Bazar Book of Decorum: The Care of the Person, Manners, Etiquette, and Ceremonials* (New York: Harper and Brothers, 1871), chapter 18; *Social Etiquette of New York* (New York: D. Appleton, 1883), chapter 6; and Kenneth Ames's study of the hallstand, hall seating, and card receivers, in his *Death in the Dining Room, and Other Tales of Victorian Culture* (Philadelphia: Temple University Press, 1992).

13. "Cartes de Visite," *American Journal of Photography* 4, no. 12 (November 15, 1861):

265. This article was condensed from the British *Art-Journal*, and was also reprinted in *Humphrey's Journal* 13, no. 21 (March 1, 1862): 326–30.

14. "Carte de Visites," advertisement/poem by Davis and Company, Boston, selling cartes from $1 to $2.50 per dozen. Handwritten date at top, "March 1864." Photography files, Society for the Preservation of New England Antiquities, Boston.

15. Marcus Aurelius Root wrote that C. D. Fredericks & Company were the first to make cartes de visite in the United States and that the publishers/booksellers Messrs. Appleton of New York first started selling them (mostly of celebrities) at their counters. Root, *The Camera and the Pencil; or the Heliographic Art* (Philadelphia: J. B. Lippincott, 1864), 381–82. However, George C. Rockwood also claimed to be first; see Darrah, *Cartes-de-Visite in Nineteenth-Century Photography*, 5.

16. "Editorial Miscellany," *American Journal of Photography* 4, no. 15 (January 1, 1862): 360.

17. "Cartes de Visite," *American Journal of Photography* 4, no. 12 (November 15, 1861): 265–66.

18. Collection of the Winterthur Museum and Library, Doc. 152 (90x8). For more on courtship, see Ellen K. Rothman, *Hands and Hearts: A History of Courtship in America* (New York: Basic, 1984); and Sarah McNair Vosmeier, "The Family Album: Photography and American Family Life Since 1860" (Ph.D. diss., Indiana University, 2003), especially chapter 2, "'Use of a Gentleman's Picture': Photographs in Friendship and Courtship in the 1860s." Although focusing on England, Patrizia Di Bello's *Women's Albums and Photography in Victorian England: Ladies, Mothers and Flirts* (Aldershot, Eng.: Ashgate, 2007) also provides a useful analysis of flirting through the exchange of photographs.

19. Andrew Wynter, "Cartes de Visite," *American Journal of Photography* 4, no. 21 (April 1, 1862): 483.

20. "Photographic Eminence," *Humphrey's Journal* 16, no. 6 (July 15, 1864): 93. Photographers maintained negatives—the number was often written on the back of the card—for future reprints, again usually by the dozen.

21. "Editorial Department," *American Journal of Photography* 3, no. 17 (February 1, 1861): 272.

22. "Fashions," *Littel's Living Age* 73, no. 936 (May 10, 1862): 299–300 (reprinted from the British *Saturday Review*).

23. Darrah notes that after the war, many photographers generally lowered their prices to $1.50 per dozen, while the finer studios in large cities raised their prices to $3 to $3.50 per dozen to appeal to a better clientele. Darrah, *Cartes-de-Visite in Nineteenth-Century Photography*, 19. It should be noted here that there was an even cheaper alternative to the carte de visite, one that was also formatted to fit into the carte album: the tintype. Its main drawback, compared to the carte, was that it was a unique image. A direct collodion positive on japanned iron, the tintype was (like the daguerreotype or ambrotype) not inherently reproducible, but multiples could be produced at the time of the sitting: a camera with multiple lenses, like that of the carte camera, produced a sheet of pictures on iron which were then clipped apart with shears. The tintype was also light enough to be sent

through the mails, and itinerant photographers who didn't need to make paper prints had a booming business on the warfront as soldiers sent home portraits of themselves in uniform. Although the tintype didn't achieve the ubiquity of the carte de visite, it shared many of the characteristics that made it so popular— affordability, portability, and some reproductive capacity—and can be seen as a slightly cheaper, often more informal, complement to the card picture. The definitive guide on the tintype, if somewhat geared toward collectors, is Floyd Rinhart, Marion Rinhart, and Robert W. Wagner, *The American Tintype* (Columbus: Ohio State University Press, 1999); see also Robert Taft, *Photography and the American Scene: A Social History of Photography, 1839–1889* (New York: Dover, 1938).

24. "The Photographic Art a Blessing to the World—Cartes de Visite," *American Journal of Photography* 5, no. 4 (August 15, 1862): 77 (reprinted from *Scientific American*).

25. All in the collection of the Winterthur Museum and Library. John Dickinson Logan account book, 1863–67, doc. 151 (77x620); Miss H. R. Weldin expense book, 1865–70, doc. 211 (91x025); and Kirkbride Diary, 1868–69. Some of Miss Weldin's other discretionary expenses, for purposes of comparison, included regular donations to the church and poor families of about 50 cents, a bonnet for $7, two yards of chintz for 70 cents, and binding and papers for 50 cents. Kirkbride's regular lunch ("dinner") cost 15 to 25 cents, the streetcar 25 cents. For more comparable expenses and wages, see Scott Derks, ed., *The Value of a Dollar: Prices and Incomes in the United States, 1860–2004* (Millerton, N.Y.: Grey House, 2004).

26. "Date Your Photographs," *Humphrey's Journal* 16, no. 16 (December 15, 1864): 254 (reprinted from *Harper's Monthly*).

27. E. Legouvé, "A Photographic Album [continued]," *Photographic Times* 4, no. 41 (May 1874): 69.

28. R. H. E., "My Photograph," *Godey's Lady's Book* 74 (April 1867): 341.

29. "The Photographic Art a Blessing to the World—Cartes de Visite," 77.

30. Lucy W. Lawrence household account books, 1873–79, in four volumes. Winterthur Museum and Library, Doc. 221, vol. 3 (91x123.3) and vol. 4 (91x123.4). For more on baby pictures, see Shawn Michelle Smith, "'Baby's Picture Is Always Treasured': Eugenics and the Reproduction of Whiteness in the Family Photograph Album," *American Archives: Gender, Race, and Class in Visual Culture* (Princeton: Princeton University Press, 1999); and Josephine Gear, "The Baby's Picture: Woman as Image Maker in Small-Town America," *Feminist Studies* 13, no. 2 (Summer 1987): 419–42.

31. Jabez Hughes, "Photography as an Industrial Occupation for Women," *Anthony's Photographic Bulletin* 4, no. 6 (June 1873): 164 (reprinted from the *London Photographic News*).

32. "The Photographic Art a Blessing to the World—Cartes de Visite," 77–78. A corollary to taking several pictures over the course of a lifetime was a need to fix these many images within a family's history. In the face of large numbers of relatively indistinguishable portraits and an increasingly photographic past, journal articles urged readers to date their photographs. See "Date Your Photographs," 254.

33. *Frank Leslie's Illustrated Newspaper* 13, no. 325 (February 15, 1862): 207.

34. John E. Cussans, "The Past and Future of Photography," *Humphrey's Journal* 17, no. 1 (May 1, 1865): 7.

35. Root, *Camera and the Pencil*, 26.

36. Ibid., 414.

37. The destination of these unclaimed portraits is particularly intriguing, as they form a sort of national album of lost souls: "Thousands, however, came back to the office for the second time, and these were all inserted in an immense album, containing several thousand portraits, which is kept in the so-called 'museum' attached to the Dead-Letter Office, and shown to visitors as one of its curiosities." Louis Bagger, "The Dead-Letter Office," *Appleton's Journal* 10, no. 242 (November 8, 1873): 595.

38. Root, *Camera and the Pencil*, 368. On photography and the Civil War in general, see Keith F. Davis, "'A Terrible Distinctness': Photography of the Civil War Era," in *Photography in Nineteenth-Century America*, ed. Martha A. Sandweiss (New York: Harry N. Abrams, 1991). For an analysis of how cartes de visite helped the nation visualize and understand the war, see Volpe, "Cheap Pictures."

39. "The Carte de Visite," *Harper's New Monthly Magazine* 25, no. 148 (September 1862): 480.

40. "Photographs," *Godey's Lady's Book* 69 (November 1864): 421.

41. Emily J. Mackintosh, "The 'Carte de Visite,'" *Peterson's Magazine* 44, no. 5 (November 1863): 376.

42. Holmes, "Doings of the Sunbeam," 77.

43. Edward L. Wilson, "To My Patrons," in *Photography: Essays and Images*, ed. Beaumont Newhall (New York: Museum of Modern Art, 1980), 129–33. The statistics on publication and sales are from Newhall's introduction to the pamphlet.

44. Wajda, "Social Currency."

45. M. DeValicourt, "Photographic Portraiture: On Likeness in Photographic Portraits," *Humphrey's Journal* 13, no. 22 (March 15, 1862): 348.

46. D. Welch, "A Few Hints on the Best Means of Obtaining Good Cartes de Visite," *Humphrey's Journal* 17, no. 4 (June 15, 1865): 59–60.

47. "Editor's Table: Portraits in Photography," *Peterson's Magazine* 45, no. 6 (June 1864): 459; Wilson, "To My Patrons," 131.

48. Chip, *How to Sit for Your Photograph* (Philadelphia: Benerman and Wilson, c. 1865), 28–29. A copy of the pamphlet can be found at the Smithsonian Institution, National Museum of American History. An excellent source on nineteenth-century American fashion is Joan L. Severa, *Dressed for the Photographer: Ordinary Americans and Fashion, 1840–1900* (Kent, Ohio: Kent State University Press, 1995).

49. Wilson, "To My Patrons," 130.

50. A[lexander] Hesler, "Advice by an Old Photographer to Those Having Photographs Taken," *Anthony's Photographic Bulletin* 4 (December 1873): 365.

51. DeValicourt, "Photographic Portraiture," 348. For an analysis of the posing apparatus, from headrests to posing chairs, as well as a discussion of gender

conventions in posing, see Volpe, "Cheap Pictures," especially chapter 3, "Bodily Attitudes: Posing Stands and the Construction of the Respectable Body."

52. Chip, *How to Sit for Your Photograph*, 23.

53. See Karen Halttunen, *Confidence Men and Painted Women: A Study of Middle-Class Culture in America, 1830–1870* (New Haven: Yale University Press, 1982), 40.

54. Chip, *How to Sit for Your Photograph*, 9–10, emphasis in original; Wilson, "To My Patrons," 132.

55. Alexander M. Gow, *Good Morals and Gentle Manners for Schools and Families* (New York: Wilson, Hinkle, 1873), 192–93.

56. H. J. Rodgers, *Twenty-Three Years Under a Sky-Light, or Life and Experiences of a Photographer* (1872; reprint, New York: Arno, 1973), 65–66, emphasis in original. A series of engravings of different exaggerated facial expressions follows this remark.

57. Holmes, "Doings of the Sunbeam," 70, emphasis in original.

58. Root, *Camera and the Pencil*, 46–48.

59. Rodgers, *Twenty-Three Years Under a Sky-Light*, 84, emphasis in original. Significantly, this advice comes in the chapter titled "Expression—How to Look Beautiful and Create Beauty."

60. Some of this was technical; most guides included posing suggestions that avoided the lens's elongation of limbs. On general proportions and poses, see A. Disdéri, "The Aesthetics of Photography," *Humphrey's Journal* 15, no. 8 (August 15, 1863): 124–28; and Rodgers, *Twenty-Three Years Under a Sky-Light*. Other flattering tricks included playing with the light source (brighter light would call attention to a feature, while less light could allow it to fade into obscurity), vignetting the portrait to hide a corpulent or awkward physique, and retouching the negative.

61. R. H. E., "My Photograph," 341.

62. Root, *Camera and the Pencil*, 32.

63. A. Disdéri, "The Aesthetics of Photography" (concluded), *Humphrey's Journal* 15, no. 10 (September 15, 1863): 155.

64. Hughes, "Carte de Visite Portraits," 188.

65. "Cartes de Visite of Celebrities," *American Journal of Photography* 5, no. 14 (January 15, 1863): 324.

66. "Backgrounds," *Anthony's Photographic Bulletin* 10 (October 1880): 307.

67. S. R. Divine, "Hints on Card Pictures," *Humphrey's Journal* 13, no. 16 (December 15, 1861): 241. The writer also offers suggestions for gendered props, recommending that women be shown in domestic interiors or in a boudoir scene, while men be given a column, representing an exterior view.

68. For the technical details of backgrounds, see John F. Cussans, "Concerning Backgrounds," *Humphrey's Journal* 16, no. 21 (March 1, 1865): 327–29; G. M. Carlisle, "The Background, Its Use and Abuse," *Anthony's Photographic Bulletin* 16, no. 16 (August 22, 1885): 490–93; and Darrah, *Cartes-de-Visite in Nineteenth-Century Photography*, 31–32. On the ongoing use of photographic backdrops today, especially in colonial settings, see James Wyman et al., "From the Foreground to the Background: The Photo Backdrop and Cultural Expression," *Afterimage* 24, no. 5

(March–April 1997), a special issue on the photographic backdrop in nineteenth- and twentieth-century photography.

69. "Backgrounds," 307.

70. "Sitting for a Picture," *St. Louis Practical Photographer* 4, no. 12 (December 1880): 422–23.

71. A. R. Crinfield, "Relation of Backgrounds to Subjects," *Philadelphia Photographer* 8, no. 86 (February 1871): 55. At the end of this article, Crinfield advocated a plain background for sitters from every condition of life.

72. James Mackay, "A Few Remarks on Backgrounds," *Photographic Times* 1, no. 1 (January 1871): 5.

73. Rev. H. J. Morton, "Photography Indoors," *Philadelphia Photographer* 1, no. 7 (July 1864): 105.

74. "How to Make Things Go: Part X," *Photographic Times* 1, no. 10 (October 1871): 152.

75. *The Private Mary Chesnut: The Unpublished Civil War Diaries*, ed. C. Vann Woodward and Elisabeth Muhlenfeld (Oxford: Oxford University Press, 1984), 50. The following quotations can be found on pages 51–53. See also Wajda's analysis of Chesnut's reactions in "Social Currency," 507–10.

76. Chip, *How to Sit for Your Photograph*, 41.

77. "Retouching Negatives," *Humphrey's Journal* 16, no. 10 (September 15, 1864): 151, 153.

78. Chip, *How to Sit for Your Photograph*, 46.

79. "Sitting for a Picture," 421, emphasis added.

80. Chip, *How to Sit for Your Photograph*, 25.

81. Bogardus quoted from *Anthony's Photographic Bulletin* 15 (1884): 65, in Newhall, *The History of Photography from 1839 to the Present* (New York: Museum of Modern Art, 1982), 64.

82. "Sitting for a Picture," 424, emphasis in original.

83. *The Private Mary Chesnut*, 49.

84. "Brady's New Photographic Gallery, Broadway and Tenth Street," *Frank Leslie's Illustrated Newspaper* 11, no. 267 (January 5, 1861): 106. For more on Brady, see Mary Panzer's thorough *Mathew Brady and the Image of History* (Washington, D.C.: Smithsonian Institution Press for the National Portrait Gallery, 1997); and Alan Trachtenberg, "Illustrious Americans," in *Reading American Photographs: Images as History, Mathew Brady to Walker Evans* (New York: Hill and Wang, 1989).

85. Wajda, "Social Currency," 338.

86. An Outsider, "My First Carte de Visite," *American Journal of Photography* 5, no. 15 (February 1, 1863): 337–43; and idem, "My First Cartes de Visite, and What Became of Them," *American Journal of Photography* 5, no. 17 (March 1, 1863): 385–92. Volpe provides an insightful analysis of this story in terms of metaphors of speculation and the stock market, calling the account a "cultural narrative of economic transformation and of the emerging terms on which the cultural economy of industrial capitalism would be constructed." Volpe, "Cheap Pictures," 239–40.

87. An Outsider, "My First Cartes de Visite, and What Became of Them," 387.

88. Ibid.

89. Tom Gunning, "Phantom Images and Modern Manifestations: Spirit Photography, Magic Theater, Trick Films, and Photography's Uncanny," in *Fugitive Images: From Photography to Video*, ed. Patrice Petro (Bloomington: Indiana University Press, 1995), 42–43.

90. An Outsider, "My First Cartes de Visite, and What Became of Them," 392.

91. "Photographic Eminence," *Humphrey's Journal* 16, no. 6 (July 15, 1864): 93–94 and *American Journal of Photography* 7, no. 2 (July 15, 1864): 45. See also Darrah, *Cartes de Visite in Nineteenth-Century Photography*, 49–53.

92. For an overview of nineteenth-century celebrity photographs, see Barbara McCandless, "The Portrait Studio and the Celebrity: Promoting the Art," in *Photography in Nineteenth-Century America*, ed. Martha A. Sandweiss (Fort Worth: Amon Carter Museum and Harry N. Abrams, 1991), 48–75. On precursors to celebrity cartes de visite, see "Parlor People," chapter 5 in Wajda's "Social Currency." On the *Gallery of Illustrious Americans*, see Panzer, *Mathew Brady and the Image of History*, and Trachtenberg, "Illustrious Americans."

93. "A Broadway Valhalla: Opening of Brady's New Gallery," *American Journal of Photography* 3, no. 10 (October 15, 1860): 151–53; reprinted in Panzer, *Mathew Brady and the Image of History*, 220.

94. Trachtenberg, "Illustrious Americans," 33.

95. "Brady's Collection of Historical Portraits," 41st Congress, 3rd sess., House of Representatives Report no. 46, March 3, 1871.

96. Trachtenberg, "Illustrious Americans," 30–33.

97. "Cartes de Visite," *American Journal of Photography* 4, no. 12 (November 15, 1861): 268.

98. Daniel J. Boorstin, *The Image: A Guide to Pseudo-Events in America* (New York: Harper Colophon, 1964). Boorstin locates the Graphic Revolution in the twentieth century, but the celebrity carte de visite seems a more appropriate starting point for the split between hero and celebrity.

99. A. Wynter, "Cartes de Visite," *American Journal of Photography* 4, no. 21 (April 1, 1862): 481. "Phiz" was a cheeky shorthand for physiognomy—in this case, portrait.

100. Ibid.

101. McCandless, "The Portrait Studio and the Celebrity," 71. William Darrah has outlined two peak periods of celebrity portraiture in the United States, the first about 1860–66 and the second 1875–85. The earlier period concentrated on political, military, clerical, literary, and theatrical figures, while the later one leaned toward entertaining and often sensational people. He also provides a more comprehensive list of photographers and celebrity sitters. See Darrah, "Portraits of Celebrities," chapter 5 in *Cartes-de-Visite in Nineteenth-Century Photography*.

102. *The Private Mary Chesnut*, 47.

103. Respectively, "Godey's Arm-Chair: Our Card Photographs," *Godey's Lady's Book* 67 (October 1863): 381; and G. W. Tomlinson, "Card Photographs of Distinguished Personages, Works of Art, Etc.," May 1864, collection of the Winterthur Museum and Library.

104. Carte de visite mail broadside, c. 1865, collection of Matt Isenburg, whom I thank for generously sending me a copy.

105. See Davis, "'A Terrible Distinctness,'" 137. On the Anthony firm, see William and Estelle Marder, *Anthony: The Man, the Company, the Cameras* (Plantation, Fla: Pine Ridge, 1982).

106. Respectively, "Catalogue of Card Photographs, Published and Sold by E. & H. T. Anthony," November 1862, collection of the George Eastman House; and "New Catalogue of Stereoscopes and Views, Manufactured and Published by E. & H. T. Anthony & Co.," 1868, collection of the Society for the Preservation of New England Antiquities, photography files. The 1868 catalogue claimed "73 Major-Generals, 190 Brig-Generals, 259 Colonels, 84 Lieut-Colonels, 207 Other Officers, 60 Officers of Navy, 525 Statesmen, 46 Prominent Women, 116 Authors, 30 Artists, 112 Stage, 127 Divines, 147 Prominent Foreign Portraits."

107. Marder, *Anthony*, 85–88.

108. McCauley, *A. A. E. Disdéri and the Carte de Visite*, 224.

109. E. Legouvé, "A Photographic Album," *Photographic Times* 4, no. 40 (April 1874): 54.

110. Root, *Camera and the Pencil*, 27.

111. This has also been interpreted as participating in republicanism, particularly in the midst of national statesmen at galleries like Brady's. See Rudisill, *Mirror Image*; and Trachtenberg, "Illustrious Americans."

112. McCauley, *A. A. E. Disdéri and the Carte de Visite*, 3.

113. Wynter, "Cartes de Visite," 486.

114. "Photography and Popularity," *Humphrey's Journal* 17, no. 13 (November 1, 1865): 207.

CHAPTER TWO. ALBUMS ON THE MARKET

1. Nod Patterson, "Two Kinds of Album Pictures," *The Photographer's Friend/Almanac and American Yearbook of Photography* (1872): 45.

2. Ibid.

3. Ibid., 47.

4. Stephanie Coontz, *The Social Origins of Private Life: A History of American Families, 1600–1900* (New York: Verso, 1988), 217.

5. Walter Benjamin, "Paris—Capital of the Nineteenth Century," in *Charles Baudelaire: A Lyric Poet in the Age of High Capitalism*, trans. Harry Zohn (New York: Verso, 1983).

6. Circulation—of goods as well as people—is considered a defining feature of modernity, as seen in the varied essays on the topic in *Cinema and the Invention of Modern Life*, ed. Leo Chaney and Vanessa R. Schwartz (Berkeley: University of California Press, 1995).

7. William W. Harding, preface to the "Flexible Chain-Back Album" (patented October 17, 1865), Smithsonian Institution National Museum of American History, Photography Collection, No. 61.539. Shirley Wajda has warned against seeing the rise of albums as the inevitable outcome of photographic production and ignoring the analysis of the cultural conditions that allowed cognition of

album use in the first place. While Wajda is certainly correct not to view albums as originating exclusively from an abundance of cartes de visite, that simple factor is most often cited in the contemporary literature. See Shirley Teresa Wajda, "'Social Currency': A Domestic History of Portrait Photography in the United States" (Ph.D. diss., University of Pennsylvania, 1992), 23–24.

8. "Editor's Table: Photography and Its Album," *Godey's Lady's Book* 68 (March 1864): 304.

9. Patent number 32,287; for more, see *Subject-Matter Index of Patents for Inventions Issued by the United States Patent Office from 1790–1873, Inclusive* (New York: Arno, 1976), entries for "Album" and "Photographic Album." Both Robert Taft, *Photography and the American Scene: A Social History of Photography, 1839–1889* (New York: Dover, 1938) and Susan Ruth Finkel, "Victorian Photography and Carte de Visite Albums, 1860–1880" (master's thesis, University of Delaware, 1984) discuss the first patents of albums and album-related devices. William Culp Darrah notes a copyright (as opposed to a patent) by O. G. Mason in the spring of 1861 for an album with window for carte and for autograph; see William Culp Darrah, *Cartes-de-Visite in Nineteenth-Century Photography* (Gettysburg: W. C. Darrah, 1981). It should be noted that photograph albums were already in circulation in the United States as early as 1860 (and in Europe slightly earlier). The first notice I have seen for such albums in America occurred in an advertisement for E. & H. T. Anthony on December 22, 1860, in both *Harper's Weekly* and *Frank Leslie's Illustrated Newspaper*. The Anthonys probably imported these albums from Europe.

10. Patent number 32,404. For more on the business practices of the Anthony firm that made them the leaders in the industry, see William and Estelle Marder, *Anthony: The Man, the Company, the Cameras* (Plantation, Fla.: Pine Ridge, 1982); and Reese V. Jenkins, *Images and Enterprise: Technology and the American Photographic Industry, 1839 to 1925* (Baltimore: Johns Hopkins University Press, 1975).

11. C. D. Fredericks & Company, "Card Albums Patent," *Harper's Weekly* 6, no. 280 (May 10, 1862): 303. At the end of the notice, the company helpfully suggested that if customers wanted albums, they could find very beautiful specimens at their galleries.

12. Jabez Hughes, "Photography as an Industrial Occupation for Women," *Anthony's Photographic Bulletin* 4, no. 6 (June 1873): 163 (reprinted from the *London Photographic News*).

13. Advertisements for C. D. Fredericks & Company, *American Journal of Photography*, Fall 1861 through 1862.

14. Tintype "gem" albums, with very small tintype portraits, could be much more intimate in size—2 × 3 inches or smaller. For more on this kind of album, see Floyd Rinhart, Marion Rinhart, and Robert W. Wagner, *The American Tintype* (Columbus: Ohio State University Press, 1999), 67–74. Ellen Maas provides an overview of various styles and physical characteristics of albums (particularly European ones) in the well-documented catalogues *Das Photoalbum 1858–1918: Eine Dokumentation zur Kultur- und Sozialgeschichte* (Munich: Münchner Stadtmuseum, 1975) and *Die goldenen Jahre der Photoalben: Fundgrube und Spiegel von gestern* (Cologne: DuMont

Buchverlag, 1977). For the physical makeup of various albums, from a conserva-
tion perspective, see Jane Rutherston, "Victorian Album Structures," *Paper Con-
servator* 23 (1999): 13–25; I thank Sylvie Penichon for this reference.

15. An invention that helped protect album leaves from frequent insertion and
removal of photographs is advertised in "Novelties: Anthony's Perfect Album,"
Anthony's Photographic Bulletin 7, no. 3 (March 1876): 96. Another innovation was
an album with removable leaves, so that each page was like an individual frame
or passepartout, with different-sized openings. Its advantages lay in the ability
to change a page of four small portraits to one larger one, say, or replace selected
soiled pages in an otherwise serviceable album. "New Patent Universal Album,"
Anthony's Photographic Bulletin 3, no. 7 (July 1872): 607.

16. One music box album at the George Eastman House (Brady-Sipley Collection,
77:468:2) claimed to play two airs: "Pretty as a Picture" and "Martha, the Last
Rose." Louise Stevenson notes an album that performed "Home Sweet Home" in
The Victorian Homefront: American Thought and Culture, 1860–1880 (New York:
Macmillan, 1991), 15.

17. This and the above quote are from "Cartes de Visite," *American Journal of Photog-
raphy* 4, no. 12 (November 15, 1861): 269. (This article was condensed from the
British Art-Journal; the same can be seen in "Cartes de Visite," *Humphrey's Journal*
13, no. 21 [March 1, 1862]: 326–30.)

18. "Photomania," *Harper's Weekly* 5, no. 216 (February 16, 1861): 99.

19. Oliver Wendell Holmes, "Doings of the Sunbeam," *Atlantic Monthly* 12 (July
1863): 1–15; reprinted in *Photography: Essays and Images*, ed. Beaumont Newhall
(New York: Museum of Modern Art, 1980), 64. See also Marder, *Anthony*, 93.

20. "Editor's Table: Harding's Chain-Back Albums," *Philadelphia Photographer* 7, no.
84 (December 1870): 431.

21. Coleman Sellers, "[Report from] Philadelphia, April 4th, 1863," *British Journal of
Photography* (May 1, 1863): 197.

22. "Editorial Department," *American Journal of Photography* 7, no. 18 (March 15,
1865): 431–32.

23. "Photographic Albums," *Humphrey's Journal* 13, no. 20 (February 15, 1862): 318–19.

24. "Photography a Progressive Art," *Philadelphia Photographer* 1, no. 9 (September
1864): 132–33.

25. H. Baden Pritchard, *About Photography and Photographers: A Series of Essays for the
Studio and Study* (1883; reprint, New York: Arno, 1973), 65. Although the book
focuses on Europe, it was well received in the United States for its applicable
lessons.

26. See Coleman Sellers, "Foreign Correspondence: Philadelphia, September 4,
1864," *British Journal of Photography* 11, no. 229 (September 28, 1864): 370. Sellers
reported that American bookbinders improved their trade by employing machin-
ery designed originally for albums.

27. "The New Size," *Philadelphia Photographer* 3, no. 34 (October 1866): 311.

28. Ibid., 312. The editors of the *Philadelphia Photographer* reproduced this advice
from their British brethren at the *Photographic News*.

29. W. J. Baker, "The New Size, Etc.," *Philadelphia Photographer* 8, no. 86 (February 1871): 41; "The Victoria Card," *Anthony's Photographic Bulletin* 2, no. 3 (March 1871): 73–74.

30. "The New Size," 312. This is also part of the citation from the *Photographic News*.

31. Ibid., 311.

32. For example, when speaking of the new albums that had emerged on the market to contain and display card photographs, the *American Journal of Photography* editors counseled, "This fashion is reasonable; and there is little doubt that it will become a permanent institution." "Editorial Department," *American Journal of Photography* 3, no. 17 (February 1, 1861): 272. A chatty piece on the carte de visite noted that albums were rapidly taking the place of the long-cherished card basket, and that "that institution has had a long swing of it." "The Carte de Visite," *American Union* [Boston] 28, no. 17 (August 16, 1862): 3 (reprinted from *All the Year Round*).

33. "Editorial Department," *American Journal of Photography* 5, no. 13 (January 1, 1863): 312.

34. Hughes, "Photography as an Industrial Occupation for Women," 162–63.

35. William Flint, cabinet card album (1866), George Eastman House (Sipley Collection 77:317:1–50).

36. "Editor's Table: Photography and Its Album," 304.

37. "Photography Abroad: Photographic Albums," *Photographic World* 2, no. 20 (August 1872): 225 (reprinted from *Mittheilungen*).

38. "Editorial Department," *American Journal of Photography* 5, no. 13 (January 1, 1863): 312.

39. "Keep Your Albums Locked," *Anthony's Photographic Bulletin* 7, no. 2 (February 1876): 43 (reprinted from *London Photographic News*).

40. Flint, cabinet card album, George Eastman House.

41. "Instructions and Directions to Agents," n. d. (after 1866), two-page pamphlet circulated to agents selling photograph albums in the field, Bella C. Landauer Collection of Business and Advertising Ephemera, vol. XIc, Collection of the New-York Historical Society. The quotations in this discussion refer to this pamphlet (ellipses prompted by rips in the page).

42. "Novelties: Albums," *Anthony's Photographic Bulletin* 1, no. 10 (November 1870): 208.

43. "Editorial Department," *American Journal of Photography* 5, no. 13 (January 1, 1863): 312.

44. This image had been published in European journals, including the *Illustrated London News* the previous holiday season, and *L'Univers Illustrei*. Thanks to Patrizia di Bello for bringing this to my attention.

45. For example, several carte de visite albums at the Society for the Preservation for New England Antiquities, Boston, have holiday inscriptions on their title pages: "Charles F. Batchelder from Aunt Katie Christmas 1862" (no. 69K); "A Merry Christmas to Freddie from Lizzie and Theo 1862" (no. 81A); "Constance Winsor, Christmas 1873, from Papa" (no. 80A). Many were also given as birthday or wedding gifts.

46. "Lay in Your Holiday Stock: Albums," *Anthony's Photographic Bulletin* 2, no. 11 (November 1871): 369.

47. "Photomania," 99.

48. "Literary Notices: Photograph Albums as Gift Books," *Godey's Lady's Book* 69 (November 1864): 443.

49. "Novelties: Albums," *Anthony's Photographic Bulletin* 1, no. 1 (February 1870): 6.

50. Ann Smart Martin, "Makers, Buyers, and Users: Consumerism as a Material Culture Framework," *Winterthur Portfolio* 28, no. 2–3 (Summer–Autumn 1993): 145. Most historical societies collect albums, especially from local families of prominence, and museums have begun to collect more unusual photograph albums.

51. "Centre-Table Gossip: Photographic Albums," *Godey's Lady's Book* 64 (February 1862): 208.

52. For other advertisements for sales agents, see circulars from the National Publishing Company and Scammel & Company, Smithsonian Institution National Museum of American History, Warshaw Collection, boxes 5 and 6, respectively. Regarding magazine premiums, *Peterson's Magazine* informed its readers in 1865 that "we do not send a Photograph Album, this year, for a premium. The only premiums we give are those advertised in our Prospectus." Presumably, then, they had previously given out albums as premiums for subscriptions and clubs. "Editor's Table: No Photograph Albums," *Peterson's Magazine* 47, no. 2 (February 1865): 164. The Sylvester & Company National Art Gallery in New York, which sold religious, historical, and genre-style steel engravings, offered photograph albums as premiums (along with watches, handkerchiefs, gloves, chains, etc.) if agents purchased a certain number of prints. "The Golden Enterprise of the Season: Confidential Proposition for Agencies," 1865, Winterthur Museum and Library, Joseph Downs Collection of Manuscripts and Printed Ephemera, No. 79x187. Finally, photographic catalogues offered wholesale prices to photographers, who would sell the albums in their galleries, while individual consumers could purchase albums from the mail-order catalogues that proliferated toward the end of the nineteenth century. There are many, but representative examples can be found in photographic supplier Richard Walzl's 1875 price catalogue, Smithsonian Institution National Museum of American History, Library; and R. H. Macy & Company, 1891 catalogue, Strong National Museum of Play, Rochester.

53. An 1872 price list in Anthony's offered albums from $1 to $27; "Novelties: Albums," *Anthony's Photographic Bulletin* 3, no. 9 (September 1872): 675–76. The previous year the journal advertised albums "from fifty cents to fifty dollars"; see "Lay in Your Holiday Stock: Albums," 369–70.

54. An Outsider, "My First Carte de Visite," *American Journal of Photography*, no. 15 (February 1, 1863): 337–38.

55. For purposes of comparison, $1.51 in 1863 would equal $22.07 in 2003, the latest figures available in Scott Derks, ed., *The Value of a Dollar: Prices and Incomes in the United States, 1860–2004* (Millerton, N.Y.: Grey House, 2004). According to Derks, other amusements and domestic goods were comparable in price, such

as a concert ticket (1877) for 50 cents; museum ticket (Barnum's, 1865) 30 cents; trimmed hat (1877) $2.50; Currier & Ives print (1877) 20 cents; hair treatment bottle (1865) $1; subscription to *Harper's Weekly* (1865) 10 cents per week. With tradesmen's wages hovering around $1.53 to 2.50 a day in 1860 (for a sixty-hour week) to $2.31–$3.50 a day in 1864, the photograph album was an indulgence but not entirely out of reach for those beyond the confines of the middle class.

56. An Outsider, "My First Carte de Visite," 337.

57. "Editor's Table: Photography and Its Album," 304.

58. "Editorial Department," *American Journal of Photography* 3, no. 17 (February 1, 1861): 272.

59. For a thorough overview of nineteenth-century American fashion practices across class lines, see Joan L. Severa, *Dressed for the Photographer: Ordinary Americans and Fashion, 1840–1900* (Kent, Ohio: Kent State University Press, 1995).

60. Georg Simmel, "Fashion," *International Quarterly* 10 (October 1904–January 1905): 130–55.

61. "The Shecesh," *Vanity Fair* 50 (April 5, 1862): 163.

62. "The New Picture Galleries," *American Journal of Photography* 4, no. 16 (January 15, 1862): 361 (reprinted from *London Review*).

63. "Lady Beggars," *Vanity Fair* 50 (February 22, 1862): 93.

64. "Photography and the Affections," *Humphrey's Journal* 17, no. 6 (July 15, 1865): 93.

65. "Keep Your Albums Locked," 43.

66. Platt provided a "model register" detailing how one might fill in the personal and physical data of the record. A few examples give insight into what he thought the typical family to be, along with some facts of life in nineteenth-century America: "Descent: English, Irish, Scotch, German, &c."; "No. Bro's and Sis's: Five Brothers and Three Sisters"; "Occupation: Farmer, Lawyer, Mechanic, &c."; "Religion: Methodist, Baptist, Catholic, &c."; "Health: Feeble, Average, Good, Vigorous"; "Disease: Consumption, Killed in Battle."

67. Unfortunately, the asking price for this album is unknown.

68. A methodological problem in examining old albums is that their provenance is sometimes not established and unscrupulous dealers may remove or replace the photographs inside. The album at the George Eastman House comes from the old Sipley Museum of Philadelphia, but little is known about how it came into that collection; the Smithsonian's album, which also has none of the lines filled in and photographs on the wrong pages, has a provenance that can be traced back to a collector, but not beyond that. My operating assumption is that they represent the families' use of the album; even if the photographs have been changed, the written portion has still been left blank.

CHAPTER THREE. ALBUMS IN THE PARLOR

1. "For Photographic Albums," *Punch Magazine* (26 November 1864), 222; reprinted in Bill Jay, ed., *Some Rollicking Bull: Light Verse, and Worse, on Victorian Photography* (Tucson: Nazraeli, 1994), 39.

2. Charlotte Stewart Album, Winterthur Museum and Library, Doc. 954.

3. "Useful Facts, Receipts, Etc.: A New Application of Photography," *American Journal of Photography* 5, no. 3 (August 1, 1862): 68.

4. George P. Morris, "My Mother's Bible," in *Gems for the Fireside, Comprising the Most Unique, Touching, Pithy, and Beautiful Literary Treasures from the Greatest Minds in the Realm of Poetry and Philosophy, Wit and Humor, Statesmanship and Religion*, ed. Rev. Otis Henry Tiffany (Tecumseh, Mich.: A. W. Mills, 1883), 523.

5. Advertisement in Junis Browne, *The Great Metropolis: A Mirror of New York* (Hartford: American, 1869), 703.

6. Arthur Jerome Dickson, ed., *Covered Wagon Days: A Journey Across the Plains in the Sixties, and Pioneer Days in the Northwest; from the Private Journals of Albert Jerome Dickson* (Cleveland: Arthur H. Clark, 1929), 192 (Robert Taft's *Photography and the American Scene* pointed me to this source). Colleen McDannell has noted that the family Bible declined in popularity after 1870, pointing out that in the 1850s there were almost three hundred *new* editions of Bibles, but by 1910, that number had fallen to fifty-five new editions. McDannell, *Material Christianity: Religion and Popular Culture in America* (New Haven: Yale University Press, 1995), 99–102. For more on Bible sales, see Peter J. Wosh, *Spreading the Word: The Bible Business in Nineteenth-Century America* (Ithaca: Cornell University Press, 1994).

7. Uncited contemporary source in Linkman, *Victorians: Photographic Portraits*, 71.

8. For example, a preprinted "Family Record," engraved with appropriate images, was published in *Gleason's Pictorial Drawing-Room Companion* 6, no. 1 (January 7, 1854): 12. With lines for family names, children, and the dates and locations of births, marriages, and deaths, it could be removed directly from the journal and filled out.

9. Oliver Wendell Holmes, "Doings of the Sunbeam," *Atlantic Monthly* 12 (July 1863): 1–15; reprinted in *Photography: Essays and Images*, ed. Beaumont Newhall (New York: Museum of Modern Art, 1980), 70. Holmes also hints at the applications of such observations for predicting criminal behavior through physiognomic means.

10. *Life History Album*, ed. Francis Galton (London: Macmillan, 1884). See also Shawn Michelle Smith, *American Archives: Gender, Race, and Class in Visual Culture* (Princeton: Princeton University Press, 1999), which examines, in part, the reciprocal influence of popular and eugenicist uses of photography in archives such as albums.

11. Emily J. Mackintosh, "To Be Left at the Office Until Called For," *Peterson's Magazine* 46, no. 4 (October 1864): 241.

12. John L. Gihon, "Photographic Albums," *Photographic Mosaics* 13 (1878): 69.

13. These conclusions are based on albums I have viewed at the Art Institute of Chicago, the Chicago History Museum, the George Eastman House, the New-York Historical Society, the Smithsonian Institution National Museum of American History, and the Society for the Preservation of New England Antiquities.

14. "Photography Abroad: Photographic Albums," *Photographic World* 2, no. 20 (August 1872): 226 (reprinted from *Mittheilungen*).

15. "Photograph Albums," *Scientific American* 6, no. 14 (April 5, 1862): 216.

16. "Keep Your Albums Locked," *Anthony's Photographic Bulletin* 7, no. 2 (February 1876): 43 (reprinted from *London Photographic News*).

17. Some studies have attempted to map out these meanings, but such readings are often drawn from a rather limited pool. Angela Wheelock examined ten albums in the Bentley Historical Library, Michigan, and discovered that there was little chronological coherence to the albums; that pictures rarely showed people several times, concentrating instead on many different sitters; that female owners included more women (and males more men); and that women often displayed fewer members of their husband's family than of their own. See Wheelock, "Icons of the Family: Nineteenth-Century Photograph Albums," in *Michigan: Explorations in Its Social History*, ed. Francis X. Blouin and Maris A. Vinovskis (Ann Arbor: Historical Society of Michigan, 1987), 105–30. Also see analyses of album arrangements in Susan Ruth Finkel, "Victorian Photography and Carte de Visite Albums, 1860–1880" (master's thesis, University of Delaware, 1984); and Sarah McNair Vosmeier, "The Family Album: Photography and American Family Life Since 1860" (Ph.D. diss., Indiana University, 2003).

18. "Photography a Progressive Art," *Philadelphia Photographer* 1, no. 9 (September 1864): 132.

19. John Elsner and Roger Cardinal, eds. *The Cultures of Collecting* (Cambridge, Mass.: Harvard University Press, 1994), 1.

20. Henry T. Williams and Mrs. C. S. Jones, *Beautiful Homes, or Hints in House Furnishing* (New York: Henry T. Williams, 1878), 111. For more on the parlor in the American Victorian home, see Shirley Teresa Wajda, "'Social Currency': A Domestic History of Portrait Photography in the United States" (Ph.D. diss., University of Pennsylvania, 1992), especially the chapters "Parlor People" and "Social Currency"; Harvey Green, *The Light of the Home: An Intimate View of the Lives of Women in Victorian America* (New York: Pantheon, 1983); Louise Stevenson, *The Victorian Homefront: American Thought and Culture, 1860–1880* (New York: Macmillan, 1991); Katherine C. Grier, "The Decline of the Memory Palace: The Parlor After 1890," in *American Home Life, 1880–1930: A Social History of Spaces and Services*, ed. Jessica H. Foy and Thomas J. Schlereth (Knoxville: University of Tennessee Press, 1992), 49–74; and Katherine C. Grier, *Culture and Comfort: People, Parlors, and Upholstery, 1850–1930* (Rochester: Strong Museum, 1988).

21. See Grier, "Decline of the Memory Palace" and *Culture and Comfort*.

22. E. Legouvé, "A Photographic Album," *Photographic Times* 4, no. 40 (April 1874): 54.

23. "The Carte de Visite," *American Union* [Boston] 28, no. 17 (August 16, 1862): 3 (reprinted from *All the Year Round*).

24. "Table-Talk," *Appleton's Journal* 6, no. 130 (September 23, 1871): 358.

25. R. H. E., "My Photograph," *Godey's Lady's Book* 74 (April 1867): 341.

26. S. Annie Frost, *Frost's Laws and By-Laws of American Society, a Condensed but Thorough Treatise on Etiquette and Its Usages in America* (New York: Dick and Fitzgerald, 1869), 61.

27. Williams and Jones, *Beautiful Homes*, 112.

28. "The Great Beauty of Photographs," *American Journal of Photography* 6, no. 15 (February 1, 1864): 348–49 (reprinted from *Punch's Almanac*).

29. Both quotes from "Editor's Table: Photography as an Art," *Godey's Lady's Book* 65 (July 1862): 97. The editorial quoted a British commentator.

30. Frank Wing, *"The Fotygraft Album": Shown to the New Neighbor by Rebecca Sparks Peters Aged Eleven* (Chicago: Reilly and Britton, 1915), n.p.

31. Frank Wing, *"The Fambly Album": Another "Fotygraft Album," Shown to the New Preacher by Rebecca Sparks Peters Aged Eleven: The "Bigger Album from Upstairs"* (Chicago: Reilly and Britton, 1917).

32. Roland Barthes, *Camera Lucida: Reflections on Photography*, trans. Richard Howard (New York: Noonday, 1981), 5.

33. *Tit-Bits of American Humour, Collected from Various Sources* (New York: White and Allen, n.d. [c. 1870s]); Shannon Thompson Perich at the Smithsonian's National Museum of American History kindly brought this piece to my attention.

34. "A Reasonable Excuse," *Harper's New Monthly Magazine* 30, no. 177 (February 1865): 406. Shirley Wajda has discussed this cartoon in brief, noting that the humor derives from the absurdity of the domestic servant's having a family album at all, rightly pointing out the different treatment of the two figures pictorially. However, I think that the cartoon plays on the validity of losing oneself in one's album—but in this case, it is not her own. See Wajda, "Social Currency," 541.

35. "Keep Your Albums Locked," 42–43. The servant's cockney slang can be explained by the article's original publication in the *London Photographic News;* it was reprinted for an American audience in *Anthony's.*

36. Susan Stewart, *On Longing: Narratives of the Miniature, the Gigantic, the Souvenir, the Collection* (Durham: Duke University Press, 1993), 138.

37. This can be seen most extravagantly in the albums of upper-class British women, which reveal extraordinary flights of fancy and wit through watercolor and collage, and which remove photographs from mass production and render them unique. American women's photograph albums tend toward comparative drabness. See my catalogue on the subject, *Playing with Pictures: The Art of Victorian Photocollage* (Chicago: Art Institute of Chicago, 2009).

38. "Album Cover and Case," *Art Amateur* 1, no. 1 (June 1879): 19.

39. Wheelock, "Icons of the Family," 109–10.

40. Anne Higonnet, "Secluded Vision: Images of Feminine Experience in Nineteenth-Century Europe," *Radical History Review* 38 (1987): 24. Higonnet's study focuses exclusively on Europe, where elaborate ladies' albums were more common. This argument should be applied carefully to American photograph albums.

41. See Todd Gernes, "Recasting the Culture of Ephemera: Young Women's Literary Culture in Nineteenth-Century America" (Ph.D. diss., Brown University, 1992); Raechel Elisabeth Guest, "Victorian Scrapbooks and the American Middle Class" (master's thesis, University of Delaware, 1996); E. W. Gurley, *Scrap-Books and How to Make Them. Containing Full Instructions for Making a Complete and Systematic Set of Useful Books* (New York: Authors' Publishing Company, 1880); Jessica Helfand, *Scrapbooks: An American History* (New Haven: Yale University Press, 2008); Debo-

rah A. Smith, "Consuming Passions: Scrapbooks and American Play," *Ephemera Journal* 6 (1993): 63–76; and Susan Tucker, Katherine Ott, and Patricia P. Buckler, eds., *The Scrapbook in American Life* (Philadelphia: Temple University Press, 2006).

42. Gurley, *Scrap-Books and How to Make Them*, 13.

43. Excerpt from William Doty, "On a Photograph," *Peterson's Magazine* 53, no. 3 (March 1868): 186.

44. Crafts employing human hair were very common for women in nineteenth-century America, and photographs often included a lock of hair as a tactile keepsake. See examples and a discussion in Geoffrey Batchen, *Forget Me Not: Photography and Remembrance* (New York: Princeton Architectural Press, 2004).

45. "Table-Talk," 358.

46. Siegfried Kracauer, "Photography" (1927), in *The Mass Ornament: Weimar Essays* (Cambridge, Mass.: Harvard University Press, 1995). Catherine Keenan, in response to Kracauer, argues that photographs can be put to the service of either remembering or forgetting. Catherine Keenan, "On the Relationship Between Personal Photographs and Individual Memory," *History of Photography* 22, no. 1 (Spring 1998): 60–64.

47. See, for example, the oft-cited Barthes, *Camera Lucida;* Walter Benjamin, "A Short History of Photography," reprinted in *Classic Essays on Photography*, ed. Alan Trachtenberg (New Haven: Leete's Island, 1980); Jo Spence and Patricia Holland, eds., *Family Snaps: The Meaning of Domestic Photography* (London: Virago, 1991); Annette Kuhn, *Family Secrets: Acts of Memory and Imagination* (New York: Verso, 1995); and Marianne Hirsch, *Family Frames: Narrative Photography and Postmemory* (Cambridge, Mass.: Harvard University Press, 1997).

48. On sentiment, see Shirley Samuels, ed., *The Culture of Sentiment: Race, Gender, and Sentimentality in Nineteenth-Century America* (Oxford: Oxford University Press, 1992); Cynthia Dickinson, "Creating a World of Books, Friends, and Flowers: Gift Books in America, 1825–1860" (master's thesis, University of Delaware, 1995); Guest, "Victorian Scrapbooks and the American Middle Class"; and Karen Halttunen, *Confidence Men and Painted Women: A Study of Middle-Class Culture in America, 1830–1870* (New Haven: Yale University Press, 1982).

49. "Sioux" Brubaker, "The Family Album," *St. Louis Practical Photographer* 2, no. 3 (March 1878): 84. This quotation is an excerpt; to read the poem in full, see the appendix.

50. Ella Walters Album, c. 1860s, George Eastman House 81:1270. This quotation is an excerpt; the entire poem is in the appendix.

51. On this topic, see Andrea Volpe, "Cheap Pictures: Cartes de Visite Portrait Photographs and Visual Culture in the United States, 1860–1877" (Ph.D. diss., Rutgers University, 1999), especially chapter 4, "Collecting the Nation: Carte de Visite Albums and the Meaning of the Civil War"; and Alan Trachtenberg, "Albums of War: On Reading Civil War Photographs," *The New American Studies: Essays from Representations*, ed. Philip Fisher (Berkeley: University of California Press, 1991), 287–318.

52. Volpe, "Cheap Pictures," 147–48.

53. Sarah McNair Vosmeier notes that this mingling of family and celebrities occurred in the South as well—perhaps with even more sentiment, as in the example of Walter Rogers, a Confederate soldier from New Orleans whose album boasted Jefferson Davis (on the opening page), John Wilkes Booth, Stonewall Jackson, and Robert E. Lee. See Vosmeier, "Seeing the South: Family Photograph Albums and Family History, 1860–1930," *Southern Quarterly* 36, no. 4 (Summer 1998): 10–19.

54. "The Carte de Visite Album," c. 1864, song written for Tony Pastor (air: "Chanting Benny"), published by H. Demarsan, Dealer in Songs, Toys, Books &c., Chatham, New York; this quotation is an excerpt; see appendix for a transcript of the complete song lyrics. A copy is in the collection of the Western Reserve Historical Society, Cleveland.

55. "Cartes de Visite," *American Journal of Photography* 4, no. 12 (November 15, 1861): 266. This article was condensed from the British *Art-Journal*; the same can be seen in "Cartes de Visite," *Humphrey's Journal* 13, no. 21 (March 1, 1862): 326–30.

56. Benedict Anderson, *Imagined Communities: Reflections on the Origins and Spread of Nationalism* (New York: Verso, 1992).

57. See Smith, *American Archives*, 6. Smith also noted this connection to Anderson's newspaper reader.

58. The verses that open and close this chapter are from cartes de visite that were in the collection of the late Peter Palmquist. I am grateful for his generosity.

CHAPTER FOUR. THE DEMISE OF THE CARD ALBUM, THE RISE OF THE SNAPSHOT ALBUM

1. From Ella Wheeler, "A Tintype," *Peterson's Magazine* 85, no. 1 (January 1884): 53.

2. H. Baden Pritchard, *About Photography and Photographers: A Series of Essays for the Studio and Study* (1883; reprint, New York: Arno, 1973), 23. This is a British take on the scene, but published in New York by Scovill.

3. Edith Wharton, *The Reef* (1912) (New York: Oxford University Press, 1998), 106. I thank Anna Macgregor Robin for pointing out this citation to me.

4. "Decorative Art Notes," *Art Amateur* 2, no. 6 (May 1880): 128.

5. See Katherine C. Grier, "The Decline of the Memory Palace: The Parlor After 1890," in *American Home Life, 1880–1930: A Social History of Spaces and Services*, ed. Jessica H. Foy and Thomas J. Schlereth (Knoxville: University of Tennessee Press, 1992), 49–74.

6. Pritchard, *About Photography and Photographers*, 24.

7. William Culp Darrah, *Cartes-de-Visite in Nineteenth-Century Photography* (Gettysburg: W. C. Darrah, 1981), 10.

8. "Unmounted Photographs in Commerce," *Anthony's Photographic Bulletin* 6, no. 10 (October 1875): 292.

9. Several other advances in camera and film technology followed. The most popular camera was the Brownie, introduced in 1900, which sold for a dollar and was geared toward children. For more of the technical details of the cameras and films, see Brian Coe and Paul Gates, *The Snapshot Photograph: The Rise of Popular Photography, 1888–1939* (London: Ash and Grant, 1977).

10. In contrast to the scant research conducted on nineteenth-century card albums, there has been a moderate amount of scholarship on the family album after the arrival of the Kodak. In addition to those works mentioned in the notes to the introduction, see Julia Hirsch, *Family Photographs: Content, Meaning, and Effect* (New York: Oxford University Press, 1981); David Halle, "The Family Photograph," *Art Journal* 46, no. 3 (Fall 1987): 217–25; David Halle, *Inside Culture: Art and Class in the American Home* (Chicago: University of Chicago Press, 1993); and Patricia Holland, "'Sweet it is to scan . . .': Personal Photographs and Popular Photography," in *Photography: A Critical Introduction*, ed. Liz Wells (London: Routledge, 1997).

11. According to Philip Stokes, a 1904 (British) Kodak catalogue boasted some forty-seven varieties of albums, with illustrations depicting a mixture of landscapes and portraits. Philip Stokes, "The Family Photograph Album: So Great a Cloud of Witnesses," in *The Portrait in Photography*, ed. Graham Clarke (London: Reaktion, 1992), 194.

12. The scrapbook itself also made a comeback once the card album's popularity began to wane. An 1880 guide for making scrapbooks encouraged the making of a single scrapbook for the entire family which would be like the family record of earlier years, but annotated with clippings and articles pertaining to the family and relatives. "As you turn its pages in after years you will see the notices of the happy weddings of brothers and sisters, of the merry evening parties, or of sickness and death which occurred at the old homestead." E. W. Gurley, *Scrap-Books and How to Make Them. Containing Full Instructions for Making a Complete and Systematic Set of Useful Books* (New York: Authors' Publishing Company, 1880), 52–53.

13. Marilyn F. Motz, "Visual Autobiography: Photography Albums of Turn-of-the-Century Midwestern Women," *American Quarterly* 41, no. 1 (March 1989): 64.

14. "Many Albums Kept by Women," *New York Sun: Current Literature* 34, no. 6 (June 1903): 741.

15. Scammel & Company advertisement for agents, n.d. (c. 1890s), Warshaw Collection, Smithsonian Institution National Museum of American History; emphasis in original.

16. Motz, "Visual Autobiography," 63.

17. Pierre Bourdieu, *Photography: A Middle-Brow Art*, trans. Shaun Whiteside (Stanford: Stanford University Press, 1990), 31.

18. "Many Albums Kept by Women," 741.

INDEX

Note: Page numbers in *italics* refer to illustrations.

Advertising, changing methods of, 93–95

Albums: collections in, 85–86, 154; craft projects in, 139–42; derivation of the term, 12; individualized, 165; literary, 115; as metaphors for life, 12–13, 29, 33; poems in, 12, 113, 114; as portraits of their owners, 12–13, 87; public and private merged in, 72, 152–53; standardization of, 72, 160; transition from text to pictures, 7, 115–16, 119, 122, 134, 138. *See also specific types of albums*

Ambrotype, 23, 179n23

American Journal of Photography: on the carte de visite craze, 24, 25, 56–59, 62; on family records in family Bibles, 116; and the photographic industry, 5, 23; on photography albums, 86, 97, 100, 131

American Publishing Company, 117

American Union, 128

Anderson, Benedict, 6–7, 153

Anthony, Henry T., 74. *See also* Edward and Henry T. Anthony Company

Anthony's Photographic Bulletin, 5, 75, 87; albums marketed in, 91; "Keep Your Albums Locked," 103; on scrapbooks, 160; "Suggestions for Posing," 43–44, *43*

Appleton, D., 60

Appleton's Journal, 130, 145

Art Amateur, 139–40, 159

Art history, 2

Atlantic Monthly, 5, 15, 122

Autograph albums, 164

Barthes, Roland, 135–36, 146

Benjamin, Walter, 146; "A Short History of Photography," 1; "Paris—Capital of the Nineteenth Century," 71–72

Bibles: advertisements for, 117, *118*; albums' origins in, 116, 120, *121*; declining popularity of, 191n6; family records in, 7, 115, 116–17, *119*, 120–21; legal evidence in, 117, 122

Bogardus, Abraham, 53

Bookbinding industry, 82

Boorstin, Daniel, 62

Booth, Edwin, 67, 129

Booth, John Wilkes, 64

Bourdieu, Pierre, 166

Brady, Mathew: and Anthony Company, 64–65; Civil War photographs by, 64, 148–49; *Gallery of Illustrious Americans* by, 60; and Lincoln, 63, 64, 65; studio/gallery of, 54–56, *55*, 60–61, 62, 152

British Journal of Photography, 80

Brubaker, Sioux, 146, 172

Burlock, Samuel D., 117, 118

Cabinet cards: albums for, 3, 86, 88, 128, *129*, 159; emergence of, 82–84

Calling cards, 21–22

Cardinal, Richard, 127

Card portraits, *see* Cartes de visite

Caricatures, 35, *36, 37, 38*

Carlyle, Thomas, 61

"Carte de Visite Album, The" (song), 150

Carte de visite albums: designs of, 75, 77, 97; filled, 95; functions of, 15, 62, 149, 152; marketing of, 77, 79, 81; patents of, 3; varied contents of, 13; viewing

of, 65; young women's interest in, 100–101. *See also* Photograph albums

Cartes de visite, 15–67, *17*; affordability of, 4, 27–28, 29, 33; American craze for, 21, 23–34, 60, 77, 100, 126; celebrity, 7, 8, 16, 59–67, 125, 128, 141, 152; collecting, 22, 24–27, 60, 83, 103, 113–16, 127, 149, 153; in courtship ritual, 24–25; customer dissatisfaction with, 35, *36*, 49–50; declining popularity of, 82, 158, 159–60; emergence of, 16–22; exchange of, 8, 16, 21, 22, 53, 81; full-figure format, 44, 53; individual, 8; marketing of, 19, 31; mass production of, 65; memories preserved via, 87–88; mosaic, 113, *115*, *154*; narratives of, 145; patents of, 20; patterns of use, 53; and photographic industry, 48–49; popularity of, 15–16, 21, 27, 33, 34, 53, 66; portraits on, 16–18, 20–21; posing for, 34–41, *38*, 42–44, *43*, *45*; props and backgrounds for, 44–48, *45*, *48*, *50–51*; quizzing, 115–16; repeated sittings for, 29–30; reproducibility of, 20; social conventions of, 21–22, 34–53, 114, 155, 178n12, 185n7; in social networks, 8, 15, 26–27, 125; studio portraits, 1, 8; symbolic value of, 15, 16, 65, 67; "Taking a Cart de Visite," 35, *37*; uniformity of, 1, 48–49, *50–51*, 116, 148, 160; use of term, 21, 22; visiting cards vs., 21, 22

"Cartomania," 16

Celebrities: "emulatory" vs. intimate personal portraits of, 61–62; and heroes, 61, 62; public worship of, 152

Celebrity portraits: in cartes de visite, 7, 8, 16, 59–67, 125, 128, 141, 152; circulation of, 58–59; collections of, 4, 22, 65–67, 125, 130–31, 148–49, *149*; competition in, 63; daguerreotypes, 19, 61, 62, 63, 152; sources of, 63–64

Chesnut, Mary, 49, 50, 54, 64

Civil War, U.S.: Brady's work in, 64, 148–49; cartes de visite in, 16, 31–33, 125; escalation of, 3–4; nostalgia and loss in, 87, 142, 148–50; and patriotism, 88; photography in, 3, 32, 94

Collodion, 5

Commonplace books, 141, 164

Community: belonging to, 116, 147; extended family as, 13, 113; imagined, 6–7, 153; national, 13, 148; social status within, 90, 147

Coontz, Stephanie, 71

Cushing, Samuel T., 12–13

Cussans, John, 31

Daguerreian Journal, 19

Daguerreotype: celebrity, 19, 61, 62, 63, 152; collections of, 60; comparisons with other formats, 15, 18, 60, 61; declining popularity of, 23–24; in display groups, 19; emergence of, 18–19, 153; preserving memories via, 87; reproduction of, 160

Daniell & Sons Catalogue, *76*

Darrah, William Culp, 160

D'Avignon, Francis, 60

Davis, Jefferson, 150

Dead-letter office, 31–32

Dickson, Albert Jerome, 119

Digital cameras, 167

Disdéri, André Adolphe-Eugène, 20

Double, phenomenon of, 58

Eastman, George, 162

Edward and Henry T. Anthony Company: albums patented and produced by, 74, 80, 83, 91, 93, 96; and *Anthony's Photographic Bulletin*, 5; and Brady's work, 64–65; catalogues of, 64–65; celebrity cartes published by, 60

Edwards, Steve, 3, 5

Elsner, John, 127

Etiquette manuals, 21–22, 40, 41

Eugenics, 122–23

Europe, cartes de visite and albums in, 4, 20–22

Expression, 140, 141

Family: defined by albums, 86–87; different concepts of, 7; dispersal of, 31–32, 87–88, 148; extended, 13, 113, 148; and the home, 71; likenesses among, 122–23; man as head of, 90

Family albums, 3, 7; assembling, 153–54; craft projects in, 139–42; cumulative records in, 30–32, 107; daguerreotype, 19; declining popularity of, 157, 160–61, 165–66; designs of, 120; *The Fambly Album*, 133, 159; focus on the past in, 146; functions of, 85–86, 147, 154–55, 166; group memory in, 166; handed down to new generations, 108; as legal documents, 106–7; looking to the future, 146, 161; marketing the idea of, 85–86, 88, 90, 94; memory and nostalgia in, 107, 108, 127, 142–53, *143, 144*; national, 13; of photographs, *see* Photograph albums; and snapshots, 165–66; stories told via, 10, 11–12, 134–39, 145, 164, 166; varied contents of, 13, 103, 126, 148–49, *149*, 152, 154, 163

Family histories, *see* Genealogy

Family portraits, *see* Portraits

Family pride, 90

Flint, William, 83, 84, 86, 88

"Fotygraft Album," 131–39, *132, 133*, 159functions

Frank Leslie's Illustrated Newspaper, 54–55, *55*

Fredericks, Chas. D., 23, 75; C. D. Fredericks & Company, 74–75

Freud, Sigmund, 58

Frost, S. Annie, 130

Gallery of Illustrious Americans (Brady), 60

Galton, Francis, 122–23

Garbanati, H., 5

Gardner, Alexander, *Photographic Sketch Book of the Civil War*, 3, 148–49

Genealogy, 116–23; in family Bibles, 7, 115, 116–17, *119*, 120–22; and hereditary features, 122–23; as legal documents, 106–8; in *The Photograph Family Record*, 103–10, *104–5*, 120; photographs as record of, 4, 29, 30, 87, 107–10, 147; transition from text to pictures, 7, 116, 119, 122

"Godey's Arm-Chair," 64

Godey's Lady's Book: crafts projects in, 139; on current fashion, 97, 100; holiday issue of, 91, *92*; on parlor courtesy, 131; on photographic albums, 73, 86, 93, 95; on the uses of photographs, 33

Grant, Ulysses S., 149

Grier, Katherine, 127

Grumel, F. R., 73, 74

Gunning, Tom, 58

Gutekunst studio, 28

Hale, Sarah Josepha, 97

Halttunen, Karen, 4, 41

Harding, H. W., 80

Harding, William W., 73, 77, *79*, 118

Harper's New Monthly Magazine, 28; "A Few Cartes de Visite," 16, *17*; "A Reasonable Excuse," 136, *137*; caricatures, *36, 37*; "Home Toilet," 97–98, *98*

Harper's Weekly, 25, 74, 79, 92, 173

Heenan, Johnny, 62

Heliographic art, 31, 96

Hesler, Alexander, 40

Higonnet, Anne, 140

Historical societies, collections of, 189n50

Holmes, Oliver Wendell, 5, 15, 34, 42, 80, 81, 122

Hughes, Jabez, 20, 29, 44, 75, 86

Humphrey's Journal, 25, 31, 59, 81, 102

Imperial portraits, 60–61, 152

Jackson, Thomas "Stonewall," 149
J. B. Lippincott and Company, 80

Kirkbride, William, 24–25, 28
Kodak camera: advertisements for, 160–
 61, *161*, 162, *165*, 166; box camera and
 roll film, 160, 162; Brownie, 195n9;
 invention of, 3, 11, 157
Kracauer, Siegfried, 145, 148, 166

Lawrence, Lucy, 29
Lee, Robert E., 149
Legouvé, Ernest, 128
Lester, Charles Edwards, 60
Lincoln, Abraham: Brady's portraits of,
 63, 64, 65; Hesler's portraits of, 40;
 portraits of, in album collections, 28,
 64, 65, 102, 125, 129, *149*, 150, 153;
 rise to the presidency, 63
Lippincott album company, 80
Lithographs, 60, 62
Littel's Living Age, 26
Logan, John Dickinson, 28

Mackay, James, 48
Martin, Ann Smart, 95
Mass production, 7; of cartes de visite,
 65; of photograph albums, 71–72, 80,
 85, 93, 116, 135, 154
McCandless, Barbara, 63
McCauley, Elizabeth Anne, 3, 21, 65
Middle class: albums as necessity to,
 86–87, 94; assimilation of, 90–91;
 cartes de visite as mark of, 28, 35, 53;
 as consumers, 4, 71–72; status symbols
 of, 101–2, 128–30
Modernity: aspects of, 7; complex experi-
 ence of, 167; shifts toward, 71–72, 146
Mora, J. M., 63

Motz, Marilyn F., 163, 165
Mourning memorials, 18
Museum collections, 189n50
Music-box albums, 93

National identity, 13, 88, 110, 148–49
National press, 153
National Publishing Company, 88, *89*
N. C. Thayer & Company catalogue,
 77, *78*
New York Sun, 164

Parlor: furnishings of, 127; manners in,
 131; public and private spheres merged
 in, 2, 9, 56, 62, 67, 72, 94–95; in Victo-
 rian America, 2, 127
"Parlorization," 55–56
Pastor, Tony, 169
Patriotism, 88
Patterson, Nod, 69–70, 102, 110, 148
Peale, Charles Willson, 60, 150, 152
Peterson's Magazine: "Children's Fashions
 for November," 98–99, *99*; craft proj-
 ects in, 139; poems in, 142, 157; stories
 in, 33–34, 123–31
Peters, Rebecca Sparks (fict.), 131–39, 159
Philadelphia Photographer, 34, 47, 80, 82,
 126
Phoebus, Frank, 74
Photograph albums: affordability of, 4,
 86, 96; assembly of, 9, 123–31; as con-
 sumer item, 95–102; craft projects in,
 139–42; criticisms of, 69–71; declin-
 ing popularity of, 157–59; designs of,
 6, 74, *74*, 75, *76*, 77, *78*, 79, 93, *94*, 96,
 120, *121*; display of, 9, 103, 110, 125,
 127–28, 130–31, 152, 159; "Fotygraft
 Album," 131–39, *132*, *133*, 159func-
 tions of, 2, 4, 7, 12, 103, 119, 120, 147,
 154–55, 158, 160; as gifts, 91–93, 124,
 125; history of, 3–4; as household
 necessity, 86–87, 94; maintaining,
 9–10, 102–11, 125, 154; marketing of,

9, 19, 77, 79, 80–82, 85–95, 101–2; mass production of, 71–72, 80, 85, 93, 116, 135, 154; memories preserved via, 31–32, 87–88, 94, 102, 127, 141–53, *143, 144;* origins of, 73, 116; patents of, 3, 9, 73–75, *74,* 85; and photographic industry, 9, 70, 73–85, 88, 110; physical materials of, 6, *163;* promoting the concept of, 75; public and private merged in, 72, 94–95; and snapshot albums, 3, 11–12, 162, *165,* 166; social networks reflected in, 8, 13, 24, 90–91, 125, 126, 127–29; sold by subscription, 88, *89;* standardization of, 6, 9, 72, 81, 85, 116, 135, 159, 160; as systems of representation, 2, 10; ubiquity of, 2, 3, 95–96, 97; use, 10; virtual, 167

Photographer's Friend, 69

Photograph Family Record, The (Platt), 103–10, *104–5,* 120

Photographic galleries, 54–56

Photographic industry, 5, 9, 23–24, 70, 73–85, 88, 110, 160

Photographic journals, 5, 29, 77, 79, 87, 91, 94

Photographic Sketch Book of the Civil War (Gardner), 3, 148–49

Photographic societies, 5

Photographic Times, 5, 49

Photographic World, 87

Photography: apparatus of, 34, 160, 162; for cartes de visite, 20, 21; commercial, 9, 23–24, 70, 72, 73–85; daguerreotype, *see* Daguerreotype; difference between memory and, 145–49; digital, 167; emergence of, 4–5, 15; in frames, 159; halftone illustrations, 160; history of, 2; and knowledge of the sitter, 145; likeness sought in, 147–48; marketing of, 19, 32, 63; mass production of, 59; memories preserved via, 4, 9, 31–33, 145, 147; memory replaced by, 166; national history in, 61; positive-negative, 51, 58; proofs in, 51, 52; retouch-

ing, 51–52; true nature revealed via, 41–42, 44; varied formats of, 161–67

Physiognomy, 33, 41–42, 65

Physiognotrace, 18

Platt, A. H., 103, 106–10, 120

Plumbe, John, 60

Poetry: "The Album," 173–74; "Carte de Visites," 23; "The Carte de Viste Album," 169–71; "The Family Album," 146–47, 172–73; "Here may your wandering eyes behold," 147; "In the wreck of an old worn album," 157; "May thy Album prove the emblem of thy life," 12; "My Album," 171; "My Mother's Bible," 117; "Now you've seen . . . ," *154,* 155; "Sweet, life-like shadow," 142; "Yes, this is my album," 113, 114

Police files, 176n11

Popular press, 5–6, 7, 24; on contemporary fashion, 97–101; romantic tales in, 33–34

Portrait albums, 3

Portrait galleries, 152

Portraits: acceptability of, 36–38; albums as, 12–13; and cartes de visite, 16–18, 20–21; of celebrities, 60–61; characteristic likeness sought in, 37, 147–48; customer satisfaction with, 35, *36,* 49–50, 54; daguerreotype, *see* Daguerreotype; "emulatory" celebrity vs. memorial personal, 61–62; expressions in, 52–53; full-length, 20–21; headrests used in, 40–41; miniatures, 17–18; oil paintings, 16–18, 20, 28–29; posing for, 42–44, *43;* posing manuals, 34–41; props and backgrounds used in, 8, 44–48, *45, 50–51;* quizzing, 115–16, 131; as record of aging, 29–31; shadow, 18; silhouettes, 18; and social status, 42, 53; standard poses of, 6, 8, 34–41, 48–49, 61; story-telling about, 145; studio, 6, 8, 34, 56; as time-specific, 30, 62; truth value of, 21, 29, 33, 52–53; vanity in, 24

Positivism, 58

Postcards, 160
Pritchard, H. Baden, 82, 158
Pullman, Emily C. N., 149
Punch Magazine, 113

Quimby's, 49, 64

Rockwood, George C., 23
Rodgers, H. J.: "I'm All Ready!" *38;*
 Twenty-Three Years Under a Sky-Light,
 38, 41–42
Rodgers, Solomon P. (fict.), 56–59, 96–97
Romantic tales, 33–34, 123–24
Root, Marcus Aurelius, 30, 32, 42, 44, 66

Salisbury, Bro. & Co., 64
Sarony, Napoleon, 63
Sayers, Tom, 63
Scammel & Company catalogue, 93, *94*
Scientific American, 29, 126
Scovill Manufacturing Company, 5, 19
Scrapbooks, 115, 127, 141, 160, 163, 164,
 196n12
Seely, Charles, 5
Sekula, Allan, 176n11
Self-presentation, 10, 12, 126–27, 147,
 166, 167
Sellers, Coleman, 80
Sentiment, culture of, 146–47
Sherman, William Tecumseh, 149, 150
Silhouettes, 18
Simmel, Georg, 99
Snapshot albums, 3, 11–12, 157–58, 162,
 163, 165, 166
Snapshots: emergence of, 160–62, 175n4;
 unique qualities of, 147–48, 162; var-
 ied formats of, 161–67
Social networks, 8, 13, 24, 90–91, 125,
 126, 127–29, 167

Stereographic albums, 93
Stereographic cards, 15
Stereoscope, 5, 15, 79
Storytelling, 10, 11–12, 134–39, 145, 164,
 166
Studio portraiture, 1, 6, 8, 34, 56
Studios, 54–56, *55*, 61

Tagg, John, 176n11
Technological innovation, 7, 11, 15, 24,
 62, 160, 167
Thumb, Tom, 67, 125, 146, *151*
Tintype, *144*, 179n23, 186n14
Tomlinson, G. W., 64
Trachtenberg, Alan, 61, 62, 149
Travel albums, 3

"Uncle Sam's Big Album" (song), 11, 13,
 150

Vanity Fair, 25, *26*, 27; "Lady Beggars,"
 100–101
Victoria Card, 83
Visiting cards, 21–22
Volpe, Andrea, 3, 149

Wajda, Shirley Teresa, 3, 35, *55*, 66
Waldack, Charles, 21
Walters, Ella E., 147, 171
Wartime portfolios, 3
Washington, George, 62
Weldin, H. R., 28
Wharton, Edith, *The Reef,* 158
Wilson, Edward L., 34, 36, 38, 40, 42,
 50–51
Wing, Frank, 132, 133
Wynter, Andrew, 25